PETER WOLLEN was born in London in 1938. He is the author
of *Signs and Meaning in the Cinema* (1968), and has taught film-
theory at many universities in the United States and Europe.
Co-writer of Michelangelo Antonioni's film *The Passenger*, he
has made several films with Laura Mulvey, including
*Penthesilea* (1974), *Riddles of the Sphinx* (1977) and *Crystal
Gazing* (1982). They have also worked together on an
exhibition of photographs and paintings by Tina Modotti and
Frida Kahlo, and are currently working on a film from Emma
Tennant's novel *The Bad Sister*.

# Peter Wollen

# Verso

# Readings and Writings

## Semiotic Counter-Strategies

Verso Editions and NLB,
15 Greek Street, London W1

Filmset in Plantin by
Red Lion Setters, London

Printed by
The Thetford Press Limited,
Thetford, Norfolk

# Contents

# Preface

This book collects together essays and fictions written during the period from 1968 to 1982 and published in a variety of magazines and journals, of which the most significant for me personally were *Screen* and *Bananas*. In different ways they attempt to develop a series of semiotic counter-strategies both in theory and in practice. During this period, as can be seen very clearly in the work of Barthes and Derrida, the classical distinctions between object-language and meta-language, between text and commentary or analysis, began to break down. The division of labour between theory and practice is one that a cultural counter-strategy should seek to overcome. Rather than dissolve one into the other, however, my strategy was to work in both areas, and to explore some of the relations between them. The volume contains fictions as well as analytic and critical texts; the fictions incorporate elements of theoretical discourse, and a few of the essays—most clearly that on Kahlo and Modotti—make use of fictional forms. These essays and fictions thus present different aspects of work from a common aesthetic position. During this period I also made a number of films, with Laura Mulvey: *Penthesilea*, *Riddles of the Sphinx*, *AMY!*, and *Crystal Gazing*. These form part of the same heterogeneous corpus.

'Cinema and Semiology' was presented to a British Film Institute Education Seminar and first published in *Form*, 7, March 1968.
'*North By North-West*: a Morphological Analysis' was presented in earlier versions to a conference organized by the Linguistics

Department of Essex University, to the Neo-Formalist Circle, and to a SEFT weekend school on 'Narrative'. It was first published in *Film Form*, 1, 1976. 'Hybrid Plots in *Psycho*' was presented to the 'Aprile Hitchcock' conference held in Rome in 1980 by the Assessorato alla Cultura della Regione Lazio and *Filmcritica*, and published in Italian in Edoardo Bruno, ed., *Per Alfred Hitchcock*, Montepulciano 1981. It first appeared in English in *Framework*, 13, 1980.

'Introduction to *Citizen Kane*' was published in *Film Reader*, 1, 1975, as the introduction to a series of studies produced as the outcome of a seminar on *Citizen Kane* held in the Film Division of Northwestern University, Evanston, Illinois.

'The Hermeneutic Code' reworks papers given to a seminar on narrative theory at New York University Cinema Studies Department, a conference organized by *Enclitic* in Minneapolis, and a conference organized by the Summer Film Institute of the University of California–Santa Barbara, all in 1981.

'Art in Revolution' was first published in *Studio International*, April 1971.

'Godard and Counter-cinema: *Vent d'Est*' was first published in *Afterimage*, 4, autumn 1972.

'The Two Avant-Gardes' was first published in *Studio International*, December 1975.

'Mexico/Women/Art' was first published in Emma Tennant, ed., *Saturday Night Reader*, London 1979. It developed out of research done for an exhibition of work by Frida Kahlo and Tina Modotti held at the Whitechapel Gallery, London, in May 1982. The significance of their work is discussed at greater length in the exhibition catalogue, written jointly with Laura Mulvey.

'The Real Projective Plane' first appeared in an earlier version in *Bananas*, summer 1975.

'Friendship's Death' was first published in *Bananas*, spring 1976, and was reprinted in Emma Tennant, ed., *Bananas*, London 1977.

'Monuments of the Future' was first published in *Bananas*, autumn 1976.

'The Mystery of Landau' was first published in *Bananas*, winter 1976.

'Cinema and Technology' was presented to a conference held at the Center for Twentieth Centuries Studies, University of Wisconsin–Milwaukee, in 1978, and published as part of the conference proceedings in Teresa De Laurietis and Stephen Heath, ed., *The Cinematic Apparatus*, London 1980.

'Photography and Aesthetics' was given as a paper at Trent Polytechnic, Nottingham, and published in *Screen*, vol. 19, no. 4, winter 1978-79.

'"Ontology" and "Materialism" in Film' was first published in *Screen*, vol. 17, no. 1, spring 1976.

'1982: Retrospect' appears for the first time in this volume.

1.

# Cinema and Semiology: Some Points of Contact

Is it possible to relate the theoretical study of film and film aesthetics to the general theory of semiology, insofar as it has been elaborated? We need to ask this question because traditional aesthetics has proved incapable of coming to terms with twentieth century art. It has not entered the modern age.

The contemporary science of semiology was first posited by Ferdinand de Saussure in his lectures at the University of Geneva. Saussure envisaged that linguistics, already a highly developed discipline, would eventually be considered a particular branch of semiology, the general science of signs. Semiology was also pioneered by Peirce in the United States, under the name of semiotic, but his legacy fell into the hands of Morris, who deflected it in the direction of Carnapian logic and behaviourist psychology. It is of no further interest to us in this Anglo-Saxon form, until Peirce's original work has been reassessed.

Previous attempts to develop Saussure's idea of semiology have concentrated on micro-languages, such as the highway code, ships' signalling systems and the language of fans. However, these are evidently extremely limited cases and, for the most part, parasitic on verbal language itself. Barthes, as a result of his investigations into the language of fashion, reached the conclusion that it is only in very rare cases that non-verbal language can exist without auxiliary support from words. Cursory examination seems to bear this out. Even such highly developed and intellectualized systems as music and painting constantly have recourse to words, particularly at a popular level in the cases of songs and cartoons, for instance. Cinema, of course, is an equally pertinent example.

Yet it is only recently that there has been any contact between semiology and the study of film, despite widespread acceptance of the idea that cinema is in some way a language, or at least has a grammar. In its most familiar version the argument is that the shot is logomorphic, in some way analogous to a word, and that the linking of shots by editing forms a kind of syntax. This idea is particularly current in books of film theory and in educational circles, perhaps because of the pedagogic charm of the over-simplification to which it lends itself.

The principal source for this logomorphic view of cinema was Eisenstein's theoretical work, given additional weight by his fame as a director. The critical pendulum has gradually but definitely swung away from Eisenstein and towards André Bazin, whose ideas have become well-known through the influence he exerted on the magazine *Cahiers du Cinéma*. Broadly speaking Bazin's cinematic heroes were Murnau, Renoir, Welles and Rossellini. He applauded their use of the long take, the travelling shot, deep focus, of natural lighting and locations. The burden of his argument was that the cinema should reflect the continuity and homogeneity of the real world; montage was a wilful and destructive intervention on the part of the director. Bazin's distrust of the director also led him towards a movement and genre theory of cinema, opposed to the auteur theory dominant in *Cahiers du Cinéma*—a point I shall return to later.

In recent years there have been two outstanding recapitulations and elaborations of Bazin's ideas: Charles Barr's essay on Cinema-Scope[1] and Christian Metz's article, 'Le Cinéma: Langue ou langage?'[2] Barr's essay is innocent of any interest in linguistics or semiology, so I shall concentrate here on that of Metz, though I shall contest some of Barr's points, notably his liberal critique of Eisenstein's theory of 'participation' and his view of the relationship of appearance and essence.

Metz's article has a particular interest in that he was trained in linguistics and was presumably a pupil of Barthes. He is fully conversant with the theory and development of linguistics and semiology, but despite this background emerges as a champion of Bazin's conception of realism and anti-logomorphism. In many respects he goes further than Bazin and behind the impressive

apparatus of linguistics he brings to bear on film can be discerned a very traditional Romantic aesthetic. This leads him, in fact, to hint at a Romantic critique of structural linguistics itself.

We can see quite clearly from Metz's work how the problem of the relationship of language, symbolism and iconography to the cinema is essentially the inverse of the problem of realism. That is to say, to what extent does film communicate by reproducing an imprint, in Bazin's terms, of reality and of the natural expressivity of the world, like a Veronica or a death-mask? Or, to what extent does it mediate and deform (or transform) reality and natural expressivity by displacing it into a more or less arbitrary and non-analogous system and thence reconstituting it, not only imaginatively, but in some sense symbolically?

Metz's answer, in effect, is to suggest that cinema can heighten natural expressivity and it can (indeed, almost must) inscribe it within a fictional 'story' which, as it were, transposes natural expressivity into a different key. Metz's view can be indicated by a schematic diagram:

**Cinema**
Natural

Denotative images, endowed with a primary level of expressivity by nature

Cultural

Connotative composition, endowing images with a secondary level of expressivity (for example, the triangular composition of heads in *Qué Viva México*) which can become denotative and non-expressive (the cross-cutting of D.W. Griffith, originally expressive, becomes part of a conventional code).

**Literature**

Denotative words, forming the non-expressive 'language of the tribe', which are endowed with expressivity by connotative composition.

It can be seen that there are a number of interesting and unexpected features of Metz's approach. First, there is the stress he places on the concepts of 'connotation' and 'denotation', that originate from J.S. Mill, and have probably reached Metz via Hjelmslev and Barthes. Of course, for Mill they represent the endproduct of the long development of Romantic aesthetics: we can see behind them Coleridge's distinction between 'imagination' and 'fancy', and the general outlook of 18th century German Romanticism. (And, of course, looking forward from Mill, we come to I.A. Richards and thence, intriguingly enough, to Charles Barr again.) It is also interesting to note how Metz attempts to synthesize the traditionally hostile expressive and mimetic theories of art by compounding the expressive compositional creativity of the director with the natural expressivity of the world. (Barr follows Mill very directly in his antagonism to the pragmatic/conative/rhetorical theory of art. Mill held that when personal expression was 'tinged also by that purpose, by that desire of making an impression upon another mind, then it ceases to be poetry and becomes eloquence'. Barr's hostility to Eisenstein as a propagandist is of the same stamp: actually Barr goes further by comparing Eisenstein's use of montage to that of advertising films and thus directly linking a theory of language with a theory of art.)

Second, Metz denies that, in the cinema, there can be any distinction between 'poetry' and 'prose'. He goes so far as to say that 'a film of Fellini differs from a U.S. navy film, made to teach new recruits how to tie knots, through its talent and its aim, not because there is anything more intimate in its semiological mechanism'.[3] This leads him into open conflict with the Italian director Pasolini, who has recently expounded a theory of poetics of the cinema, again heavily influenced by structural linguistics. Metz's view is the inevitable result of his belief that all visual images, even of bowlines and sheepshanks, are endowed with expressivity (though he does not say if he means equal expressivity) whereas words are not, unless manipulated in a particular way. Actually, Metz admits to a difficulty in a footnote, when he cites Bally's analyses of the spontaneous expressivity of popular language and slang (analyses that are actually at the basis of Mukarovsky's

theory of aesthetics) and relocates the abyss between expressivity and non-expressivity from the dichotomy between prose and poetry, to the difference between code and message.

Metz goes on to argue that since cinema is, in his terms 'homogeneously connotative',[4] that is, always connotative through and through, therefore it is originally art and, if it is to be coded language at all, only later. Here, of course, we are right back to the beginnings of Romanticism in the 18th century, with Rousseau and Vico, who, in Venturi's words, assigned to art the auroral moment of knowledge. Again, this view was largely popularized by German thinkers: thus Hamann, the ideologist of Storm and Stress, held that poetry was to prose as barter to commerce. In this way, Metz, in his description of the primitive art of cinema, returns to Romantic theories of the development of language from art in primitive societies. Thus he goes on to explain how cross-cutting, which now simply denotes simultaneity of time in two different places, was originally introduced as a connotative device to generate excitement, as in the famous Griffithian last-minute rescue. It is not surprising also that he should launch a severe attack on documentary, despite his attachment to natural reality, for its banal attempt to describe the world denotatively, instead of making use of it to evoke emotion in a fictional context. Indeed, as we shall see, Metz is only willing to see germs of a film grammar in various narrative devices.

Clearly, given the views outlined above, Metz feels antipathetic towards Eisenstein, who prided himself on being an intellectual, whose ambition was to make a film of Marx's *Capital*, and who always associated emotion with shock and practically refused to believe in pathos or ecstasy unless he actually saw people screwing up their faces in agony or jumping out of their skins: thus, in his stage productions, 'rage is expressed through a somersault, exaltation through a *salto mortale*, lyricism on "the mast of death"'[5] and sentiment merges with acrobatics. Eisenstein, following Meyerhold, believed that ordinary reality was quite inadequate to shock and hence change spectators sunk in apathy and ideology: to fulfil its maieutic function, art must exaggerate and schematize. Here, curiously, we again encounter a completely different heritage of Romanticism in the admixture of the sublime

and the grotesque. Thus Lenz, the Storm and Stress dramatist, like Eisenstein, admired the grotesque, the *Commedia dell'Arte* and caricature: of course, this grotesque strain meets with the Longinian sublime pre-eminently in Shakespeare, the Shakespeare of the Romantics, that is, of Garrick.

But it is the intellectualizing, schematizing side of Eisenstein for which Metz feels most distaste. He describes Eisenstein's method as being like that of Meccano or an electric train set: first, reality is decomposed into isofunctional units, then these units are reconstituted into a new, devitalized totality: a product, not of *poiesis* or pseudo-*physis* but of *techne*. Metz and Barr use exactly the same image of the ersatz to describe this process. Thus Barr: 'Pudovkin' (Barr makes very little attempt to distinguish between Pudovkin and Eisenstein) 'here reminds one of the bakers who first extract the nourishing parts of the flour, process it, and then put some back as "extra goodness": the result may be eatable but it is hardly the only way to make bread, and one can criticise it for being unnecessary and "synthetic". Indeed one could extend the culinary analogy and say that the experience put over by the traditional aesthetic is essentially a predigested one. These two epithets have in ordinary usage a literal meaning and, by extention, a metaphorical one, applied pejoratively; the same correlation is valid here.'[6] Or Metz: 'Prosthesis is to the leg as the cybernetic message is to the human phrase. And why not also mention—to introduce a lighter note and a change from Meccano—powdered milk and Nescafé? And all the various kinds of robot?'[7]

Thus Rossellini, for both Barr and Metz, becomes a wholemeal director, while Eisenstein is likened to bleached white bread. And Metz, biting the hand that fed him, extends his condemnation of Eisenstein beyond the cinema to include the great masters of structuralism itself, especially Claude Lévi-Strauss, who are reproached, under the banner of vitalism, with preferring the intellectual model to the reality itself. Thus Barthes's 'structural man' is presented as a robot with prosthetic limbs, uttering computerized binary messages and, when he directs films, making *Strike* and *October*. Monster indeed.

Metz, more cautious than Barr, as befits one publishing in France rather than California, does not link this condemnation of

Eisenstein's 'manipulative mind' directly with his political viewpoint. Barr, who develops an ideology of free choice and judgement, leading naturally from appearance to essence, speaks of Preminger's use of CinemaScope in a way reminiscent of Bazin's equivocal comment on Wyler's use of deep focus: 'William Wyler's deep focus seeks to be liberal and democratic like the consciousness of the American spectator and the heroes of the film.' Interestingly, Barr finds support for his liberal and democratic ideology in an article by Norman Fruchter on teaching film appreciation to unsophisticated teenagers . . . whose visual acuteness has not been atrophied by familiarity with ideas and concepts!

Metz, as far as he can—and we have seen the extent of his commitment to vitalism and Romanticism—tries to conduct his argument as though it were part of an academic discussion about the more knotty problems of semiology. He reproaches Eisenstein for being dissatisfied with the natural sense of things (which is 'continuous, global, without specific significance: like the joy which spreads across a child's face'[9]) and therefore of seeking specific significances in images, hence falling into an erroneous logomorphism.

In fact, Metz is guilty of the over-simplification he attacks in others, including Eisenstein himself. He alludes in passing to the intellectual climate in which Eisenstein was formed and in which he worked, drawing attention to Eisenstein's training as an engineer and his links with Constructivism, but this is as far as he goes. In a way this is understandable: it is still very difficult to reconstruct the intellectual climate of Russia in the twenties, and it would be useful to know much more not only about the theatrical work and ideas of Meyerhold, but also of Foregger, Tretyakov, and the full extent of the writings of the Russian Formalists on cinema. These would be especially fascinating, since they would provide a link between the study of language and of cinema obviously relevant to Eisenstein. We know that Shklovsky wrote scripts and a book on literature and film, Eichenbaum edited an anthology on the poetics of the cinema, Tynyanov worked on several scripts for FEX, Brik scripted Pudovkin's *Storm Over Asia* and wrote theoretical defences of Vertov's Kino-Eye for LEF:

unfortunately little of this has yet been translated from the Russian. However, a great deal more could be said about Eisenstein and his relation to his context—and the Bolshevik Revolution—than Metz attempts.

Cursorily, in defence of Eisenstein, it should be said that his view of both the world and of art was very different from that of Barr or Metz. He did not believe that the world of appearances would offer up its meaning to the ordinary spectator: it would only feed his prejudices, his ideology in the Althusserian sense of ideology as 'the very "lived experience" of human existence.' He believed that the spectator had to be emotionally provoked into participating in a new schematization of the world, demanded of him by his own will to understand the film and thus, by a maieutic process, to reveal to himself an understanding of the world, inherent in appearances but transcending them: an esoteric meaning. This remained a schematization, but it could be enriched by future thought and experience. In many ways Eisenstein's approach was similar to Brecht's. And also, in that like Lévi-Strauss, he came to his theory of the intelligible through Marx and Freud, Metz was correct to link them together. But we must be quite clear that what is at stake is not a simple semiological error but a clash of quite different world-views. Of course, to prefer Eisenstein's is not to say that, for instance, Rossellini's films are worthless, but it is to see them in a different light: they are among the most remarkable products of their age, but they can be located stylistically and ideologically and they are not absolutely validated by any scientific laws of semiology. The same is true, *a fortiori*, of Preminger.

On the other hand, Metz is justified in condemning Eisenstein's logomorphism: we must develop a much more flexible attitude to the question of cinematic language than that expounded in *Film Form* and *Film Sense*. However, as Metz allows, there is a great deal in those two books that will have to be integrated into any future theory. Thus, for instance, the section on 'Colour and Meaning' is indispensable to anybody interested in the development of semiology. There Eisenstein concludes 'In art it is not the absolute relationships that are decisive but those arbitrary relationships within a system of images dictated by the particular work of art. The

problem is not, nor ever will be, solved by a fixed catalogue of colour symbols, but the emotional intelligibility and function of colour will rise from the natural order of establishing the colour imagery of the work.' This resembles both Saussure's insistence on the arbitrary (non-analogous) character of the sign and developments in modern film criticism, principally in *Movie*, stimulated by the use of colour of directors such as Sirk, Minnelli, Ray or Godard.

Metz, finally, can only see two possible zones of study for semiology in cinema, insofar as semiology implies an element of abstract denotation and not mere reproduction of the natural sense of things. One is the field of iconography, where Metz quotes Rieupeyrout's remarks on the distinction between good and bad cowboys being shown by their wearing white and black shirts respectively, and comments that this kind of iconography is very partial and provisional. Incidentally, Erwin Panofsky, the world's most outstanding scholar on this subject, concludes that the examples adduced by Rieupeyrout—the villain's black moustache and walking stick, the poor but honest milieu signified by a checkered table-cloth, the newlyweds' breakfast coffee—were doomed to extinction by the sound film. Since emblems of this kind seem very persistent, at least in genre movies, this may have been a premature threnody, but nevertheless it is clear that iconographic programming is nowhere near so prominent as in Renaissance painting, for example.

Second, Metz comments on the various kinds of conventional cutting, such as flashbacks, *champ-contrechamp*, that he claims have by now a constructional and normative value. He rightly stresses that these are not clichés but simply syntactic (or rather syntagmatic) features, in the same way that Flaubert's use of the imperfect is not a use of a cliché but of a conventional (basic and permanent, to all intents and purposes) feature of language. He also comments that such syntactic features are not strictly necessary, citing Hitchcock's *Rope* (even more apposite, I suppose, is Warhol's *Sleep*). However, Metz has not resolved certain problems in this discovery of syntactic features, which bring him at times uncomfortably close to the traditional, Eisenstein view of film language, though he asserts that they are secondary and partial rather than primary and global. Thus he is forced to admit

that Resnais leans in the direction of *techne* rather than pseudo-*physis* and Godard's frequent neo-Eisensteinian montage is admitted as a syntactic feature under the somewhat hermetic title of 'non-diegetic metaphor'. Thus practical changes in the character of cinema itself—and Metz admits that to dismiss Resnais and Godard is in some sense to dismiss modern cinema altogether—begin to modify his absolutism and force him to posit a bipolar development. On the other hand he celebrates the fact that the Lumière tendency has completely vanquished the Méliès tendency and confined it to minor genres: even this may prove to have been too bold a claim. And, in any case, even if the Méliès tendency is now only a diffuse element scattered among Hammer films, peplums, science-fantasies, one cannot entirely reject a tradition which also must surely include the Arthur Freed musical, particularly its Donen-Kelly peaks.

In fact, Metz has limited himself by refusing to see linguistic features almost anywhere except in narrative technique. In this field it could certainly prove more fruitful to develop Proppian techniques, which Metz mentions, much more finely by scaling them down from gross constituent elements into sub-elements, of phrase or sequence. Before developing this line of thought, I would like to suggest two possible points of entry for semiology that Metz neglects. These are merely disparate suggestions and I do not claim, at this stage, to see any connection between them. They are both drawn from the Prague School of linguists: Vilem Mathesius on functional sentence perspectives, Jiří Veltrusky's studies of the theatre.

Mathesius was a Czech linguist, a student of English, who concentrated on Czech after he went blind at an early age, and developed a series of comparisons between the two languages. Among his innovations was the functional analysis of the sentence into two components: themes and rhemes. The theme corresponds roughly to that part of the sentence which conveys information already known. The rheme is the part which conveys new information. Mathesius's concern was to show the differing ways in which the syntactic structure of English and Czech sentences coincided with the structure of theme and rheme within them. Clearly, this kind of analysis could be usefully applied to the

analysis of film sequences, to investigate the problems of establishment, suspense, surprise. Hitchcock for instance provides an interesting paradox: on the one hand, he always insists that the setting should enter into the action, thus thematising rhemes which would otherwise be discarded without ever contributing any dynamic information at all. On the other hand, his theory of the MacGuffin centres the plot construction around a rheme which is deliberately never thematized, reminiscent of Lévi-Strauss's *mana*.

The work of Veltrusky, another member of the Prague School, deals with the relation between person and object in the theatre. Veltrusky describes a dual movement of signification to action and back. Thus the human performers can be either vectors of action, or be placed along a scale of 'human props' like servants and on through sentries, spear-carriers, eventually to become merely part of the scenery. And objects, on the other hand, can also move from being part of the set or props to intervening in the action, as for instance in Strindberg's *The Pelican* in which a storm howls through the house slamming doors and extinguishing lamps. The same kind of personification of natural objects takes place a great deal in Oriental theatre. This kind of approach is equally applicable to the cinema. And it could perhaps be supplemented by work on gesture and the development of choreographic notation. And even Balázs's dream of a lexicon of facial expressions might be made possible by the extension of Birdwhistell's work on kinesics and the recording of eye, mouth and face movements. Here we are back in the physiognomic tradition of Lavater and Lenz (again), which so fascinated Eisenstein.

We must now return to problems of narrative and plot analysis, of the syntagmatic structure in its gross constituent elements. This will also allow us to confront the relationship of cinema to myth and of folk to mass art. The basic groundwork for plot analysis was done by students of the folktale: the two crucial stages were the work of Olrik in Denmark and Propp in Russia. Propp, most interestingly for our purpose, analysed the folk-tale into chains of moves or functions, that, Propp claimed, represented the logical sequence of the plot construction. He reached the surprising conclusion that all the tales he studied, despite the

richness of their specific variants, had in effect the same plot structure. Although this conclusion is open to question the interest of his method is beyond doubt.

As far as I know, there are three elaborations of Propp's analyses now available in English. These are Dundes's work on the Red Indian folktale, Umberto Eco's analysis of the Bond novels in *The Bond Affair* and Lévi-Strauss's studies of myth. Each of them slightly revises Propp: Dundes, following Pike, reformulates the concept of functions in terms of 'motifemes' and 'allomotifs'; Eco sees the James Bond plots as similar to a game, in which there is a code and moves and links it to a binary series of oppositions (Bond-M, Bond-Villain, Bond-Woman, Free World-Soviet Union, Luxury-Discomfort); in this way he brings Propp closer to the main body of structural linguistics. Lévi-Strauss develops a harmonic analysis, allowing for the repetition and redundancy of units, and working from the analogies of an orchestra score and fortune-telling with playing-cards. He also introduces a distinction between diachronic and synchronic dimensions.

It should be possible to present a concrete analysis along Proppian lines. For the time being I would like to draw further attention to the two problems mentioned above. First, the relation of folk to mass art. It is certainly true of mass as well as folk art that in Jakobson's words, in his postscript to Afanasiev, 'the tale's entry into the folklore habit depends entirely on whether or not the community accept it. Only a work that gains the consensus of the collective body, and of this work only that part which the collective censorship passes, becomes an actuality of folklore. A writer can create in opposition to his milieu, but in folklore such an intention is inconceivable . . . The socialised sections of the mental culture, as for instance language or folktale, are subject to much stricter and more uniform laws than fields in which individual creation prevails.' But, of course, mass art is by no means identical with folk art. We need a theory of the transition between the two. The suggestions made by Hall and Whannel on the intermediary role of vaudeville and music-hall between folk-art and cinema could be followed up, and also the possible origins of cinema in peepshows, waxworks, Wild West Shows. In this connection, Henry Nash Smith's work in *Virgin Land* provides a starting-point. Of

course the relationship with myth is more complex still: film critics and scholars are still prone to use comparisons between the Western film and Ancient Greece without much attempt at rigorous definition. There is an affinity of sorts, but this will not get us very far. The problem is perhaps insoluble until the nature of myth itself is clarified: here the work of Lévi-Strauss is of great interest and it is interesting that he has applauded the cinema's capacity for conveying the myths of our own civilisation.

Another crucial question implied by use of Propp's methods is that of individual authorship: the comments quoted from Jakobson pose the problem quite clearly. Here, of course, we are back on familiar territory with the debate over the *Cahiers du Cinéma* line and the auteur theory. (The same problem applies to Eco's analyses of the Fleming novels although he does not in fact mention it.) The problem is that there is an obvious social synchronic level—the genre—and another, apparently individual and diachronic, which can yet be treated synchronically—the author. My own tentative view is that there are two mutually dependent levels of redundancy in operation: one that of the genre, opening on to myth: one that of the author, opening on to art. The first is a proper subject for the study of myth, for an ethnology of the modern world; the second belongs properly to aesthetics, which remains a matter of messages rather than codes (though of course no message is explicable or even intelligible without its code). Furthermore, I am inclined to think, with Shklovsky, that great works of art always transcend their genre, through frequently incorporating many elements from different, often vulgar or exotic genres. Thus we cannot understand *The Nightwatch* simply within the framework of the Dutch portrait group or *Crime and Punishment* within that of the mystery story. Or, in terms of cinema, *Lola Montès* is more than a costume drama; *Vertigo* more than a suspense thriller.

One more point needs to be made on the auteur theory. A true structural analysis cannot rest at the observation of resemblances or repetitions (redundancies) but must also comprehend a system of differences. In the long run, the main problem for study will be the reconstruction of authors by going beyond the orthodox canon of their works to include their apparent eccentricities. Thus,

while the *She Wore a Yellow Ribbon* trilogy is essential to an understanding of Ford, it may turn out that *Wings of Eagles* is the crucial film. In the case of Hawks, a system of differences can already be discerned at the surface of comprehension, in the obvious contrast between the dramas and the comedies. Eventually, it is the explanation of this system of oppositions that will define Hawks. Renoir once remarked that a director spends his whole life making one film: this film, which it is the task of the critic to construct, consists not of the typical features of its variants, which are merely its redundancies, but of the principle of variation that governs it, that is its esoteric structure, which can only manifest itself or 'seep to the surface' in Lévi-Strauss's phrase 'through the repetition process'. Thus Renoir's 'film' is in reality 'a kind of permutation group, the two variants placed at the far-ends being in a symmetrical, though inverted relationship to each other.' Of course some films will have to be discarded as being indecipherable because of 'noise' from the producer, or even the actors; other directors may have to be split into two: thus English and American Hitchcock. But our guiding methodological principle remains the same.

Finally, I would like to make a few remarks about the question of 'world view', to use Dilthey's term, or 'symbolic' conceptions of the world, following Cassirer and Panofsky. It has to be remembered that these too are accessible only through what the author betrays, not what he parades, as Panofsky stresses. But the problem of the relationship of analysis of world-views to stylistic or Proppian analysis and semiology in general is a pressing one, which we do not seem to be in sight of solving.

Almost all the interesting work in this field springs from German culture at the end of the last century: Dilthey, neo-Kantianism, Simmel, Wolfflin, Riegl, but it is marred by an overwhelming current of idealism. Personally, I must admit to an inability to see my way. My own earlier criticism, springing as it does from Lucien Goldmann's work, particularly on Malraux, and Andrew Sarris's redefinitions of the auteur theory, is certainly marked by an unresolved dualism. I no longer find it possible to accept Goldmann's views, least of all his famous 'homology of structures', which is extremely schematic and historicist, to the extent

of simply ignoring anomalies. Indeed, Goldmann's attempt to save Lukács's thought by rescuing it from social realism and re-endowing it with the *nouveau roman* has really meant nothing more than exchanging one necessity for another. Sarris's work, on the other hand, is always veering in the direction of stylistics and then back again towards 'what ultimately interests' a director thematically. Perhaps the truth is, as Renée Balibar has recently boldly announced, that form and content are not in fact inseparable, as orthodoxy avers, but in conflict, that history exerts its influence on the work of art through style and ideology in contrary directions. (This position was also taken up by Shklovsky, as part of his controversy with Trotsky: the whole Formalist debate on this issue, pressed on the protagonists by the Bolshevik Revolution, is worth further study.)

In the last resort these grand problems of aesthetics are the vital ones. Until they are solved (if they are to be solved at all) they simply create turbulence throughout every other kind of discussion. In the controversy between Eisenstein and Metz, my sympathies on the question of logomorphism lie with Metz, but my sympathies on the question of aesthetics lie with Eisenstein. Perhaps the whole problem has been wrongly posed and we should start again with Hitchcock, who is certainly not a victim of logomorphic illusions, but who is so like Eisenstein in other ways: his careful pre-planning of each film for effect, his penchant for emotional shocks, his system of 'participation', his assault on common-sense ideas about reality. It is only by extending the argument in this kind of way, by arguing and re-arguing, that we can finally define, first our field of discourse and then our truth.

# North By Northwest:
# A Morphological Analysis

*Symbols denoting morphological 'functions' in North By Northwest*

| Day | (δ) α | β | γ | δ | ε | ζ | A | ↑ |
|---|---|---|---|---|---|---|---|---|
| **1** | D | E – | F = | G = | K | ↓ | P | Rs |
| **Day** | § | ε | ʒ – | | A^J | B | C | |
| **2** | O | o | Q | Rs | D | E | (h) F } | |
| **Day** | F/F = | (θ) | G = | H | I | ↓ | | (K –) |
| **3** | § | ε | ʒ | ↑ | p | Rs | ↓ K | ↑ |
| **Day** | B ↑ | M | N | ↓ | W – | § | C ↑ | ε |
| **4** | (L =, Ex +, U =)OQ | § | K | ↓ | P | Qs | () (r) | lv |

## North By Northwest: Morphological Breakdown*

| | | |
|---|---|---|
| α | 1-6 | Credits. Thornhill, the hero, talks to secretary. |
| β | 3-6 | Thornhill leaves office for the Plaza Hotel. |
| | 5 | Thornhill comments that his mother disapproves of his drinking. |
| δ | 7-8 | Thornhill goes to the Oak Bar for martinis. |
| ε | 8-11 | 'Paging Mr. George Kaplan'. Thornhill responds & villains identify him as Kaplan. |

> * Numbers in this breakdown correspond to the (unnumbered) scenes in the film-script of *North By Northwest*, New York 1973.

| | | |
|---|---|---|
| A | 12 | Villains kidnap Thornhill. |
| ↑ | 13-20 | Thornhill is taken to Glen Cove, to Townsend mansion. |
| A | 21-22 | Thornhill is locked in library. |
| D | 23 | VanDamm comes in and questions him. Interrogation. |
| E – | | Thornhill, who knows nothing about 'Kaplan' is unable to answer. |
| F = | | VanDamm orders his execution. |
| G = | 24-32 | Villains fake fatal driving accident, after transporting Thornhill to cliff. |
| ↓ K | 33-36 | Miraculous escape. |
| ↑ P | 37-41 | Thornhill drives off, pursued by villains. |
| Rs | 42 | Police arrest Thornhill, after crashing into his car. |
| § | 43-45 | Thornhill in police station. His trial next morning. Thornhill tells story. |
| ε | 46-52 | Thornhill returns to Townsend mansion hoping to corroborate his story. |
| 3 | | He can find no evidence and leaves. Police and mother unconvinced. |
| P | 53 | Villain looks up from flowers. Presentiment of further danger. |
| ε | 54-59 | Thornhill and mother go back to Plaza Hotel to search for 'Kaplan'. |
| 3 – | | They find some clues, but nothing substantial. |
| P | 60-72 | Villains re-appear. Thornhill evades them and goes to UN building. Pursuit. |
| A | 73 | Murder. Thornhill is 'framed', as he asks for information. |
| J | | He is photographed by reporters. |
| B | 74 | CIA in Washington. Professor explains that 'Kaplan' does not exist. Thornhill is acting as unwitting decoy to protect real agent ('Number One') and the CIA will play along with this, leaving him at large. |
| C | 75-81 | Grand Central Station. Thornhill decides to go to Chicago to find 'Kaplan'. |
| ↑o | | He sets off in disguise, wearing dark glasses. |

| | | |
|---|---|---|
| P | | He is spotted and chased onto the platform and the Chicago train. |
| QRs | 82-83 | He is recognised and rescued by Eve Kendall, who diverts the police |
| P | 84-85 | Rudimentary further pursuit and evasion after train leaves. |
| D | 86 | Thornhill meets Eve again. She invites him to her sleeping compartment. |
| E | | Thornhill responds favourably. |
| F | 87-91 | Eve hides Thornhill in the upper berth of her compartment. |
| 7 | 91-96 | Eve sends message to VanDamm. |
| F | 97-114 | Eve aids Thornhill on arrival in Chicago. He runs gauntlet of police disguised as a red-cap; then hides his face shaving with her razor. |
| θ | 115-119 | Eve receives instructions from VanDamm and gives them to Thornhill. |
| F = G = | | She tells him to go to a prairie-stop on the Chicago-Indianapolis road. |
| H | 120-121 | Thornhill arrives at the prairie-stop where, after a delay, he is attacked by plane. |
| I | | Thornhill escapes death and the plane miraculously crashes into tanker. |
| ↓ | | Thornhill seizes pick-up truck and drives back to Chicago. |
| (K−) | 122-125 | Thornhill resumes search for 'Kaplan' at Michigan Avenue Hotel. |
| § | 126-127 | Thornhill confronts Eve again. She is embarrassed and evasive. |
| ε | 128-129 | Thornhill devises and puts into action a plan to find out where Eve is going. |
| 3 | | He is able to read the imprint of an address on note-pad by telephone. |
| ↑ | 130-131 | Thornhill takes cab to Shaw & Oppenheim Gallery. |
| P | 132 | Thornhill confronts VanDamm and Eve. VanDamm threatens him. Villains close in. |

| | | |
|---|---|---|
| Rs | 133 | Thornhill is once again arrested, this time after provoking a public affray. |
| ↓ | 134-136 | Thornhill is taken to Midway Airport by Chicago police. |
| K | 137-140 | Professor explains situation to Thornhill and seeks his co-operation. |
| ↑ | 141-144 | Thornhill leaves Chicago and arrives at Mount Rushmore. |
| B | 145 | Professor continues his entreaty to Thornhill. |
| ↑ | 146-147 | Thornhill leaves Observation Deck for Cafeteria. |
| M<br>N | 148-155 | The Professor watches, after giving instructions to Eve, while she and Thornhill stage a pantomime in which Eve appears to shoot Thornhill after a quarrel. VanDamm is taken in by this. |
| ↓ | 156 | Thornhill is removed in an ambulance. |
| W – | 157-160 | Secluded glade. Professor double-crosses Thornhill. It is revealed that Eve is under orders to go overseas with VanDamm that night. |
| § | 161 | Thornhill is detained by Professor, who advises him to forget Eve. |
| C | 162-167 | Thornhill tricks Professor into leaving, so he can make a getaway. |
| ↑ | | Thornhill escapes along ledge and then takes cab. |
| ε | 168-175 | Thornhill reconnoitres. He looks in to VanDamm's house through window. |
| 3 | | Inside VanDamm and party are preparing to leave, discussing the time their plane is due to arrive at adjoining airstrip. |
| (L = | 176-181 | Leonard has discovered that Eve is working for the CIA. |
| Ex = | | While she is out of the room, he betrays her to VanDamm through a re-play of the pantomime with the pistol she used earlier. |

| | | |
|---|---|---|
| U = ) | | VanDamm orders her execution after the plane has left. |
| o | 176-192 | Meanwhile, Thornhill is concealed outside on the cantilever. |
| Q | | Eventually he manages to make his presence known to Eve and warn her. |
| § | 193-215 | VanDamm's party leave for the plane, but Thornhill is prevented from following when he is stopped by the housekeeper. |
| K | | Suspense, as Eve waits by the plane, puzzled. Finally, Thornhill appears. |
| ↓ | 216 | Eve grabs the MacGuffin and makes a break for it. |
| P | 217-267 | Leonard and villains pursue Thornhill and Eve. They end up on the monument. |
| Rs | 268 | In the nick of time the police arrive and shoot Leonard. |
| U | 269-273 | Leonard falls to his death. Police are shown to have arrested VanDamm. |
| (T) W | 274-279 | Thornhill proposes marriage to Eve. A Kuleshov 'creative geography' effect transfers them magically from peril on Mount Rushmore to the upper berth of the Twentieth Century Limited.  END. |

V. Propp's *Morphology of the Folktale* was first published in 1928. It provided a method for the analysis of the narrative form/structure of the group of tales in the Afanasi'ev collection which could be categorised as 'fairy' tales, according to Aarne's system of classification. Propp suggested a limited and exhaustive set of 'functions', which in combination would make up a tale. Each function was assigned to one of a limited set of characters, non-exclusively: the same character could perform different roles for different functions. It was Propp's contention that all tales he analysed derived from a single archetypal model, in which all the functions occurred in the determined sequence he assigned them. In practice, different tales omitted various functions or reversed their order of appearance, owing to corruption of the archetype. Even within these empirical variations, however, Propp pointed

out certain constancies, which we may assume to be rule-governed. For instance, functions were paired or grouped in fixed patterns of association, coincidence and order. Thus, where 'pursuit' occurred, there would also be 'rescue', and in that order.

Propp's book was translated into English in 1958 and, since that date, has exerted considerable influence within the fields of anthropology, folklore studies and textual analysis. Its appearance closely followed Lévi-Strauss's development of his own ideas on the structural study of myth, obliquely related to Propp through the influence on Lévi-Strauss of Jakobson. Lévi-Strauss himself was quick to recognise the importance of Propp's work when the English translation appeared—he reviewed it at length in 1960. Since then Propp's (and Lévi-Strauss's) method of morphological analysis has been revised, elaborated and expanded in various directions by numerous writers: principally Bremond, Dundes, Eco, Greimas, Kongas & Maranda, Leach, Meletinsky, Prince, Todorov. It has been virulently criticized, along with work by Dundes and Lévi-Strauss, by Nathhorst. There have been four main lines of development: 1) to expand the area of application outside the Russian fairy-tale; 2) to iron out various anomalies and contradictions in Propp's presentation and simplify and clarify the somewhat motley array of functions Propp outlined; 3) to revise and clarify the role of the characters (actants) and 4) to try and build a generative transformational grammar of narrative, using Propp to a greater or lesser degree as a starting-point.

I want to discuss the problems encountered in attempting a Proppian morphological analysis of Hitchcock's MGM film, *North By Northwest*. I first undertook this for five reasons.

First, I wanted to test Propp's method by applying it not simply outside the field of the Russian folktale or oral narrative in general, but outside literature too, in the narrative field of the cinema.

Second, I hoped in this way to see whether there was any affinity between the folk stories of a traditional, oral culture and those of contemporary mass culture.

Third, it is clear that *North By Northwest* has many similarities with other Hitchcock films: *The Thirty Nine Steps, Saboteur, Torn Curtain*. Proppian analysis suggests a way of grouping these films as members of a transformation group.

Fourth, it might be possible to correlate narrative functions with types of sequence and stylistic features. Thus pursuit is associated with Metz's 'alternating syntagm' (cross-cutting).

Fifth, it might be possible to relate a narrative analysis of this kind to such psychoanalytic concepts as phantasy-scenario or family romance.

Finally, I should add that Truffaut in his interview with Hitchcock suggests that many of his films are like fairy-tales. Hitchcock himself resists this, preferring a comparison with the short story and the daydream.

The functions Propp notated with Greek letters pertain, in his view, principally to what he called the preparatory section of a tale, everything that precedes the function villainy. (For Propp, functions A and K were the two essential minimum functions. Dundes supports this view.) In effect, though Propp does not really state this, the preliminary section consists of the establishment of the villain's superior power, by virtue of which he can commit his act of villainy. This can take various forms. Propp's function absentation explains why an object of value is left unguarded or why the hero or some other future victim is by himself, not with family or friends, and hence vulnerable to the villain. The pair interdiction/violation anticipates the punishment of the hero or future victim, which is then in effect carried out by the villain. The pair reconnaissance/receipt of information explains that the villain has superior knowledge. And the pair trickery/submission to trickery is straightforward.

The next stage of the tale—the complication—concerns the re-establishment of the hero's superior powers. It is thus, in some sense, an inverted repetition of the preparatory section. The various functions concerning the donor and the provision of magical help explain how the hero has power superior to the villain. In *North By Northwest* as we shall see, this reversal of power relationships is retarded (cf. Shklovsky) till the very end. (Hitchcock himself associates this with the short-story form. It is unlike most of the tales studied by Propp in which the climax occurs much before the end.)

*North By Northwest* begins by establishing place and time (New York, 'now'), then introduces the hero and informs us of his

name (address by liftman), his profession and state of well-being. We also learn his family situation—his close relationship with his mother and the fact that he is not married. This is signified by lower-case a—lack—and it is this lack which is liquidated at the very end of the film with the function W, wedding. Propp himself comments that often Ivan, the hero, sets out to find a steed or some other object of value, but returns as well or even instead with a bride. There are two lacks, one of which sets off the action, the other—only foregrounded later in the tale—concluding it. *North By Northwest* also follows this pattern.

Next follows the function absentation—Thornhill leaves his office and is also separated from his mother who is absent from home, playing bridge. He is in a public place. Along with this there are unemphasized, but important, examples of interdiction and violation. Thornhill's mother has forbidden him to drink too much, but nevertheless he goes to the Oak Bar in the hotel to have two martinis. The reason this is important is that he is later punished for this when he is arrested on a drunk driving charge— his true story is disbelieved, because there is a presumption that he has violated this interdict. In fact, there is a recurrent pattern of interdiction/violation followed (later) by arrest and rescue. (Dundes, in his analysis of American Indian tales lays much more stress on the interdiction/violation pair than does Propp.)

After violation, 'at this point', says Propp, 'a new personage who can be termed the villain enters the tale.' Sure enough, as Thornhill enters the bar, we see the villain(s) Valerian and Licht, in the background for the first time. The role of villain as actant is split among numerous characters in *North By Northwest*—principally VanDamm, Leonard and Valerian, the brains, the sinister secretary and the heavy, respectively. Hitchcock himself speaks of splitting the villain into three.

Next follows the villain's reconnaissance ('Paging Mr. George Kaplan') as a result of which they identify Thornhill as their victim and immediately abduct him, after a rudimentary second absentation when he leaves his circle of friends to send a telegram from the desk.

From this point on, Thornhill is a 'victim-hero' rather than a 'seeker-hero', to use Propp's distinction, though he reverts later in

the film to the role of 'seeker-hero'. The 'victim-hero' clearly does not have to be dispatched on a quest, nor decide on counteraction, except in an obvious and rudimentary sense: immediate resistance, attempts at escape. Consequently, as predicted by Propp, we would pass straight towards struggle, victory and liquidation of lack—liberation and restitution of free action to the hero's own self. I have, however, notated the meeting with VanDamm not as a struggle with villain, but interrogation by helper. VanDamm asks Thornhill to tell him all he knows (understood to mean all Kaplan knows) in exchange for a gift/payment ('Naturally, I don't expect to get this for nothing'). If not, he threatens Thornhill with death ('not . . . a very happy conclusion'). Naturally, since Thornhill is not Kaplan he cannot answer and consequently VanDamm orders his execution, punishment instead of reward—$F = $ (contr.) rather than $F-$ or $F$. The subsidiary villains force Thornhill to drink till he is stuporous, then put him in a car and send it over a cliff. Miraculously, Thornhill escapes: liquidation of lack. However, a new lack has intervened—lack of knowledge, lack of an answer to the riddle set by VanDamm—Who is Kaplan? Why was I kidnapped?

Lack of knowledge raises another issue: the relationship of *North By Northwest* to the classic mystery story. As Butor first pointed out, this is always really two stories—the story of a mysterious event (usually a crime) and the story of an investigation into it. Each story has its own protagonist—typically, a criminal and an investigator. The second story, we should note, is only concluded when its protagonist is able to narrate the first story— the second story ends with the narration of the first. This may be a confession, or it may be a reconstruction on the basis of the various partial, fragmentary and misleading accounts given by a series of subsidiary narrators called witnesses. The investigator switches from the role of narratee to that of narrator. Different characters may switch roles in many ways. Thus in the classic Oedipus story, investigator as criminal, the two protagonists turn out to be identical. Tiresias is a witness-narrator of a special kind. Other stories (Borges's *Death and The Compasses*) have an investigator-victim. Hitchcock is particularly well-known for the wrong man variation, of which *North By Northwest* is an example—the

investigator pursues not the real criminal, but a 'wrong man', an innocent who must try to expose the real criminal himself, by conducting his own investigation. The criminal, in turn, wants to find him to eliminate him and thus clear himself.

However, the relevant point here is that Thornhill is now seeking the solution to a riddle of this kind. The riddle is a form of lack of knowledge, liquidated by discovering the correct answer. He begins by narrating the story we have already seen in the role of witness, after his escape and rescue by the police: rescue/arrest. Nobody else believes him, and he then turns investigator, seeking out Kaplan, Townsend, and other witnesses in order to establish his narrative and insert it into another, still mysterious story. The object of value is now no longer himself, or a princess, but a story. Consequently, we get a renewal of the search involving the quest for witnesses and in particular for Kaplan, the apparent protagonist. Again we can see the functions for reconnaissance and information (negative), this time reversed, pertaining to the hero rather than the villain. This section ends with the murder of a witness by the villain in the United Nations building—a murder which it seems Thornhill has committed himself. Being photographed is equivalent to branding—a means of identification, followed by disguise and eventual recognition.

The murder also of course inaugurates the principal 'wrong man' situation. Thornhill is now pursued both by the villains and the police. It is also in a sense a further case of interdiction/violation—the hero must now act as an outlaw, and is consequently once more vulnerable. The fact of his real innocence does not alter the immediate effect in the story, where he must behave as though indeed guilty. The murder is followed immediately by a famous bird's-eye-view shot which underlines his vulnerability by a violent reduction in scale. It is very similar to shots in *The Birds*, with similar resonance.

There now follows a particularly interesting sequence, designated B—dispatch. For the first time the *focus* of the story shifts away from the hero, to the CIA offices in Washington. In this sequence the Professor tells us the answer to the mystery: a gang of enemies of the country, led by VanDamm, are being investigated by the CIA, who set up a decoy Kaplan, who does not in reality exist, in order to protect their real agent.

Thornhill is believed to be Kaplan by VanDamm and therefore the CIA cannot intervene without endangering their own agent. In fact, this is the narration which Thornhill is seeking, but the narratee is not him, but the spectator. This is typical of Hitchcock who often asserts you should tell the spectator as much as possible early on, in order to replace mystery with suspense. Hitchcock's categories of mystery and surprise/shock coincide with Freud's categories of *angst, furcht, schreck* (anxiety, fear, fright), that is, danger anticipated from source unknown; danger anticipated from known source; unanticipated danger. Thus the emotional effect of the film is modulated by manipulating the information flow and making a 'distance or non-concurrence' between spectator and protagonist.

This sequence also functions as 'dispatch' in the sense outlined by Propp: 'The hero is allowed to depart...the initiative for departure comes from the hero himself...The parents bestow their blessing...The hero sometimes does not announce his real aims for leaving.' It is also worth noting that the dispatcher also often doubles as father of the princess (tsar), as indeed happens in *North By Northwest* too (though we have not yet encountered the princess, Eve, and when we do, it takes some time before we discover that the Professor stands *in loco parentis* for her).

Dispatch is followed by counteraction (announced in farewell telephone conversation with mother) and departure, assimilated with pursuit—the same journey is both quest and flight, the hero is both seeker and victim. Thornhill is then recognized and rescued by Eve, whom he meets on the train. Eve, like VanDamm, presents herself as a donor-helper, whose gift turns out to be a poisoned apple. (Clearly too she has an element of the villain, with whom she is in league, and perhaps we could interpret Thornhill's falling in love with her as seduction or enchantment, a typical act of villainy.) At first sight, Eve's main role is to grant Thornhill aid—virtually in the form of the magical power of invisibility. Three times (triplication) he evades his pursuers, through being concealed in an upper berth in Eve's cabin, through disguise as a redcap at Chicago Randolph Street station carrying Eve's baggage, and by lather while shaving with Eve's miniature razor. The miraculous success of these simple disguises suggests

magical powers. (These gifts incidentally are bestowed in return for an erotic transaction represented by an extremely elaborate circular kiss.) These three acts of help are accompanied however by a fourth act, apparently of help, but actually of harm, in the form of guidance $(G=)$. It is revealed to us, though not to the hero, that Eve is in league with VanDamm, and when she sends him by Greyhound Bus to the prairie-stop on the Chicago-Indianapolis highway, she is sending him to his death—a reprise of the earlier failed attempt with the car. Thus an element of deceit and submission is also introduced. In a sense, Thornhill is betrayed three times—by his mother, his bride, and his 'father' the professor.

The cropduster sequence coincides with Propp's 'fight in an open field'—Thornhill is victorious and escapes, again miraculously, as experiencer of victory rather than agent. Throughout victory is experienced as akin to rescue. He then returns to the search for Kaplan—still looking for the narrator of a story in which he is clearly designated victim.

The next section of the film is the most difficult to analyse according to Propp's methods. Clearly there is an element of continuation of a quest (reconnaissance, information—and also deceit, submission) this time a trick played by Thornhill on Eve —in rudimentary form. But these scenes are dominated also by the establishment of motivation—the ambiguous love/hate nature of Thornhill's relationship with Eve, who is seen to play the contradictory roles of villain and princess, antagonist and object of desire. This establishment of dual motivation is important for later events. Thornhill now falls into danger again, at the auction, is pursued (in a rather rudimentary way) and once again rescued by means of arrest by the Chicago Police—thus bringing towards its end the suspended triad of interdiction/violation/punishment. Note too that the auction introduces yet another object of value, the antique figure purchased by VanDamm, which we learn later contains the MacGuffin ('My most perfect').

We now get a second meeting (Thornhill's first) with the Professor at Midway Airport. Again the professor acts as a narrator— telling Thornhill the Kaplan story (liquidating this lack for him) and also telling him Eve is in fact the secret CIA agent the fiction of Kaplan was designed to protect. Thus, by re-constituting the lack

of the princess he inaugurates the quest to recover her, and—acting now as princess's father—he promises to do this, if Thornhill will perform a difficult task for him. He must allow himself to be shot and gravely wounded by Eve. In fact this will be another deception, designed to trick VanDamm. The gun will fire blanks. Perhaps this could be interpreted as negative help by a donor—who seems to be bestowing immortality through the agency of a magic gun—but who is in fact again deceiving and double-crossing. Thornhill duly performs the task (M, N) and normally this would be followed by (W) wedding. The Professor, however, double-crosses Thornhill and breaks his contract. Eve is ordered to leave the country with VanDamm—perhaps fated even to perform W = (wedding to villain) rather than W − (absence of wedding), as I have notated it.

Thornhill is detained by the professor, but escapes (again after using a trick of a very rudimentary kind, to get the Professor out of the room). The quest (spatial transfer, reconnaissance, information) begins again, this time approaching its climactic conclusion. The information received is particularly notable. Perched on a cantilever peering through a window, Thornhill hears and watches the action inside VanDamm's house. There Leonard, the sinister secretary, exposes Eve's imposture and VanDamm orders her death—she is to be thrown out of the airplane over the sea. This sequence is the contrary of one described by Propp: typically, when the hero arrives home, he finds an impostor making false claims to the credit which rightfully belongs to the hero, he is exposed (an act often correlated with the recognition of a hero in disguise) and punished. In *North By Northwest*, in this instance, it is a false villain who is exposed and ordered punished. The hero however, though not disguised, is nonetheless concealed—a weaker form of the same function—and must be recognised by Eve before he can warn her. He achieves this with a monogrammed match-folder, shown in insert earlier in the dining car scene on the Twentieth Century Limited. He warns her and tells her not to board the plane.

Next follows a typically Hitchcockian retardation/delay and suspense interlude. Thornhill is detained by one of the villains (the housekeeper) while Eve waits for him on the airstrip (differential

information flow: spectator/Eve, on whom this sequence is focussed). At the very last possible moment, Thornhill gets away, Eve grabs the MacGuffin, runs to him and they flee together—two lacks liquidated: the MacGuffin and Eve. There then follows the final pursuit and chase over the Mount Rushmore Monument (a typical Hitchcock location—the dome of the BM reading room, on stage at the Palladium, the Statue of Liberty) concluding with downfall of the villains, rescue—at the hands of the Professor and the police—and an accepted marriage proposal. The film actually ends with a Kuleshov 'creative geography' cut from Mount Rushmore to the berth in the Twentieth Century Limited, a piece of camera magic which I have conjecturally designated transfiguration, like suddenly awakening in a marvellous palace, an example Propp gives.

I was surprised how easily Propp's functions and method of analysis in general could be applied to *North By Northwest*. It does seem to have something in common with a fairy-tale at least, as Truffaut suggested. Certain elements, particularly those involving deceit, misrecognition, imposture, masquerade, are much more prominent than in the tales Propp analysed (though more like those described by Dundes—'trickster' stories, for instance). These functions of course, are also typical of the paranoid phantasies that Hitchcock characteristically evokes. Again, differential flow of information complicates analysis, but not to an impossible extent. There are more red herrings and also a fairly constant reiteration of the pursuit function—which may well have something to do with the nature of the medium. In a film of this sort, the functions involving spatial transference are much more than simple link-functions: they make possible a wide variety of decors, and there are also of course a great number of different means of transport in the film: foot, cab, car, (villains and police), elevator, train, Greyhound bus, pick-up, plane, ambulance.

The basic structure described by Propp is present in *North By Northwest*. This can be expressed as follows: a task is set the hero (by the dispatcher). If he performs it successfully, he will be rewarded (gift of the princess, by her father = the dispatcher). The task involves finding and returning with an object of desire,

to liquidate a lack. This object may be the princess, or some other object. It may simply be lacking or it may have been taken by a villain, from whom it must be taken in turn, by combat or by trickery. To retrieve the object the hero will need help and to receive this, he must perform a subsidiary task for a donor. At first he may fail and receive hindrance or harm instead of help (delaying mechanism). After retrieving the object of desire, he may still have to perform a further task or tasks before receiving his reward and concomitantly the hero is not recognised. In *North By Northwest* there is a second type of lack—lack of knowledge—so that there is a mystery story interwoven with a quest story.

Clearly—Greimas has pointed this out—a number of Propp's functions are redundant or at any rate, variations of each other. Thus there is one set of functions, which can be summarised as 'assignment of task', 'acceptance' 'performance of task', 'reward'. As Greimas points out, the fundamental form of this set is that of a 'contract' and it is a breaking of this contract that marks the negative gift of Eve and the withholding of the princess by the Professor. (This breaking of the contract does not occur in the tales Propp analyses.)

Nevertheless, unlike Greimas, I do not conceive of H.I as precisely equivalent to M.N. but rather related, as hindrance to be overcome, to F help and F = harm. Similarly, Greimas, under the influence of Lévi-Strauss and his version of information theory, sees the princess or indeed any object of desire as a message to be communicated from source to receiver, and therefore associated with functions such as reconnaissance and information. This seems wrong to me. The object should be seen as part of a set of rewards (gratifications concluding a sequence of lack, desire and frustration), the inverse of a set of punishments, inflicted by helper F or dispatcher/father of princess (U—punishment of impostor who did not perform the assigned task). In fact all the tasks can be seen as a system of exchanges: dispatcher transfers princess to hero after hero transfers object to dispatcher. Donor transfers helper to hero after hero responds correctly where response can be seen as a form of transfer to donor.

Paradoxically, this model fails to account for the villain, apparently the second most important character after the hero. I

think the villain is an agent of separation, responsible for the initial separation of the object from the dispatcher. He subsequently attempts to prevent their reunion. Similarly, it should follow that it is the villain who is responsible for the separation of the donor from whatever it is they require from the hero. The film, like the tale, follows alternating rhythms of separation and unification, punishment and reward. Within this schema are various functions mainly concerned with spatial transference and verbal communication and other methods of obtaining information or, of course, misinformation. Other aspects might perhaps be included, it has occurred to me recently, within a case grammar type of model: location, instrument, agent, experiencer, patient.

Finally, I would like to stress that Propp's techniques, though surprisingly applicable to *North By Northwest*, and hence indicative of a more universal concept of the tale than Propp himself intended, still need a certain amount of re-formulation. Nevertheless I think they remain a useful starting-point, more so than most of the subsequent work, because more concrete.

# Hybrid Plots in *Psycho*

I want to say something about the narrative role of the shower-bath murder in *Psycho*, and more generally, about plot structure in Hitchcock's films. Of course I am aware that the plots are not Hitchcock's invention, but those that attracted him and through him attracted us. The murder in *Psycho* makes a break, a rupture in the film as a result of which it is broken into two separate stories by the removal of the protagonist. The first is the story of Marion Crane up to her death. The second is the story of the investigation of her death by Arbogast and her sister Lila. In the second story the focus of the narration, however, is Norman Bates. In thinking about this I want to make a comparison with both *North By Northwest* and *Marnie*.

All three tales concern, partly, the abduction of a princess, to use the terminology of Propp drawn from his study of the Russian fairy-tale. In *North By Northwest* the princess is released by her own abductor, who is (in an ambivalent sense) also a rescuing prince, or at least the lesser of two ogres. In *Psycho* the princess is killed by the ogre.

*North By Northwest* follows in many respects the typical structure of fairy-tales as described and analysed by Propp. The hero sets out on a quest, and after various tests and adventures, receiving help and hindrance from those he meets, succeeds in penetrating the ogre's lair and rescuing the princess. Even here however there is one crucial difference: the hero of *North By Northwest* sets out not in search of an object but in search of information, the answer to a riddle. *North By Northwest*, unlike a simple fairy tale, is also a mystery story, a story of investigation and detection. And

of course where there is investigation there always has to be something to investigate, an enigma. In effect another story, the story of a crime.

As Michel Butor was the first to point out, a detective story is always a double story, the story of an investigation ends with the telling of another story embedded in it, the story of a crime. The narrative of one story concludes with the narration of another.

In *North By Northwest* crime story and investigation story are woven together. Indeed, this is typical of Hitchcock's films, particularly those structured around a wrong man. The protagonist in the wrong man type of film both undertakes a flight from investigation, because he is thought guilty and hence is pursued, but also undertakes a quest to investigate the real criminal, the ogre. And the two stories then converge in a public spectacle at the end.

*North By Northwest* folds into three sections: there is an introductory section in New York, a journey section, climaxing with the crop-duster sequence, and then after Chicago a concluding section. In the concluding section the focus shifts from the pursuit of Thornhill to the release of Eve.

Both *Psycho* and *Marnie*, though apparently dissimilar in many respects, follow similar underlying patterns. In each case an introductory section motivates the journey (flight as a result of crime). During the journey the protagonist meets a stranger, Eve in *North By Northwest*, Norman Bates in *Psycho*, Mark Rutland in *Marnie*. Each encounter has both erotic and threatening overtones and results in the realization of the underlying threat: the crop-duster attack in *North By Northwest*, the shower-bath murder in *Psycho*, the confrontation at the stables and consequent forced marriage in *Marnie*. The story then takes a different turn; it no longer focuses on the flight of the protagonist, accused of or guilty of a crime, but on the release of the abducted princess, or in the case of *Psycho*, the attempted release that is in fact impossible (since she is dead). All three films then end with an intrusion into the house that holds the secret of the abduction.

There is a further parallel I would like to draw. In *Marnie* Mark Rutland suspects Marnie of shielding and hiding her mother, who we believe has committed a murder. In fact it turns out it was

Marnie herself who committed the murder, but she was not fully responsible for her action. In *Psycho* Arbogast and Lila suspect Norman of shielding and hiding his mother, who we believe has committed a murder. In fact it turns out it was Norman who committed the murder, but he was not fully responsible for his action. In both films it is the mother's sexual involvement with another man, not the father, which is at the root of the original trauma.

The differences, of course, are that in one case the trauma has set off a further train of murders, in the other a chain of thefts. And secondly that in *Psycho* the murders are committed by the abductor of the heroine and in *Marnie* by the abductee herself (passive rather than active). So that in these various films, apparently dissimilar in type and plots, we find a series of transformations and redistributions of roles reminiscent of those described in Freud's study of 'A child is being beaten'. This could be extended by looking at other films, and *Vertigo* is an obvious candidate for inclusion.

What motivates this series of plots and transformations of plots? Is there some underlying mechanism that explains the series and perhaps some plot that was never told?

It's worth remembering, I think, that Propp himself in writing about fairy-tales writes about an example of the hybrid plot, a hybrid story, the story of Oedipus. Here too he detected elements of the simple fairy-tale. The hero who sets out on a quest, an adventure, kills an ogre (the Sphinx) and releases a princess (Jocasta) whom he marries. In this case however, the stranger killed turns out to be the father and, of course, the princess, his mother. This in turn, as Propp demonstrates, necessitates the further change of transforming the story into one of detection. Oedipus investigates the crime which turns out to be his own. The original fairy-tale is thus transformed into an embedded crime story of the type I described earlier.

Hitchcock's characteristic plots are not those of the Oedipus story whose distinctive feature is the identity of investigator and criminal. Nonetheless, the mechanism of transformation at work is similar, and I think concerns what Freud called 'family romance': that is, the fantasy of belonging to an imaginary family, different from one's own. Family romance in one form is in fact at

the root of the simple fairy-tale, which recounts the fantasy of belonging not to your own family, but to the family of the princess, the ideal royal family. Often the hero is an orphan. In the Oedipus story the fantasy (feared rather than wished) is ruined by the identification of the real with the fantasy families, their superimposition.

In all three of Hitchcock's films I have discussed, the original protagonists—Thornhill, Marion Crane and Marnie—lose their family names and assume those of others. They fall into the role of orphans.

In *Psycho* and in *Marnie* they are blocked from entering another family, unable to complete the family romance, to assume their different roles and different names. And these of course are the two of the three films with female protagonists. In both films the women are thieves. In fact it is their theft that, so to speak, turns them into orphans. The reasons for their crimes are different. Marnie's crimes are directly related to her own family and the money she steals goes to her mother. Marion's are related to her fiancé's family: to pay his dead father's debts and his ex-wife's alimony.

In *Psycho* it is Norman Bates, not Marion Crane, whose compulsion originates in past family trauma like Marnie's. What has happened is that Marnie is, so to speak, a composite of Marion and Norman, or, to put it the other way round, her character and role can be decomposed into those of the two protagonists of *Psycho*. One, a woman, who is a runaway and a thief; the other, the person with a compulsion rooted in earlier family trauma involving the mother.

So in a sense Norman in *Psycho* is not only a successful Hamlet (killer of his mother's lover), but also a failed Mark Rutland. In fact he cannot undertake the role of releasing Marion precisely because like Hamlet he is himself excluded from his father's place.

I now want to return to the starting point, the murder. The plots of the films we have discussed are hybrids of the fairy tale with a detective story, whose transformations are motivated by a series of underlying family romances hinged around the abduction and marriage of the princess—as reward and gratification in the typical fairy tale of *North By Northwest*; as a mixed hybrid of

abduction and release, confinement and abduction, with no possibility of release in *Psycho*.

In *Psycho* this impossibility of release (the murder after the abduction) has first a simple plot motivation. In this film flight is followed by quest, instead of being intertwined with it. But it also has a motivation in terms of family romance: the entering into a new ideal family is blocked for both protagonists, both Marion Crane and Norman Bates. The only way in which this double blockage can be broken would be for the ogre to marry the princess, in a version of the Beauty and the Beast story. And in a sense *Marnie* does have elements of the Beauty and the Beast story. But in *Psycho* this can't happen because the princess is already betrothed and the ogre takes the form of a cruel mother whose sexuality has been displaced into violence.

There is another way of looking at it. The flight section of *Psycho*, as in other Hitchcock films, is dominated by fears of being watched, apprehended and taken back like a child who has run away from home. The quest section, on the other hand, is dominated by the wish to penetrate the secret and see what has been hidden.

In *Psycho*, as in *Marnie*, of course, the secret is that of the mother in the bedroom. These are the typical structures in Hitchcock that we associate with paranoia and voyeurism. The impulse towards the quest, the insistence on discovering secrets, cannot come in *Psycho* from the protagonists of the flight, because in the last analysis the secret is what they are fleeing from. The MacGuffin is not only to be found at the end, in the ogre's lair, but motivates the protagonists' own flight from the beginning. It is the mother whose picture must be turned to the wall so that her castrating stare is averted, who Marion's sister eventually discovers staring horribly in the fruit-cellar.

The more Hitchcock foregrounds psychoanalytic secrets rather than microfilms or money as the objects of search and desire, the more impossible it becomes to reach a happy end. The lack that motivates the whole journey and story becomes symbolic and unsatisfiable, rather than imaginary and soluble.

*Psycho*, I think, is the most extreme case of a film in which this is made brutally clear, in which the fairy-tale is not simply a

hybrid with the tale of detection, but is also transformed into a different type of story that following Freud, we can call the tale of the uncanny. This is because it centres not on the kind of lack Propp described, the lack of money or of a microfilm, or even of a wife, or a princess, but on a symbolic lack that cannot be liquidated, so that instead of the liquidation of the lack we get the liquidation of the princess.

# The Hermeneutic Code

Some years ago I made a morphological analysis of Hitchcock's *North By Northwest*, on the model of Propp's analysis of Russian folk-tales. The main problem I encountered was that of the *secret*. In *North By Northwest*, as in other Hitchcock films, the Proppian quest is not simply for a desired object, but for desired knowledge. There is a structuring enigma to which the hero seeks the answer.

Propp does in fact note two sets of functions concerned with knowledge: deception/complicity and the pair false claim/exposure and branding/recognition. However, these belong either to the initial preparatory section of the tale, or the second move, rather than the principal first move or complication. Their effect is either to make it easier for the villain to commit villainy or more difficult for the hero to collect his reward for vanquishing the villain. In *North By Northwest*, and in Hitchcock's films in general, the secret is located in the complication, the main section of the story. It is knowledge that is lacking and it is lack of knowledge that must be liquidated. Thus the secret is at the very heart of the plot mechanism.

We can put this another way, using Barthes's terminology: in Hitchcock's films it is the hermeneutic rather than the proaieretic code that is dominant, the code of truth rather than the code of actions. These are the two codes described by Barthes in *S/Z* as codes of narrative. Barthes distinguishes them as 'sequential codes' which, in contradistinction to the others (cultural, semic and symbolic) are constrained by temporal order and hence are temporally irreversible. It is precisely these two codes that block

the reversibility of any narrative text, prevent it from becoming a fully modern text.

In adopting the concept of 'hermeneutic code' in order to develop a structural model of its working, as one component of a possible narrative grammar, I am of course flying in the face of Barthes's own method which was evaluative rather than scientific and radically anti-narrative in its evaluation. However, I believe it is necessary to try to understand the mechanics of narrative if we are to discover different modes of story-telling rather than pursue the utopian and pointless project of dispensing with narrative altogether. Any counter-language must be preceded by a meta-language.

I also want to add insult to injury by discussing the hermeneutic code in terms borrowed from Lacan's reading of Poe's *The Purloined Letter*. Like Poe's tale, *North By Northwest* is in its form a detective story and so there is a certain appropriateness in the borrowing. Lacan, of course, is concerned with *The Purloined Letter* as an analogue for the practice of psycho-analysis with its own particular structure of the secret and the quest, but it seems to me that much of what he says can be transposed into the register of the detective story itself and hence be assimilated into the study of the narrative codes.

The hermeneutic code, seen in Lacanian terms, involves the relationship of three times:

1. Seeing/ being blind to      *The instant of the look*
2. Interpreting / misinterpreting      *The time to understand*
3. Knowing/ denying      *The moment of conclusion*

These three times follow a logico-temporal order and each is a couplet: what one character sees may be exactly what another character is blind to; every interpretation may be a misinterpretation; a character may deny all knowledge of what he or she knows.

Seeing should be construed as observing or, better, noticing. Sherlock Holmes explains the difference between seeing and observing in *A Scandal in Bohemia* when he asks Watson how many steps there are leading up from the hall to his room. Watson cannot answer and Holmes comments 'You have not observed. And yet you have seen. Now, I know that there are seventeen

steps, because I have both seen and observed.' What is significant for the purpose of the hermeneutic code is precisely what is noticed rather than what is simply seen. Seeing (noticing) is a verb with a propositional object, seeing that something has occurred. Like knowing it is also punctual rather than durational (taking place in an instant or moment of time, rather than over a period) and factive in that the truth of a proposition such as 'I noticed that there were seventeen steps', as also 'I know that there are seventeen steps', is dependent on the truth of the propositional object. You can only notice seventeen steps if there are seventeen steps. On the other hand, 'I believe that there are seventeen steps' can be true however many steps there really are. Thus times (1) and (3) can be grouped together in contrast to time (2).

The three times are exemplified in miniature in a short sequence in *North By Northwest*. While Thornhill is in the washroom, on the New York-Chicago train, Eve hands a message to the steward who takes it down the corridor to another compartment where it is handed to and read by VanDamm. The spectator notices the message to which Thornhill is blind. There is a time for interpretation or conjecture while the note is carried down the train. Then there is a moment of knowledge when the note's addressee is revealed to be VanDamm, though the actual content of the message remains an enigma still.

In the seminar on *The Purloined Letter* Lacan elaborates on the three times of the hermeneutic code, describing them in terms of three looks (which we are now analysing as elements in the narrative structure rather than the libidinal economy of a text). These three looks take place twice: in the Queen's boudoir and in the Minister's House. They are: (1) A look that sees nothing; (2) a look which sees that the first sees nothing and deludes itself as to the secrecy of what it hides and (3) a look which sees that the first two looks leave what should be hidden exposed to whomsoever would seize it, 'the second believing itself invisible because the first has its head in the ground, and all the while letting the third calmly pluck its rear', as Lacan describes them.

In the Queen's boudoir, the King comes in while the Queen is reading a letter. He notices nothing and the Queen is able to put the letter down on her dressing-table. The Minister, however, has

noticed both the letter and that the King has not noticed. He is able to seized the letter and use it against the Queen. Later, the Prefect of police searches for the purloined letter in the Minister's home but is unable to find it. Poe's protagonist, the detective Dupin, is able to see what has been hidden without the Minister noticing it has been seen. Thus we have a twice-occurring three-fold pattern of looks:

> (1) *Sees nothing.*
>
>     The King               The Prefect (the agent
>                             of the Queen)
>
> (2) *Sees (1) and deludes itself as to the secrecy of what it hides.*
>
>     The Queen          The Minister
>
> (3) *Sees (1) and (2) leaving what should be hidden exposed to whomsoever would seize it.*
>
>     The Minister       Dupin (potential agent
>                             of the King)

In effect, there is a rotating triad of actantial roles, in which characters fill different roles on each occasion. This type of rotation of actantial roles is, in fact, fundamental to the detective story, in which characters rotate among three roles: Victim (or potential victim), Criminal, Detective or Investigator. It has often been noted how characters frequently fill each of these roles in turn in Hitchcock films. Thus in *North By Northwest* Thornhill is potential victim of VanDamm, assumed criminal of the United Nations murder, wanted by the police, and investigator on his own account into the identity of Kaplan. (It is worth adding that these three roles are, so to speak, hermeneutic variants of the standard Proppian triad of Victim of villain, Villain and Quest Hero, in a story in which the villainy is *secret*).

Hitchcock's stories typically exhibit two variations on the detective story format: the 'wrong man' story, such as *The Thirty Nine Steps* (with a male protagonist) and the 'infiltrator' or 'mole' type of story, such as *Notorious* (with a female protagonist). *North By Northwest* combines the two: Thornhill is the progatonist of a 'wrong man' story, Eve Kendall of an interwoven 'mole' story. In fact, each of these types of story is the inverse of the other. In

both, the protagonist (P) is in reality not-guilty ($-$G) rather than guilty (G) in the eyes of the law (L) but there is a different pattern of belief (B) and knowledge (K), which we can symbolize as follows:

| | | | |
|---|---|---|---|
| Wrong Man story | $L_B P(G)$ | $V_K P(-G)$ | Law believes P guilty<br>Villain knows P not-guilty |
| Mole story | $L_K P(-G)$ | $V_B P(G)$ | Law knows P not-guilty<br>Villain believes P guilty |

In these inverse types of story there are two secrets: the secret of the crime and the second secret of the identity of the 'wrong man' or 'mole'. Both types of story depend also on the moment of transition from belief to knowledge. In *Notorious*, for example, knowledge is conferred on Sebastian by his look at the key returned to its proper place, thus ending the state of false belief he had been in as regards his wife and causing a rotation of roles and a switch in the story. A more complex type of look (A knows that B knows, rather than simply A knows) confers knowledge on the criminal that the crime has been discovered. A classic example of this is in *Rear Window*, where Lisa is showing a wedding-ring she has found by gesturing to a hidden observer (Scottie). Scottie looks at the ring; then the murderer looks at the ring and moves in an instant from noticing (the ring) to knowing (that it is being exhibited to a third person); then the murderer looks and sees Scottie; then Scottie sees the murderer looking at him. In this sequence, there is an extremely rapid series of secrets revealed and, concomitantly, roles rotated.

More complex still, of course, are the series of looks described by Lacan, which are also to be found in Hitchcock's films. Essentially, though Lacan himself does not comment on this, the situations he describes are those of *blackmail*, something made quite explicit by Hitchcock. The third Lacanian look is that of the blackmailer, the second that of the blackmailee, and the first that of the person the blackmailer threatens to tell about the blackmailee. (Of course, Hitchcock actually made a film called *Blackmail* about this particular triad). The cycle of blackmail in *The Purloined Letter* is brought to an end when Dupin is able to use the

power conferred by the third look to ruin the previous incumbent, the Minister, by returning the letter to the Minister's blackmail victim, the Queen. (Perhaps, since the third look is clearly that of the analyst, Lacan did not see any reason to raise the question of blackmail involved by the privileged possession of a secret).

The clearest example of this triad of looks in Hitchcock is in *Marnie*, where Strutt is put in the position of the King (blind), Marnie believes herself to be unobserved (secret intact) and Mark Rutland is able to blackmail Marnie into marrying him. Mark's secret itself (the secret of his complicity with Marnie's secret) is in turn discovered by Lil, who actually believes at first that he is being blackmailed by Strutt. There is another variation in *Notorious* where, although Sebastian obtains knowledge of Alicia's secret, he is unable to use his power because he cannot inform his own colleagues and accomplices (who remain in the first position when he is in the third) as he has been compromised by being duped.

The crucial point is that the third position (that of the Minister and then of Dupin) is the position of power. The look that confers knowledge of the secret also confers power to extort the object of desire by the threat of punishment. Thus the rotation of characters among the three actantial roles also involves shifts in the relations of power between them. The character in the second position (that of the Queen) is vulnerable to the character in the third. This in turn may provoke counter-action. In Hitchcock's films the discovery of a secret tends to instigate violence. Even in *The Birds* the exchange of looks between Melanie and Mitch across the waters of the bay (secret discovered; knowledge that secret has been discovered) is immediately followed by the first gull attack. In *Vertigo* Scottie's look at the jewel, which confers knowledge of the secret of Judy's identity (shifting him from first to third position and placing her in the second position) triggers his violence towards her.

In *North By Northwest* the array of secrets and pattern of rotations is bewilderingly complex. Take, for instance, the scene in the cafeteria at Mount Rushmore, at which all the characters are present. In this scene Thornhill makes an (illusory) attempt to blackmail VanDamm into letting him have Eve by threatening

to reveal the secret of the MacGuffin (the microfilm hidden in the sculpture) to the Professor (representative of the Law). He is then (apparently) shot by Eve. From the point-of-view of VanDamm the Law is still blind (the dupe), he is the holder of a secret and Thornhill has gained knowledge of the secret enabling him to blackmail VanDamm. In reality the Law (the Professor, who is a witness of the whole scene, unknown to VanDamm) already knows and it is VanDamm who does not know the secret and is blind to Eve's identity (Kaplan's identity). Hence the irony of the Professor's knowing look. Later the same situation is re-played in a second theatrical reversal, after Leonard reveals the secret of Eve's identity to VanDamm. Eve is now placed in the second position and is hence vulnerable (under virtual sentence of death) but once again there is a doubling of secrecy and discovery: Thornhill has seen VanDamm's discovery of Eve's secret without himself having been discovered: he is in the third position in relation to VanDamm and is thus able to reverse once again the relations of power and eventually free Eve. These types of situation involve not only the original Lacanian triad of looks but a *trick* whereby secrets and discoveries are fabricated and simulated, so that characters who believe themselves to be in one position are in fact in another, because of a secret theatre that they have not discovered and of which, in their blindness, they are the dupes.

Finally, I would like to introduce briefly three areas for further research. First, the psychoanalytic implications of the pattern of seeing, interpreting and knowing. Beyond Lacan's own use of these terms, we can note three other relevant aspects of psychoanalytic theory. In his paper on 'The Uncanny' Freud describes how the effect of the uncanny is caused by 'something which ought to have been concealed but which has nevertheless come to light', the secret which its discoverer does not wish to discover. In Hitchcock's films key instances of this kind of unwished-for discovery are the sight of the locket in *Vertigo* and of the broken champagne bottle and subsequently the key in *Notorious*. Both, of course, are instances of discovery of the deception (infidelity) of the woman the discoverer loves.

In another paper, that on 'Fetishism', Freud describes the process of disavowal, whereby an individual continues to believe

something they know to be untrue. This involves a maintenance of the time of interpretation and belief beyond the moment of knowledge, because this moment is reversed into a moment of denial. Both *Spellbound* and *Marnie* depend on fetishistic disavowals, in which the male protagonist continues to act as though the woman he loves is innocent though there is every reason to know her guilt. In both movies he is more or less justified in the end— her innocence is miraculously established in *Spellbound* and her crimes are extenuated in *Marnie*, but the mechanism of disavowal nonetheless structures the central sections of the films. The time of interpretation, of course, also recalls the infantile time of development of sexual theories, typically after the sight of the primal scene (observation of a crime that is also a secret), or of the genitals of the opposite sex ('A little girl . . . makes her judgement and her decision, in a flash. She has seen it and knows that she is without it . . .'). There are possibilities here of linking work on the hermeneutic code with work on the libidinal economy of texts, especially through the multiple functions of the look.

The time of interpretation can also be approached using Eco's concept of 'inferential walks' and using concepts drawn from epistemic logic. It is a time when 'belief-worlds' of characters proliferate, conflict and are filtered out, till only one shared 'knowledge-world' remains. The various hermeneutic devices of decoys, red herrings, false clues, could be examined as different kinds of sets of beliefs and knowledges distributed unevenly among the characters, as well as different types of relation between noticing (false clues) and interpreting (false beliefs). Again, as Eco points out, the spectator too can be induced into a state of false belief by being encouraged to notice misleading things.

In Hitchcock's films, as is well-known, the spectator's time of interpretation is frequently cut short before that of the characters, in order to build up suspense. Hitchcock's concept of suspense, contrasted with mystery and surprise or shock, can be characterized as follows:

Suspense.   Spectator knows secret but character does not.
Mystery.    Spectator does not know secret but knows there is a
            secret. (Parity with character).

Shock      Spectator doesn't know there is a secret, till it is sud-
denly revealed.

The conferring of knowledge on the spectator places them in a
position of knowledge without power, unlike characters within
the action, because of the inaccessibility of the fictional from the
actual world. Spectators can never cash their knowledge—this too
is part of the mechanism of suspense.

In conclusion, we can look forward to an exciting period of
work on the hermeneutic code, with the possibility of a converg-
ence of approaches drawn from Freud/Lacan, Barthes's hermen-
eutics (travestied) and Eco's 'text pragmatics'. In time, the her-
meneutic code can be articulated with the proaieretic and tales
and plots that depend on lack of knowledge related to those that
depend on lack of a desired object. The immense revolution in the
study of narrative inaugurated by Propp is still only in its initial
stages. It is not yet time to call a halt to the desire for scientificity
and start to dissolve semiotics into para-literature. There is a need
for much more precise knowledge of narrative before we can
develop the variety of innovative narrative modes that will trans-
form the practice, as well as the theory of story-telling.

# Introduction to
## *Citizen Kane*

To write about *Citizen Kane* is to write about the cinema. It is impossible to think about this film without thinking about its place in film history. Most critics, despite Welles's own unhappy relations with Hollywood, have seen him primarily within the framework of the American narrative cinema. Pauline Kael talks about the thirties newspaper picture and builds up the role of Mankiewicz, a hardcore Hollywood scribe if ever there was one. Charles Higham talks of a 'wholly American work', Andrew Sarris of 'the American baroque' and they leave no doubt, I think, that where the cinema is concerned, for them America = Hollywood. And, from the other side, an enemy of Hollywood such as Noël Burch places Welles in relation to Kazan, Aldrich, Losey and Penn and condemns *Kane* for simply displaying an amplification of traditional narrative codes that it does nothing to subvert.

Against this mainstream trend, of course, we have to set the massive influence of André Bazin. For Bazin, *Kane* and *The Magnificent Ambersons* were crucial moments in the unfolding of the cinema's vocation of realism. Together with the work of Renoir and Wyler, Kane represented a rediscovery of the tradition of realism, lost since the silent epoch (Feuillade, Von Stroheim, Murnau). *Kane* looked forward to Italian neo-realism and, had Bazin lived longer, his interest would surely have turned to cinéma-vérité and the new developments in documentary that followed the invention of magnetic tape, lightweight recorder and camera, and the tape join. (Indeed the strain of 'technological messianism' in Bazin's thought must surely have taken him in this direction).

For Bazin, of course, the crucial feature of *Citizen Kane* was its use of deep focus and the sequence-shot. Yet one senses all the time, in Bazin's writings on Welles, an uneasy feeling that Welles was far from sharing the spiritual humility and self-effacement, or even the democratic mentality, which marked for Bazin the 'style without style', the abnegation of the artist before a reality whose meaning outruns that of any artefact. It is easy to forget that, on occasion, Bazin talked about the 'sadism' of Welles, of his *rubbery* space, stretched and distended, rebounding like a catapult in the face of the spectator. He compared Welles to El Greco (as well as the Flemish masters of deep focus) and commented on his 'infernal vision' and 'tyrannical objectivity'. But this awareness of Welles the stylist and manipulator did not deflect Bazin from his main point. Fundamentally, his enthusiasm was for the deep focus cinematography which Welles and Toland introduced with such virtuosity. It was on this that Welles's place in film history would depend.

Yet a third current has been felt recently, again often more implicit than explicit. Putting together some remarks of Robbe-Grillet, the article by Marie-Claire Ropars-Wuilleumier in *Poetique* and that by William Van Wert in *Sub-Stance*, we can see how it is possible to place *Kane* as a fore-runner of *Last Year at Marienbad*, a film that pointed the way towards the breakdown of unilinear narration and a Nietzchean denial of truth. It is in this sense too that we can understand Borges's praise of *Kane* as a 'labyrinth without a center'. *Kane*'s perspectivism (leading so easily to nihilism), its complex pattern of nesting, overlapping and conflicting narratives, put it in a particular tendency within the modern movement, which has its origins perhaps in Conrad or Faulkner and its most radical exponents in Pirandello and the further reaches of the French new novel.

And of course, this tendency, whose origins are in literature, has begun to spread into the cinema, especially in France, through the influence of writers—Duras, Cayrol, Robbe-Grillet—who have worked on films, even become film-makers.

The oddest of these three versions of *Kane* is undoubtedly Bazin's. So flexible, so generous in many respects, Bazin was nevertheless able at times to restrict and concentrate his vision to

an amazing degree. Obviously he felt the influence of expression-
ism (which he hated) on *Kane*, but he simply discounted it—or
tried to justify it by pointing to the exaggeration and tension in the
character of Kane, a kind of psychological realism, similar to the
way in which he defended the expressionist style of a film about
concentration camps (in the same vein, Christian Metz remarks
how the formal flamboyance of *Kane*, the film, parallels the flam-
boyant personality of Kane, the man). In general, however, Bazin
simply hurried on to his favourite theme—the importance of deep
focus and the sequence-shot.

The key concepts here for Bazin were those of spatial and tem-
poral homogeneity and of dramatic unity. It is almost as if the
theatrical scene was the model for Bazin's theory of the cinema.
Of course, he believed that filmed theatre should respect the scene
and the stage. Beyond that, it seems he believed in a *theatrum
mundi*, which it was the calling of the cinema to capture and
record—there is a sense in which all cinema was for him filmed
theatre, only in neo-realism, for instance, the world was a stage,
the players were living their lives, and the dramatist, who gave
meaning to the action, was God himself. No wonder then that for
him the artist, in Annette Michelson's phrase, was 'artist as wit-
ness' and the whole of reality the offering of an 'Ultimate Spec-
tacle'. Indeed, Bazin writes that in Italy daily life was a perpetual
Commedia dell'Arte and describes the architecture of Italian
towns and cities as being like a theatre set.

Bazin always laid great stress on the theatricality of Orson
Welles. He saw Welles as a man of the theatre and talked about the
sequence-shot as a device for maintaining the primacy of the
actor. 'An actor's performance loses its meaning, is drained of its
dramatic blood like a severed limb, if it ceases to be kept in living,
sensory contact with the other characters and the setting. More-
over, as it lasts, the scene charges itself like a battery . . . '

Bazin justifies the sequence-shot and deep focus for three
reasons: it maintains the dramatic unity of a scene, it permits
objects to have a residual being beyond the pure instrumentality
demanded of them by the plot, and it allows the spectator a certain
freedom of choice following the action. In *Kane* it was the first
which was uppermost. The second was important to Bazin—he

talks about the door handle of Susan Alexander's bedroom, in the sequence after the suicide attempt, and goes on to describe the cold feel of copper, the copper or indented enamel of a door handle, yet we must feel that this is his own projection, reverie almost (in the Bachelardian sense) which has little relevance to *Kane*. As for the third reason, Bazin recognizes that Welles directs the spectator's attention through lighting and movement as imperiously as any editor at times, but he remains aware of the potential ambiguity of the sequence-shot and, of course, links this to the ambiguous portrayal of Kane's character.

Yet, with the advantage of hindsight, we can see that Bazin's love of the sequence-shot has been strangely betrayed by the film-makers who have subsequently used it. Who do we think of? Warhol, Snow, Godard, Straub, Jancso. There are links of course —Straub reveres Bazin's hero, Bresson; Godard was deeply marked by Rossellini—but clearly the sequence-shot has been used for purposes quite different from those foreseen by Bazin. Some of these filmmakers have stressed the autonomy of the camera and its own movement, rather than the primacy of the actors or the drama (Jancso, Snow), others have used the sense of duration to de-realize the imaginary world of the film (Godard), others have been interested in duration as a formal feature in itself (Warhol). Straub, probably the closest to Bazin in his insistence on authenticity, on a refusal of guidance for the spectator's eye, has nonetheless put his Bazinian style to purposes very different from those Bazin himself could have envisaged.

It is worth noting that most of the sequence-shots in *Citizen Kane* are, in fact, used in the framing story rather than the flash-backs, in the scenes in which Thompson talks to each of the interior narrators. The average length of a shot in *Citizen Kane* is not particularly long because of the number of short shots that exist both in the newsreel sequence and in the numerous montage sequences which Welles uses, mostly as transitions. The decision to use sequence-shots in the framing story is clearly a decision not to use classical field reverse-field cutting, and thus to de-emphasize the role of Thompson, the narratee. Thompson only appears as a shadowy figure with his back to the camera. It is hard to separate decisions on length of shot and editing from decisions on narrative

structure. By shooting Thompson in this way Welles precludes any spectator identification with the character who, from the point of view of information and focalization, is the spectator's representative in the film.

In the last analysis, what concerned Bazin was dramaturgy (even if, as with the neo-realists, he could speak of a 'dramaturgy of everyday life') and he tended to assume the need for characters and a continuous narrative line. He simply thought that psychological truth and dramatic configurations would reveal themselves more fully if there was a minimum of artistic intervention. He remained hostile throughout to experimental film (for him Von Stroheim was the great experimentalist and Welles, of course, can easily be perceived as an avatar of Von Stroheim) and thought of theatre and the novel as the models with which cinema should be compared. There too he tended to have conventional tastes—he aligns himself with Sartre's condemnation of Mauriac, but seems also to accept without question Sartre's positive tastes—Dos Passos, Faulkner, Hemingway—and clearly was not interested in the literary revolution inaugurated by Gertrude Stein and James Joyce.

Yet the example of contemporary film-makers has shown that the long take and the sequence-shot tend to undermine the primacy of the dramaturgy: duration becomes a stylistic feature in itself and, far from suppressing the filmmaking process, the sequence-shot tends to foreground it. At most, the sequence-shot can be associated with a Brechtian type of dramaturgy, based on tableaux. In fact this tendency can be seen even in *Citizen Kane*, where it is disguised by the movement in and out of the framing story and the complex character of the transitions. Bazin thought that the principal function of the cut should be that of ellipsis, but within the kind of rhythm built up by a series of long sequence-shots, the cut automatically plays a role as caesura rather than ellipsis alone.

Although Bazin talked mainly in terms of traditional dramaturgy and the realistic essence of photography (photo-chemical transfer of *presence* from the world to the film) his writings seem now almost to be—or at least to conceal—a theory of time in the cinema, hence a theory of *absence*. What strikes us with the long

take is not so much that the image is there, but that it is *still* there. Bazin talks about time in terms of length, lasting, duration. The type of montage he liked least was the 'accelerated' montage he associated with Gance—indeed, he is at pains to point out how montage sequences in *Kane* are equivalent to the frequentative, the imperfect—designating continuous or repeated actions— rather than being 'accelerated' montage of the Gance type. One feels that by the same token, his suspicion of Eisenstein was not simply a dislike of abstraction but a dislike of the short duration of Eisenstein's shots: exactly the feature that attracted Brakhage. Montage in the classical sense, by stressing relations between shots rather than relations between objects in the shot, produced a dialectic of loss and absence, difference and division, rather than of presence, continuity and unity.

Time in the cinema involves at least two—perhaps three— realms of time. There is the imaginary time of the story and there is the real (with reservations) time of the film—story time, screen time, and also perhaps production time, film-making time. (Certainly it is the introduction of film-making time as a conscious category which marks the films of directors such as Godard-Gorin, Morgan Fisher, Vertov. Of course, film-making time can be phantasmatically incorporated into imaginary time, as with Truffaut's *Day for Night* ). Between these different realms of time there is a series of differential relations—relations which can be analysed through the concepts of duration, order and frequency, as developed by Gérard Genette in his work on literature. We should note also that, as the cinema is constituted at present, screen time is determinate and fixed—it can be calculated by the number of frames and constant (standard) speed of projection. This was not always the case—silent films were projected at variable speed, so that the projectionist was somewhat like the performer of a piece of music, who, to a certain extent, can vary tempo and duration. In the future, when films are watched through video recorders, we can envisage a screen time more like that of book-reading, with a spectator who pauses, hurries through, re-plays, turns back to refresh the memory.

In most films—Hollywood films particularly—story time is longer than screen time and hence the basic operational figures

are those of compression and ellipsis. In contrast, independent and experimental films have tended to suppress imaginary time entirely and to work with screen time alone, often with great complexity, or else they have chosen to move towards isochronicity (Warhol) or, through repetition, for instance, to have story time shorter than screen time (Conner). Independent films, too, have tended to have screen time either of shorter (down to one frame) or longer duration than Hollywood films (Snow, Rivette, Warhol, *Scottie's Endless Movie*, of indefinite duration, because never completed). In general terms, we can say that Hollywood cinema has tended to suppress consciousness of screen time, to transport the spectator into the realm of the imaginary, but here again it is easy to think of exceptions in which time is organized in a very complex or idiosyncratic way—Hitchcock's *Rope*, Raphael-Donen's *Two For the Road* and, of course, *Citizen Kane*.

The most obvious feature of *Kane* in this context is the flashback structure, which involves duration, order and frequency. Kane's life as a whole is narrated twice (newsreel, memories) and one section of it, the opera sequence, twice by different interior narrators. In a sense, there is a third narration—the tracking shot over the accumulation of objects in the great hall of Xanadu, which passes over the residue of different periods of Kane's life in inverse order, culminating with the sled preserved from early childhood. Order is also affected by the movement in and out of the framing story and the variations from unilinear order within the flashbacks. Duration is clearly involved in the compression of Kane's life into roughly two hours of screen time, through the selection of key scenes (Bazin's sequence-shots, or near-sequence-shots) and complicated transitions between them.

Fundamentally, the flashback structure of Kane is a variation on the classical detective story format. Every detective story is in fact two stories: the story of a crime and the story of an investigation. The crime story revolves around a mystery, a secret, and the investigation story ends with the revelation of the secret and the *narration* of the crime story. Thus the investigator is presented first as a narratee, who listens to the fragmentary, misleading or limited versions of various witnesses, participants in the crime story, and then must piece these together into a coherent story,

which he finally *narrates*. (Or he may elicit a confession, in which case he remains in the role of narratee, whose function has been not to tell the story, but to hear it by inducing or compelling someone else to tell it, whether witness or criminal.)

*Kane* follows this pattern of the 'twofold' story, the second ending with the narration of the first, but with a number of crucial differences and variations. First, of course, we must point out that the investigator—Thompson, a journalist rather than a detective—never himself discovers the clue which would enable him to reveal the secret and tell the story of Rosebud. The secret is revealed by the filmmaker to the spectator alone. Within the imaginary world of the film story, the enigma is never solved. It remains insoluble. However, it is solved for us. In effect, there is a second framing narrative—the prologue and the epilogue to the film—which is narrated by the filmmaker(s), the implicit or inscribed author.

This secret—the secret of Rosebud's identity—is not, of course, the answer to the riddle set by a crime, which always involves discovering the identity of a criminal—casting one of the characters in the investigation story as protagonist in the crime story. However, almost all the 'evidence' narrated to Thompson by Thatcher (via the written word), Bernstein and the others, is set in a time period after the crucial event, the loss of the sled, rather than before it, as is usual in a crime story, in which the secret is that of the ending rather than the beginning. Most of the interior narration, in the flashbacks, has no direct bearing on the secret. In fact, the narrators typically begin by denying any knowledge of Rosebud. The structure of *Kane* is that of a biographical portrait, from different points of view, set within an investigation story. This is the opposite of the type of investigation story in which the personality of the detective becomes more important than the solution of the crime. Here the investigator is almost anonymous —it is the personality of Kane that dominates. In effect, also, there is a play on the problem of identity: who or what was Rosebud? Who or what was Kane? In Hitchcockian terms, Rosebud is the MacGuffin around which the narrative pivots, but which is of structural rather than informational significance.

Each level of narration in the film is in a different register and

has a different kind of time structure. The investigation story proper—the series of interviews which Thompson has—lasts for about a week. We are shown the interviews themselves—or rather their beginning and end—principally in sequence-shots, but book-ended or introduced by an insert or short establishing sequence. The story time omitted—the time in which Thompson travels from one interview to another, for instance—is marked elliptically by a dissolve. At times, we return to the framing story within a flashback, presumably to cover a difficult transition. Apart from the opening sequence in the screening-room and the closing sequence in Xanadu, Thompson is always shown subordinated to the interior narrators—in the inserts which introduce interviews he is sometimes absent (the famous crane shots through the El Rancho skylight) or scarcely present (the shot of the hospital under the bridge). Even the 'interview' with Thatcher, which cannot show Thatcher live, is dominated by sculpture and painting which portrays him.

The flashbacks themselves are almost in chronological order, and it is interesting to note that the major ellipses exist *within* rather than *between* flashbacks. Between Leland's narration and Susan Alexander's there is overlap and repetition; there is a minor ellipsis between Bernstein's and Leland's and direct continuity between Susan Alexander's and Raymond's. The flashbacks, which make up the bulk of the film, show the most varied types of time organization. Following Genette, we can distinguish five types of relation between story and screen time in respect of duration. These exist both at the level of the shot and at the level of the sequence:

1) *Elongation.* Screen time greater than story time.
2) *Summary/abbreviation.* Screen time less than story time.
3) *Scene.* Screen time and story time the same.
4) *Stasis.* Screen time continuous. Story time discontinuous.
5) *Ellipsis.* Story time continuous. Screen time discontinuous.

These categories provide an alternative approach to that of Christian Metz and the classification of types of syntagma, which are also defined largely in terms of temporal and spatial relationships between the diegesis, the story and the screen. Both the

'autonomous shot' and the 'scene' (in Metz's sense) fall within the category of 'scene' (in Genette's sense), one with spatial discontinuity of field-of-view, the other without. The ordinary sequence displays minor ellipses, the episodic sequence major ellipses; in fact, one of the difficulties with Metzian analysis is deciding when a minor discontinuity becomes major. An important difference, which also produces problems, is that Metz assumes that the narrative is discontinuous and that the story can be readily divided and demarcated into actions or events, each of which is a unity. While this may be true logically (though this is very uncertain once the Proppian realms of fairy tale are left behind) it does not follow that a logical caesura will be co-terminous with a chronological break, marked by an ellipsis, *between* syntagmas, while other ellipses, *within* syntagmas, lack the same logical status.

In any case, the flashbacks in *Kane* contain a number of interesting temporal features. The mini-sequence (two shots linked by a dissolve) of snow falling on the sled, after young Kane's departure with Thatcher, is an example of summary or abbreviation, a variant on the classical 'calendar leaves' shot. The famous breakfast montage is an example both of spatial continuity with major temporal discontinuity and also of repetition with variation within the story time. There are two examples of freeze-frame/photographed still (stasis) discussed by Van Wert in relation to the use of freeze-frame in the films of Robbe-Grillet. The first, the still of journalists at the *Chronicle* coming to life when they join the *Inquirer*, plays on both the duration of stills (passage of time) and their non-repeatability (ironic repetition; same image/different time and circumstance). The second, when the door of Kane's 'love-nest' freezes into a press photograph, after the departure of his wife, takes up the recurrent theme of the contrast between the emblematic public image, frozen and apparently objective and determinate, and the fluidity/subjectivity and indeterminacy of the life which lies behind.

A further category of filmic time is found both in the flashbacks and more obviously, in the newsreel sequence: the shot Bazin calls 'frequentative' and Genette 'iterative'. For instance, the shot in the newsreel of the paper running through the press signifies not a particular incident in the story time, but a repeated process. Paper

runs through the press every day. This usage, which approaches the symbolic, depends partly, however, on context—introduced within what Metz calls the 'bracketing syntagma'—and partly on our familiarity with the 'look' of stock-shots and library material— Welles and Toland also attempted to simulate filmmaking time in the newsreel by making some of the footage look old, in the same way that Godard and Coutard shot *Les Carabiniers* to simulate the look of silent orthochromatic stock.

Finally, there are the prologue and epilogue. Here the major time phenomenon is symmetry. The film begins with a series of shots dissolving into each other—the dissolve establishes an element of continuity in screen time, lacking with the cut; it is rarely used to signify a purely spatial change in the field of vision —beginning outside the fence of Xanadu, passing the No Trespassing sign, then approaching the house, high up, as though with a crane shot. The end is similar, though not quite identical, as we leave Xanadu, again in a series of dissolves, pass the No Trespassing sign, and end outside the fence once more. Symmetry, of course, is a figure that combines order with repetition: the same shots are repeated, but in inverse order. In fact, the whole of *Kane* is marked by symmetry—the crane shots in and out of El Rancho, for instance, or, perhaps more subtle, the way in which the sequence of Kane's rage, the destruction of Susan Alexander's bedroom, is book-ended by two quasi-inserts: the screeching cockatoo and the empty series of receding mirror images.

In an essay 'On the Problems of Symmetry in Art', Dagobert Frey observes that 'Symmetry signifies rest and binding, asymmetry motion and loosening, the one order and law, the other arbitrariness and accident, the one formal rigidity and constraint, the other life, play and freedom.' Without necessarily seeing the question in such clear-cut terms, there is an apparent tension in *Kane* between the formal symmetry of the film and the themes of the irreversibility of biographical time and the shifting perspectivism which led Borges to his description of it as a 'labyrinth without a center'. In fact, *Kane* reflects the old contrast between the order, permanence and certainty of art and the disorder, transiency and uncertainty of life. Despite everything Pauline Kael or François Truffaut have said about the 'journalistic' quality of

*Kane*, its formal structure alone demands that we approach it as 'art'. (In this respect we can compare Welles with Fuller—another director of whose films it is appropriate to talk in terms of 'lay-out' or 'headline shots', but who seems less insistent on his own identity as an artist.)

Truffaut, always fundamentally a conservative critic—as he has shown himself to be a conservative film-maker—has said that 'if *Citizen Kane* has aged, it is in its experimental aspects'. It seems to me that precisely the opposite is true. All Welles's 'tricks', as they are often contemptuously called—the lightning mixes, the stills which come to life, the complex montages, the elasticity of perspective, the protracted dissolves, the low-angle camera movements—are what still gives the film any interest. Nobody, after all, has ever made high claims for its 'novelistic' content, its portrayal of Kane's psychology, its depiction of American society and politics in the first half of the twentieth century, its anatomy of love or power or wealth. Or, at any rate, there is no need to take such claims very seriously. It seems quite disproportionate for Noël Burch to submit them to his acute dissection and attack, as he himself seems to half-acknowledge.

Indeed, the 'pro-Hollywood' defense of *Kane* is quite pathetic in its lack of ambition. (*Kane*, after all, is widely held to be the greatest film ever made.) Pauline Kael begins with hyperbole— 'the one American talking picture that seems as fresh now as the day it opened'—but soon descends to dub *Kane*, in a famous phrase, 'a shallow work, a *shallow* masterpiece'. The shallowness does not worry her, however, because it is what makes *Kane* 'such an American triumph', and then we discover its triumph lies in 'the way it gets its laughs and makes its points'. She assimilates *Kane* to the tradition of the well-made Broadway play, translated into the thirties comedy-film, with all its astringency and sense of pace and fun. Other critics do not really claim much more— Charles Higham talks of a 'masterpiece', but also 'epic journalism'; once again, we get the insistence on the 'American' quality of Welles and *Kane*, ironic in the light of the original intention to call *Citizen Kane*, *The American*. Energy, grandeur and emptiness.

The truth is that the 'content' of *Citizen Kane* cannot be taken

too seriously. Yet it had an enormous impact—largely because of its virtuosity, its variety of formal devices and technical innovations and inventions. In themselves, of course, these are purely ornamental, and the dominant aesthetic of our age is one that rejects the concept of ornament—the ruling aesthetic of our day is one of expressionism or functionalism or symbolism or formalism, seen as a complex process of problem-solving rather than wit or decoration. Welles is usually described in terms of baroque or expressionism, sometimes the gothic, but this seems to reflect the ponderousness of his themes. His interest in formal devices and technical ingenuity places him closer to mannerism, to a conscious appreciation of virtuosity and the desire to astonish.

It is this 'mannerist' aspect of Welles that is still significant—not the dramatic unity which deep focus and the long take make possible, but the long take and deep focus as formal features in themselves. Similarly, it is not the theme of time, youth, memory, age, that is of any interest, but the devices used to organize time within the film. Many of these point the way toward a quite different kind of use—contemporary filmmakers' variations on the long take, Robbe-Grillet's variations on the freeze-frame/still. *Kane* remains an important film historically, not within the terms it set itself, or those within which it has been mainly seen by critics, but because, by a kind of retroactive causality, it is now possible to read there an entirely different film, one that Welles probably never intended. *Citizen Kane*, we can now say, was a milestone along the road that led, not to a re-invigoration of Hollywood, or a novelistic complication of narrative, or the unfolding of the realistic essence of film, but towards the expansion and elaboration of a formal poetic that would transform our concept of cinema entirely, towards film as a text that is a play with meaning rather than a vehicle for it.

2.

# Art in Revolution

The number of Russian artists and architects who supported the October Revolution immediately was very small. Indeed, only a handful of intellectuals of any kind rallied to it. Even a writer like Maxim Gorky, later closely identified with the Soviet regime and one of the leading protagonists of 'socialist realism', took a hostile attitude at first. Consequently when Lunacharsky was appointed Commissar for Education in 1917, in charge of NARKOMPROS, as his commissariat was known, he had great difficulty in filling most of the posts with people both qualified and sympathetic. The previous establishment of civil servants simply refused to work with him, the academic community was openly hostile, and even left-inclined intellectuals took up a wait-and-see position, not wanting to plunge in too precipitously. He was even reduced to making public appeals for support, but the response was derisory. When eventually he set up a Department of Fine Arts, the IZO, he called on a painter whom he had known in Paris, a left Bundist called David Shterenberg, who had fallen under the influence of French Cubism. Shterenberg got together a staff of artists, almost all of whom were from the avant-garde. Altman was put in charge of the Petrograd IZO, Tatlin in charge of the Moscow IZO. Responsibility for museum and gallery exhibition policy was given to Rodchenko.

This bias towards the avant-garde was inevitable in the circumstances. Academic and even moderately modernistic artists felt they had nothing in common with the new order and, in any case, most of them thought it would not last for long and it might be better not to have been compromised by association with it when the White generals rode into the capital. Naturally it was the

avant-garde, Cubists and Futurists for the most part, impatient with the past, with tradition, with established values, who identified their own destiny with that of the revolution. Thus was inaugurated what came to be thought of as a 'left monopoly' of state patronage that lasted for four years, till the New Economic Policy (NEP) was introduced in 1921, accompanied by a re-organization of NARKOMPROS, one of the features of which was a purge of the IZO. For four years, however, there is no doubt that the most avant-garde groups of painters, poets, theatre directors and musicians were in the ascendancy, insofar as it makes sense to talk about 'ascendancy' in those years of war, famine and heroism.

Besides handing over the IZO to the avant-garde, Lunacharsky made one other decision which had an important effect on the history of the arts in Soviet Russia. He decided to sponsor the *Proletcult*, an organization inspired by ideas developed in exile by his old friend and comrade Bogdanov, and subsidize it out of NARKOMPROS funds.

Bogdanov believed that the proletariat should have its own specifically cultural organization, as well as political and economic organizations. The proletariat must create a new cultural order as well as a new political and economic order. A new proletarian science and a new proletarian art must be produced by worker scientists and worker artists. The creative energy of the proletariat was boundless once it was released. Indeed, the *Proletcult* quickly showed the dynamism Bogdanov expected of it. By 1920 it had over half a million members, at a time when the Bolshevik Party itself had only 620,000.

Lenin had longstanding political and ideological differences with Bogdanov. Not surprisingly he was suspicious of the *Proletcult* as a possible rival organization to the Party. Moreover, once he had formed the decision to launch the NEP, which implied an accommodation with the peasantry and a limited return to the free market, it was clear that ultra-proletarian organizations and tendencies such as the *Proletcult* would have to be curbed. It was Lenin's belief that the completion of the revolution would be a difficult and arduous process, involving compromises and even retreats. The *Proletcult*, like the Workers' Opposition which grew up at the same time, took a much more optimistic view and could

see no overriding reason why the working class should not move on straight away toward the promised land. Their reckless attitude towards the peasantry in particular meant that they had to be bridled and consequently, when NEP began, funds were cut off from the *Proletcult*, it was attacked by Lenin, pressure was brought to bear on Bogdanov, and he left political life. He began to work on the problems of blood transfusions and died in his clinic later in the twenties after experimenting on himself.

Patronage of the arts in the first four years of the revolution, the period of 'heroic communism', thus fell to two principal tendencies—the Cubist and Futurist avant-garde and the *Proletcult*. These represented two different concepts. On the one hand, there was the idea of the avant-garde artist rallying to the revolution and bringing his specialized skill to its service. On the other hand, there was the concept of the proletariat, now it had achieved political power, producing its own artists and its own art. These two concepts were not necessarily contradictory but they could easily become so. Neither tendency was particularly inclined to pay much attention to the problems of the peasantry who, as Lenin was well aware, constituted the great bulk of the Russian population. The *Proletcult*, by its very nature, was exclusively proletarian in composition and outlook. The avant-garde, especially its dominant Futurist section, was fanatically urban and cosmopolitan in its world-view, mesmerized by the city, by the machine, by industrial civilization. The hatred of the old that brought it to the revolution went hand-in-hand with an aversion to rural life and rustic values. Neither tendency was ready to make concessions to populism or to peasant culture. As a result, neither was to emerge a victor in the battles which were to ensue.

At first, there was a considerable overlap between the *Proletcult* and the avant-garde. *Proletcult* artists joined with Futurists in contempt for the past and determination to produce new forms, representative of a machine age. It was a *Proletcult* pamphleteer, Kershentsev, who first launched the slogan of 'Art in the streets'. Later the IZO organized mass pageants and festivals and decorated whole cities with paintings on buildings, walls and gigantic hoardings. Kershentsev was made head of ROSTA, the forerunner of TASS, where he commissioned Mayakovsky, among others, to

produce the famous ROSTA windows, posters-cum-broadsheets, satirical cartoons combined with sloganeering verse. Another *Proletcult* artist, Gastev, collaborated with Mayakovsky in organizing a symphony of factory sirens and locomotive whistles, conducted by semaphore from a rooftop. During the brief period that *Proletcult* survived into the NEP years, it was one of its chief figures, Pletnev, who gave Eisenstein his start in the theatre, with his 'montage of attractions'. The first years of the revolution were a time when collaboration was possible.

In part, this was a result of the emphasis on taking art to the public, in tearing it out of the salons and presenting it to the masses. Rodchenko sent abstract, Futurist and Suprematist works all over the country, filling every gallery with them. Painted agit-trains and agit-steamers travelled all over Russia. Whole cities were covered with paintings. Huge public spectacles were organized. The storming of the Winter Palace was re-enacted. Acting on a suggestion of Lenin's, monuments were erected. The IZO commissioned Tatlin's *Monument to the Third International* which, though it was never built, was exhibited and driven round the streets as a model. Artists had not yet given up the idea that art was a particular activity, with a validity of its own. Assuming it to be of value, they were eager to take it to the masses, to make it accessible to everybody. Yet already the idea was beginning to form that art was itself a pointless luxury and that for art to have any real meaning, it must be subordinated to the exigencies of industrial production, it must have an immediate practical utility. As artists began to ask themselves what the role of art should be in the revolution, pragmatist and utilitarian arguments began to come to the fore. Artists must not just take art to the workers; they must become workers. Ironically enough, the ideology of the *Proletcult* demanded exactly the reverse—workers must become artists. Both proved abortive ambitions.

The underlying problem was that of the relationship between the working class and the revolutionary intelligentsia. Many workers, especially militant workers, perhaps the majority, deeply distrusted intellectuals, whom they saw as parasites. Either intellectuals were actual servants and lieutenants of the bourgeoisie or else they were pointless adjuncts. Marxism seemed

to point to the truth that all value was produced by the working class. The cult of physical labour was pervasive at the time. Indeed, the intelligentsia itself felt worried about its role. Arvatov, one of the theorists of Futurism and Constructivism, wrote that 'the radical and leading part of the intelligentsia, the so-called technical intelligentsia (to be precise) has been educated in the industrial centres of the present and has been permeated with the positivism of the natural sciences and has become "Americanized".... At the time when the former intelligentsia was soaring above the clouds in its "pure ideology" the new and "urbanized" intelligentsia was concentrating on the material world, the world of things'. This kind of attitude envisaged that the 'literary' and 'artistic' intelligentsia had to make a clean break with its past. 'Pure art' was to be rejected alongside 'pure ideology'. The new intelligentsia must be urban, technicist, materialist, integrated into modern industry, working alongside the proletariat.

Not all artists accepted this vision of the future. In the first four years of the revolution, for instance, Kandinsky was prominent in the INKHUK, the Institute of Artistic Culture which had been set up by the NARKOMPROS to gather artists sympathetic to the revolution into one organization. Gabo and Pevsner were active at this time. Most important of all, Malevich, who had ousted Chagall from control of the art school at Vitebsk, also demurred and, unlike Kandinsky or Gabo, he had a group of talented and loyal pupils and followers, the UNOVIS group. Malevich was emphatically not 'permeated with the positivism of the natural sciences'. He was a visionary who believed that art had a realm of its own, distinct from the 'world of things' (his most famous manifesto, of course, is titled *The Non-Objective World*). Art must pass beyond Futurism, in fact the art of the present, to Suprematism, in reality the art of the future. In Malevich's mind this was connected with an extra-terrestrial migration, a movement into space. The white of his suprematist canvas *White on White* was the colourless white of space, when the sky was no longer blue. The new forms created by the artist would necessarily prove appropriate to the new world and the new age that would be inaugurated after the revolution. There was no need to be obsessed by 'utilitarianism' which, in any case, could only be transitory.

At the beginning of the NEP period, Malevich moved to Petrograd where he worked, with his pupils, in the GUINKHUK, the Petrograd branch of the INKHUK. At the same time, following the re-organization of the NARKOMPROS and of education in general, the Moscow School of Art and Design, the VKHUTEMAS, was itself re-organized. Rodchenko, no longer in charge of exhibition policy, became the moving spirit of the new school and the head of its metal-work department, the METFAK. The history of the VKHUTEMAS remains to be written. It was, roughly speaking, the Russian equivalent of the Bauhaus. The examples of student work that have been exhibited and described suggest that the atmosphere was much the same—costume designs for a pantomime, *The Trials of a VKHUTEMAS Student*, as well as functional design.

As at the Bauhaus, there was a strong visionary streak in the teaching, but the bias was increasingly towards what would now be thought of as functionalism. The aim was to design articles (furniture, clothing, chinaware) suitable for factory production on a mass scale. Stepanova and Popova, two artists in the same Constructivist circle as Rodchenko, in fact went to work in the Seindel factory as fabric designers. This experiment was not a great success and they had difficulty in getting their designs accepted. In 1924 Popova died, from scarlet fever, and Stepanova left the factory to take up a post as head of the textile workshop in the VKHUTEMAS. This retreat from industry was representative. Most of the VKHUTEMAS designs remained unrealized. For instance, the furniture Rodchenko designed for a worker's club was actually used for the Paris Exhibition of 1925 and never installed in Russia at all.

In a curious sense, the path taken by Rodchenko, perhaps the most politically committed of the avant-garde artists, was in the last resort de-politicizing. It is interesting to read the programmatic statement Rodchenko used to present his last public exhibition of abstract paintings, at the beginning of 1919. This consisted of quotations from writers such as Kruchenikh, Weininger and Max Stirner. The Stirner quotation, which is typical, reads 'As a basis for my work I put nothing'. One of the paintings, the centre-piece, was *Black on Black*, a reply to Malevich's *White on White*.

In retrospect, it is possible to see that, at this time, the prevailing influence on Rodchenko was nihilism. For him, abstract painting was the painting of nothing, the suicide of himself as an artist. This is in contrast to Malevich's programmatic vision of Suprematism, which was a further move forward towards absorption into art. It is possible too to see how Rodchenko's nihilism was the logical prelude to his later functionalism. Once the 'artist' had committed suicide, he was reborn as the 'technician' and the 'engineer'.

Paradoxically enough, it now seems that Malevich's choice has turned out to be the more *political*, though he himself believed it to have been made for reasons indifferent to politics in any direct sense. In Soviet versions of art history it is Malevich's canvases that are totally absent, banned by the present Russian government. Even today, fifty years later, they are *politically* explosive. This is not true of Rodchenko's metal chairs which, though pioneering, are by now commonplace. It is clear that there was an element of truth in Malevich's belief that the choice of 'utilitarianism' was a choice of the ephemeral. Even the easel painting, regarded by the Constructivists as a derisory backwater, still has a dynamic, contains a threat of change, which Constructivist design now lacks. One of the main elements in the promulgation of 'socialist realism' was the suppression of utopianism. Soviet science-fiction, for example, is technicist in emphasis. The Soviet space programme is presented pragmatically without any of the mythological and rhetorical overtones of the American programme. It is not the space programme of a power which can harness dreams of utopia.

Functionalism, moreover, is de-politicizing in itself. It is significant that for many Russian revolutionary intellectuals of the twenties, there was a cult of Americanism. This can be seen in the Arvatov quotation above, it runs throughout Mayakovsky (consider, for example, his hymn of praise to Brooklyn Bridge), it is sloganized by Gastev: 'Let us take the storm of the Revolution in the Soviet Union, unite it to the pulse of American life and do our work like a chronometer!' What they admired was the mass-production of Ford cars, the technological symbolism of the sky-scrapers, the high productivity of American labour. Taylorism,

the 'scientific' study of work habits and the possibilities of greater efficiency and speed-up, was officially supported. (To his credit, Kershentsev was one of the few to attack this tendency). The end results of this trend, of course, were the Stalinist institutions of the shock brigade and Stakhanovism, an unalleviated work ethic and a repugnant *machismo*. This cult of Americanism had its roots, quite understandably, in the need to industrialize backward, agricultural Russia. But the particular form of the ideology also made possible a de-politicization of the working class, whose efforts it celebrated so highly. The period of industrialization was marked by the introduction of piece-rates, make-or-break work schedules and, in reality, an intense exploitation of the Russian proletariat, compensated for by the rhetoric of heroically reached targets. Functionalism and production-mania, scientism and technolatry were integral to this rhetoric.

It is often said that artists like Rodchenko were condemned to spend much of their life sidetracked into fields like exhibition design or photographic layout. Evidently, there is an element of truth in this. Every sign of 'formalism' was brutally suppressed and artists like Meyerhold who spoke out openly against 'socialist realism' were simply killed. But there was also an element of choice in this destiny. From the beginning of the twenties, many artists were vigorously claiming that industrial and propaganda art were the proper fields for the artist. Mayakovsky asserted that his advertising jingles for MOSSELPROM were as valuable as anything else he had ever written. There is no particular difference between this and the fate of a Bauhaus artist like Bayer, who also ended up in typography and advertising, but under capitalism. In fact, of course, Rodchenko never fully subordinated himself to the functionalist consequences of the death of art that he preached. His most important work of the twenties—his photomontages and typography for *LEF* and Mayakovsky's poem *Pro Eto*—are instantly recognizable as Rodchenko's by their use of photographs, their heavy, bold print and unremitting use of black. Rodchenko created a style for himself, like so many other functionalists.

Nevertheless, during the twenties, the functionalist aspect of Constructivism gradually became uppermost. This can be seen,

for instance, in the split in architecture between OSA and ASNOVA, accused of formalism, in the re-organization of the VKHUTEMAS into the VKHUTEIN towards the end of the decade and in the more rigid line followed by the magazine *Novy Lef* in comparison with its forerunner *LEF*. This evidently connects with the introduction of the first Five Year Plan, when combat lines were sharply drawn. In 1929 Lissitzky, recently returned to Russia from Western Europe, wrote that 'Once again the "Utilitarians" are opposed by the "Formalists". The latter assert that architecture is not covered by the concept of "engineering". To solve the utilitarian task, to construct a volume that functions correctly for the purpose, is only one part of the problem. The second part is to organize the materials correctly, to solve the constructive problem. A work of architecture comes into being only when the whole thing springs to life as a spatial idea, as a form that exercises a definite effect on our psyche. To do this it is not enough to be a modern man; it is necessary for the architect to possess a complete mastery of the expressive means of architecture'. Lissitzky had been a colleague of Malevich in Vitebsk during the period of 'heroic communism' and never shed his influence, strengthened and re-defined by his association with the architect Ladovsky, who taught at the VKHUTEMAS. He poses clearly the problem of an architect conscious of the appeal of functionalism but still attached to the idea of art.

It might have seemed that the functionalist current was destined to triumph in the end. (It was a team of OSA architects, functionalist-constructivists, who built the Dnieper Dam, centrepiece of the Five Year Plan.) Yet this was not so. To understand why not it is necessary to go back and take up the threads of the history of the *Proletcult* movement. After the introduction of NEP, after Lenin's reproof to Lunacharsky had been delivered and funds for the *Proletcult* had been severely cut back, the movement, evidently much diminished, fell under the leadership of Pletnev, who had been heavily influenced by the avant-garde. As a result, most of its proletarian support fell away and re-organized itself in a number of militantly 'proletarian' literary and cultural groups, including *On Guard!* and *The Forge*, eventually re-grouping in the more general All-Russian Association of Proletarian Writers, the VAPP, later

RAPP. These organizations spontaneously, lacking now the more elaborate ideological backing Bogdanov had provided, called for a proletarian art and literature and advanced the claims of a number of worker poets. As well as these proletarian groups and their publications, there also existed *LEF*, the magazine of the artistic avant-garde that published Mayakovsky and other futurist writers, Rodchenko and the Constructivists, the OPOIAZ group of literary formalists and film-makers and theatre directors such as Eisenstein, Vertov and Meyerhold. *LEF* aimed at a circulation of 5,000 but in fact had difficulty getting into four figures, a situation those concerned blamed on the State Publishing House for not promoting the journal properly. Finally, there was *Krasnaya Nov*, the magazine of what were called the 'fellow-travellers', who had rallied to the regime in the calmer, more settled climate of the NEP period.

During the twenties, a relatively liberal publishing policy was pursued by the state. Nevertheless, the various artistic tendencies were inevitably drawn into the inner-party struggles that took place after Lenin's death. The RAPP, for example, or at least its most prominent spokesmen, Vardin and Lelevich, supported Zinoviev, who tried to use the Petrograd working-class as a power base and was hence naturally drawn to 'proletarian' anti-peasant, anti-'fellow-traveller' and anti-NEPman rhetoric. Bukharin, equally naturally, supported peasant writing. Trotsky supported the 'fellow-travellers' and Voronsky, the editor of *Krasnaya Nov*, though he also expressed considerable sympathy with the functionalist element in Constructivism and came out with moderate praise for Mayakovsky and for *LEF*. (He criticized the Tatlin tower, however, for being perverse, without a clear functional logic.) Trotsky clearly felt some affinity with the production-mania side of Futurism and Constructivism and he had always been a defender of the need for the Soviet state to tolerate and utilize 'bourgeois' intellectuals and specialists—though unlike, say, Lunacharsky, he was prepared to discipline them if they stepped too far out of line.

In retrospect, it can be seen that contrary to appearances at the time, accommodation with the peasantry was a short-term policy. Sooner or later, an onslaught on the *kulaks* was on the agenda and

when it came, it was savage, determined and decisive. It was during this period of collectivization that the 'proletarian' current was once again revived. As during the period of heroic communism, the working class had to be fully mobilized. The RAPP re-appeared and proletarian organizations emerged even in fields such as architecture, where hitherto they had been unknown. The 'fellow-travellers' on the other hand were subject to unrelenting attacks. This was the period, for instance, when the universities were seriously purged for the first time. Education was re-organized once again, forcing Lunacharsky's resignation. The Constructivists were caught in the middle. Themselves hostile to the populist, pro-peasant and pre-revolutionary aura of the fellow-travellers, they were nevertheless open to attack as fellow-travellers themselves, since they were obviously intellectuals and not bona fide workers. It is not surprising, in this atmosphere, that they took refuge in an intensified functionalism.

After his letter *Dizzy With Success*, when the collectivization campaign was completed, Stalin and his cohorts worked out a new cultural policy. First, he wanted a return to calm and order, a period of consolidation and stability. Second, in line with this, he wanted an end to factional quarrels that might disturb the new order. Third, he wanted to re-establish the 'link' with the peasantry, now their economic and political power was broken, on a cultural basis. 'Socialist realism' expressed these three priorities. It was hostile to ultra-proletarian tendencies—RAPP, TRAM, VOPRA were once again brought to heel; it was hostile to Futurism and ultra-urbanism, which could only be disturbing; it was hostile to cosmopolitanism, which might conflict with the nationalism on which the new worker-peasant alliance was to be ideologically based; and it was hostile to experimental forms which would only exasperate both the proletariat and the peasantry, as indeed they had exasperated Lunacharsky. (Lunacharsky remarked about the Tatlin tower that 'I believe it would be a matter of great exasperation, not only to myself, if Moscow or Petersburg were to be adorned with such a product...' and this was in 1922.) In effect, 'socialist realism' boiled down to a party line, party and national sentiment in content and academicism, bordering on kitsch, in form. It was institutionally guaranteed by turning

renegade 'proletarian' artists and critics into party officials with the job of enforcing it. Functionalism and technicism made up an element of 'socialist realism', but stripped of the militant Futurism, formal experimentalism and cosmopolitanism that had historically accompanied their growth. Now artists really were going to become engineers and propagandists serving the party and industry.

I think it is idle to imagine that things could have turned out very differently if the artists had acted differently. The problems of the artists far transcended their ability to determine events. Nevertheless, I believe that there are some things that need to be said. As the twenties progressed the arrogant tone proper to avant-garde manifestos became increasingly out of place. Consider, for example, the comments of the opening editorial of *LEF* on prolet-art: 'the third and best part, leaving behind the rose-coloured Belys, is re-learning with our things as guides and, we believe, will go further with us'. It is obvious that this tone was not going to make it easy for avant-garde artists to find friends among the masses. In fact, the only time there was real collaboration between the avant-garde and the masses was during the early years of agit-prop, street art and mass fêtes and festivals. This period was one in which Futurist ideas were modified and changed by contact with the *Proletcult* and vice versa. After the beginning of the NEP, the main strongholds of the avant-garde, VKHUTEMAS and *LEF* were, in effect, cultural ghettoes. (Malevich, of course, cut himself off deliberately.) Perhaps things might have been different if Rosanova, who was in charge of industrial and applied art for NARKOMPROS, had not died in 1918. Already, in the year since the revolution, she had travelled throughout the country visiting schools, trying to break down the metropolitanism of her fellow artists.

The real problem was that expressed by Lissitzky, to find a way in which Constructivism could intervene, not simply in the production process but in everyday life as well and, for this to happen, there must be some recognition of the psychic and semiotic dimension of art. Unfortunately Lissitzky himself was out of Russia during most of the twenties and, though he acted as a catalyst for the European avant-garde in general, he did not have

much effect in Russia itself. Indeed, his cosmopolitanism only made him suspect. (There is a photograph of Melnikov, the most talented of the ASNOVA Formalist-Constructivist architects, standing outside his own house, the living image of a NEP-man, with folded handkerchief and spats!—like the caricature villains in Kuleshov's *Mr West in the Land of the Bolsheviks*.) There was no tendency in the visual arts akin to the OPOIAZ group in literary studies, analysing the formal and semantic qualities of poetry. Kandinsky had tried to introduce, along with Vygotsky, a programme of studies along these lines while he was in the INKHUK, but it came to nothing because of the prevailing anti-psychologism. It would be valuable to know more about the VKHUTEMAS introductory course, which seems to have been broadly similar to that of the Bauhaus, but the exhibition of the OBMOKHU, the group of younger, radical VKHUTEMAS students, which included the Stenberg brothers, suggests that the main point of interest, for the most talented students at least, lay in the engineering problems of cantilevering, tensile strength and so on. Eisenstein was another who was interested in the psychology and semiotics of art, but he was never able to synthesize his provocative mélange of Freudianism, Pavlovian behaviouristic psychology, idiosyncratic linguistics and a heavily Hegelianized version of Marxism.

Thus very few of the avant-garde artists of the time were at all equipped even to begin to wonder what the *ideological* role of art was. For the most part this was the concern of the proletarian artists, who adopted very simple schematic criteria for abstracting political messages from works of art and tried to pinpoint the class position of the artist, on the assumption that class ideology could be inferred from this mechanically. The net result of this inability to think through the ideological role of art was to open the way for the kind of hyper-political de-politicization which I have described above. Where artists were unwilling to sacrifice the concept of art completely, the result was a peculiar, striking and ultimately tragic new grotesque. Consider, for instance, Tatlin's tower, his production of Khlebnikov's *Zangezi* and his Letatlin air-bicycle, designed on the assumption that the masses would need air-bicycles. Yet this grotesque, far from being simply unsatisfactory, as Trotsky found it, is to my mind sublime. It expressed more

than anything else the quest for the marvellous and the utopian in contradiction with the exigencies of the practical and the utilitarian. In this respect, it is like Mayakovsky's last poem, the unfinished prologue to the second part of a poem on the First Five Year Plan:

'Shameful common-sense—I hope, I swear—
Will never come to me.'

Malevich's funeral took place in December 1934, according to the instructions he had given his pupil, Suetin. He was laid in state in a white coffin, with a black square above a green circle. Above his head hung his picture of the black square. A memorial pillar in his late architectonic style stood at the foot of the coffin. A poem was read. The coffin, with its guard of honour, was driven to the railway station on an open truck with a black square on the radiator. Over his grave was placed a square of cement on which was painted a red square. *Proletcult* was dead. The peasant-singers were dead. *LEF* was dead. Now Malevich was dead. One day all the white coffins will re-open and the phantoms will emerge to resume combat.

# Godard and Counter Cinema: *Vent d'Est*

More and more radically Godard has developed a counter-cinema whose values are counterposed to those of orthodox cinema. I w⌐nt simply to write some notes about the main features of this counter-cinema. My approach is to take seven of the values of the old cinema, Hollywood-Mosfilm, as Godard would put it, and contrast these with their (revolutionary, materialist) counterparts and contraries. In a sense, the seven deadly sins of the cinema against the seven cardinal virtues. They can be set out schematically in a table as follows:

| | |
|---|---|
| Narrative transitivity | Narrative intransitivity |
| Identification | Estrangement |
| Transparency | Foregrounding |
| Single diegesis | Multiple diegesis |
| Closure | Aperture |
| Pleasure | Un-pleasure |
| Fiction | Reality |

Obviously, these somewhat cryptic headings need further commentary. First, however, I should say that my overall argument is that Godard was right to break with Hollywood cinema and to set up his counter-cinema and, for this alone, he is the most important director working today. Nevertheless, I think there are various confusions in his strategy, which blunt its edges and even, at times, tend to nullify it—mainly, these concern his confusion over the series of terms: fiction/mystification/ideology/lies/deception/illusion/representation. At the end of these notes, I shall touch on some of my disagreements. First, some remarks on the main topics.

1. Narrative transitivity v. narrative intransitivity. (One thing following another v. gaps and interruptions, episodic construction, undigested digression).

By narrative transitivity, I mean a sequence of events in which each unit (each function that changes the course of the narrative) follows the one preceding it according to a chain of causation. In the Hollywood cinema, this chain is usually psychological and is made up, roughly speaking, of a series of coherent motivations. The beginning of the film starts with establishment, which sets up the basic dramatic situation—usually an equilibrium, which is then disturbed. A kind of chain reaction then follows, until at the end a new equilibrium is restored.

Godard began to break with this tradition very early. He did this, at first, in two ways, both drawn from literature. He borrowed the idea of separate chapters, which enabled him to introduce interruptions into the narrative, and he borrowed from the picaresque novel. The picaresque is a pseudo-autobiographical form which for tight plot construction, substitutes a random and unconnected series of incidents, supposed to represent the variety and ups-and-downs of real life. (The hero is typically marginal to society, a rogue-errant, often an orphan, in any case without family ties, thrown hither and thither by the twists and turns of fortune).

By the time he arrives at *Vent d'Est*, Godard has practically destroyed all narrative transitivity. Digressions which, in earlier films, represented interruptions to the narrative, have hypertrophied until they dominate the film entirely. The basic story, as much of it as remains, does not have any recognizable sequence, but is more like a series of intermittent flashes. Sometimes it seems to be following a definite order in time, but sometimes not. The constructive principle of the film is rhetorical, rather than narrative, in the sense that it sets out the disposition of an argument, point by point, in a sequence of 1-7, which is then repeated, with a subsidiary sequence of Theory A and B. There are also various figures of amplification and digression within this structure.

There are a number of reasons why Godard has broken with narrative transitivity. Perhaps the most important is that he can

disrupt the emotional spell of the narrative and thus force the spectator, by interrupting the narrative flow, to re-concentrate and re-focus his attention. (Of course, his attention may get lost altogether.) Godard's cinema, broadly speaking, is within the modern tradition established by Brecht and Artaud, in their different ways, suspicious of the power of the arts—and the cinema, above all—to 'capture' its audience without apparently making it think, or changing it.

2. Identification v. estrangement. (Empathy, emotional involvement with a character v. direct address, multiple and divided characters, commentary.)

Identification is a well-known mechanism though, of course, in the cinema there are various special features which mark cinematic identification off as a distinct phenomenon. In the first place, there is the possibility of double identification with the star and/or with the character. Second, the identification can only take place in a situation of suspended belief. Third, there are spatial and temporal limits either to the identification or, at any rate, to the presence of the imago. (In some respects, cinematic identification is similar to transference in analysis, though this analogy should not be taken too far.)

Again, the breakdown of identification begins early in Godard's films and then develops unevenly after that, until it reaches a new level with *Le Gai Savoir*. Early devices include non-matching of voice to character, introduction of 'real people' into the fiction, characters addressing the audience directly. All these devices are also used in *Vent d'Est*, which takes especially far the device of allowing voices to float off from characters into a discourse of their own on the soundtrack, using the same voice for different characters, different voices for the same character. It also introduces the 'real life' company into the film itself and, in a rather complicated figure, introduces Gian-Maria Volonte, not simply as an actor (Godard shows the actors being made-up) but also as intervening in the process of 'image-building'. As well as this, there is a long and extremely effective direct address sequence in which the audience is described—somewhat pejoratively—from the screen and invited into the world of representation.

It is hardly necessary, after the work of Brecht, to comment on the purpose of estrangement-effects of this kind. Clearly, too, they are closely related to the break-up of narrative transitivity. It is impossible to maintain 'motivational' coherence, when characters themselves are incoherent, fissured, interrupted, multiple and self-critical. Similarly, the ruse of direct address breaks not only the fantasy identification but also the narrative surface. It raises directly the question, 'What is this film for?', superimposed on the orthodox narrative questions, 'Why did that happen?' and 'What is going to happen next?'. Any form of cinema which aims to establish a dynamic relationship between film maker and spectator naturally has to consider the problem of what is technically the register of discourse, the content of the enunciation, as well as its designation, the content of the enunciate.

3. Transparency v. foregrounding. ('Language wants to be overlooked'—Siertsema v. making the mechanics of the film/text visible and explicit.)

Traditional cinema is in the direct line of descent from the Renaissance discovery of perspective and reformulation of the art of painting, expressed most clearly by Alberti, as providing a window on the world. The camera, of course, is simply the technological means towards achieving a perfect perspective construction. After the Renaissance the painting ceased to be a text which could be 'read', as the iconographic imagery and ideographic space of pre-Renaissance painting were gradually rejected and replaced by the concept of pure representation. The 'language' of painting became simply the instrument by which representation of the world was achieved. A similar tendency can be seen at work with attitudes to verbal language. From the seventeenth century onwards, language was increasingly seen as an instrument which should efface itself in the performance of its task—the conveyance of meaning. Meaning, in its turn, was regarded as representation of the world.

In his early films Godard introduced the cinema as a topic in his narrative—the 'Lumière' sequence in *Les Carabiniers*, the film within a film in *Le Mépris*. But it was not until his contribution to *Loin Du Vietnam* that the decisive step was taken, when he simply

showed the camera on screen. In the post-1968 films the process of production is systematically high-lighted. In *Vent d'Est* this shows itself not simply in taking the camera behind the scenes, as it were, but also in altering the actual film itself: thus the whole worker's control sequence is shown with the film marked and scratched, the first time that this has happened in Godard's work. In previous films, he had not gone further than using special film stock (*Les Carabiniers*) or printing sequences in negative (*Les Carabiniers, Alphaville*).

At first sight, it looks as if the decision to scratch the surface of the film brings Godard into line with other avant-garde film makers, in the American 'underground' especially. However this is not really the case. In the case of the American film makers marking the film is best seen alongside developments in painting that have dominated, particularly in the USA, in recent years. Broadly speaking, this involves a reduction of film to its 'optical' substrate. Noise is amplified until, instead of being marginal to the film, it becomes its principal content. It may then be structured according to some calculus or algorithm, or submitted to random coding. Just as, in painting, the canvas is foregrounded, so in cinema, the film is foregrounded.

Godard, however, is not interested in this kind of 'de-signification' of the image by foregrounding 'noise' and then introducing a new constructive principle appropriate to this. What he seems to be doing is looking for a way of expressing negation. It is well-known that negation is the founding principle of verbal language, which marks it off both from animal signal-systems and from other kinds of human discourse, such as images. However, once the decision is made to consider a film as a process of writing in images, rather than a representation of the world, then it becomes possible to conceive of scratching the film as an erasure, a virtual negation. Evidently the use of marks as erasures, crossing-out an image, is quite different from using them as deliberate noise or to foreground the optical substrate. It pre-supposes a different concept of 'film-writing' and 'film-reading'.

Some years ago, Astruc, in a famous article, wrote about le caméra-stylo. His concept of writing—écriture—was closer to the idea of style. Godard, like Eisenstein before him is more

concerned with 'image-building' as a kind of picto-graphy, in which images are liberated from their role as elements of representation and given a semantic function within a genuine iconic code, something like the baroque code of emblems. The sequences in which the image of Stalin is discussed, are not simply—or even principally—about Stalin's politics, as much as they are about the problem of finding an image to signify 'repression'. In fact, the whole project of writing in images must involve a high degree of foregrounding, because the construction of an adequate code can only take place if it is glossed and commented upon in the process of construction. Otherwise, it would remain a purely private language.

4. Single diegesis v. multiple diegesis (A unitary homogeneous world v. heterogeneous worlds. Rupture between different codes and different channels.)

In Hollywood films, everything shown belongs to the same world and complex articulations within that world—such as flashbacks—are carefully signalled and located. The dominant aesthetic is a kind of liberalized classicism. The rigid constraints of the dramatic unities have been relaxed, but mainly because they were over-strict and limiting, whereas the basic principle remains unshaken. The world represented on the cinema must be coherent and integrated, though it need not observe compulsory, statutory constraints. Time and space must follow a consistent order. Traditionally, only one form of multiple diegesis is allowed—the play within a play—whereby the second, discontinuous diegetic space is embedded or bracketed within the first. (It should be added that there are some exemplary cases of transgression of single diegesis within literature, such as Hoffmann's *Life of Tomcat Murr*, which consists of Tomcat Murr's life—the primary diegesis—interleaved at random with pages from another text—the life of Kreisler—supposedly bound into the book by mistake by the bookbinder. The pages from the secondary diegesis begin and end in the middle of sentences and are in the wrong order, with some missing. A novel like Sterne's *Tristram Shandy*, however, simply embeds a number of different diegeses on the play-within-a-play model. (Of course, by recursion this principle

can be taken to breaking-point, as Borges has often pointed out.)

Godard uses film-within-a-film devices in a number of his early works. At the same time the primary diegesis begins to develop acute fissures and stresses. In *Le Mepris*, for example, there is not only a film-within-a-film, but many of the principal characters speak different languages and can only communicate with each other through an interpreter (an effect entirely lost in some dubbed versions, which have to give the interpreter meaningless remarks to speak). The first radical break with single diegesis, however, comes with *Weekend*, when characters from different epochs and from fiction are interpolated into the main narrative: Saint-Just, Balsamo, Emily Bronte. Instead of a single narrative world, there is an interlocking and interweaving of a plurality of worlds.

At the same time that Godard breaks down the structure of the single diegesis, he also attacks the structure of the single, unitary code that expressed it. Not only do different characters speak different languages, but different parts of the film do too. Most strikingly, there is a rupture between soundtrack and images: indeed, the elaboration of this rupture dominates both *Le Gai Savoir* and *Pravda*. The text becomes a composite structure, like that of a medieval macaronic poem, using different codes and semantic systems. Moreover, these are not simply different, but also often contradictory. *Vent d'Est*, for instance, presents alternative ways of making a film (the Glauber Rocha sequence) only to reject them. It is one of the assumptions of contemporary linguistics that a language has a single, unitary semantic component, just as it has a single syntax. In fact, this is surely not the case. The semantic component of a language is composite and contradictory, permitting understanding on one level, misunderstanding on another. Godard systematically explores the areas of misunderstanding.

5. Closure v. aperture. (A self-contained object, harmonized within its own bounds v. open-endedness, overspill, intertextuality—allusion, quotation and parody.)

It has often been pointed out that in recent years, the cinema has become 'self-conscious', in contrast to the 'innocent' days of

Hollywood. In itself, however, 'self-consciousness' is quite compatible with closure. There is a use of quotation and allusion that simply operates to provide a kind of 'surplus' of meaning, as the scholastics used to say, a bonus for those who catch the allusion. The notorious 'Tell me lies' sequence in *Le Petit Soldat*, borrowed from *Johnny Guitar*, is of this kind: it does not make much difference whether you recognise it or not and, even if you do, it has no effect on the meaning of the sequence. Or else quotation can be simply a sign of eclecticism, primarily a stylistic rather than semantic feature. Or, as with Makavejev's use of quotation, the objective may be to impose a new meaning on material by inserting it into a new context: a form of irony.

Godard, however, uses quotation in a much more radical manner. Indeed, his fondness for quotation has always been one of the distinguishing characteristics of his films. At the beginning of his career, Godard used to give instructions to the cameraman almost entirely in terms of shots from previous films and, at a more explicit level, there are endless direct quotes, both from films and from painting and literature. Whole films contain obvious elements of pastiche and parody: *Une Femme est une Femme* is obviously derivative from the Hollywood musical, *Les Carabiniers* from Rossellini, *Le Mépris* is 'Hawks and Hitchcock shot in the manner of Antonioni' . . . it would be possible to go on endlessly.

However, as Godard's work developed these quotations and allusions, instead of being a mark of eclecticism, began to take on an autonomy of their own, as structural and significant features within the films. It becomes more and more impossible to understand whole sequences and even whole films without a degree of familiarity with the quotations and allusions which structure them. What seemed at first to be a kind of jackdaw mentality, a personality trait of Godard himself, begins to harden into a genuine polyphony, in which Godard's own voice is drowned out and obliterated behind that of the authors quoted. The film can no longer be seen as a discourse with a single subject, the film maker/auteur. Just as there are multiplicity of narrative worlds, so too there are a multiplicity of speaking voices.

Again, this takes us back to the period before the rise of the

novel, the representational painting, to the epoch of the battle of the books, the logomachia. Perhaps the author who comes most to mind is Rabelais, with his endless counter-position of quotations, his parodies, his citation of authorities. The text/film can only be understood as an arena, a meeting-place in which different discourses encounter each other and struggle for supremacy. Moreover these discourses take on an independent life of their own. Instead of each being corked up in its bottle with its author's name on it as a label, the discourses escape, like genies, are let out to intermingle and quarrel.

In this sense, Godard is like Ezra Pound or James Joyce who, in the same way, no longer insist on speaking to us in their own words, but can be seen more as ventriloquist's dummies, through whom are speaking—or rather being written—palimpsests, multiple *niederschriften* (Freud's word) in which meaning can no longer be said to express the intention of the author or to be a representation of the world, but must like the discourse of the unconscious be understood by a different kind of decipherment. In orthodox logic and linguistics, context is only important as an arbiter between alternative meanings (amphibologies, as they are called in logic). In Godard's films, the opposite process is at work: the juxtaposition and re-contextualization of discourses, leads not to a separating-out of meanings, but to a confrontation.

6. Pleasure v. unpleasure. (Entertainment, aiming to satisfy the spectator v. provocation, aiming to dissatisfy and hence change the spectator.)

The attack on 'entertainment' cinema is part of a broader attack on the whole of 'consumer society'. Cinema is conceived of as a drug that lulls and mollifies the militancy of the masses, by bribing them with pleasurable dreams, thus distracting them from the stern tasks which are their true destiny. It is hardly necessary to insist on the asceticism and Puritanism—repressiveness—of this conception that unflinchingly seeks to put the reality-principle in command over the pleasure-principle. It is true that the short-term (cinematic) dream is sometimes denounced in the name of a long-term (millenarian) dream and short-term (false, illusory, deceptive) satisfactions contrasted with long-term (real, genuine,

authentic) satisfactions, but this is exactly the kind of argument which is used to explain the accumulation of capital in a capitalist society by the saving principle and postponement of consumption.

Brecht was careful never to turn his back on entertainment and, indeed, he even quotes Horace in favour of pleasure as the purpose of the arts, combined, of course, with instruction. This is not to say that a revolutionary cinema should distract its spectators from realities, but that unless a revolution is desired (which means nothing less than coinciding with and embodying collective fantasies) it will never take place. The reality-principle only works together with the pleasure-principle when survival itself is at stake, and though this may evidently be the case in a revolutionary situation, it is not so in the advanced capitalist countries today. In a situation in which survival is—at least relatively—non-problematic, the pleasure-principle and the reality-principle are antagonistic and, since the reality-principle is fundamentally adaptive, it is from the pleasure-principle that change must stem. This means that desire, and its representation in fantasy, far from being necessary enemies of revolutionary politics—and its cinematic auxiliary—are necessary conditions.

The problem, of course, concerns the nature of the fantasies on the one hand, and the way in which they are presented in the text/film on the other hand, the way in which fantasy scenarios are related to ideologies and beliefs and to scientific analysis. A revolutionary cinema has to operate at different levels—fantasy, ideology, science—and the articulation of these levels, which involve different modes of discourse and different positions of the subject, is a complicated matter.

In *Vent d'Est* the 'struggle against the bourgeois notion of representation' certainly does not rule out the presence of fantasy: fantasy of shooting the union delegate, fantasies of killing shoppers in a supermarket. Indeed, as long as there are images at all, it is impossible to eliminate fantasy. But the fantasies are almost entirely sado-masochistic in content, and this same fantasy content also seems to govern the relationship between film maker and spectator, rather on the lines of the relationship between the flute-player in the film and his audience. A great many of the

devices Godard uses are designed to produce a collective working relationship between film maker and audience, in which the spectator can collaborate in the production/consumption of meaning. But Godard's view of collective work is conceived of in very imprecise terms. 'Criticism' consists of insults and interrogation. The fantasy content of the film is not articulated correctly with the ideology or political theory. This, in turn, seems to spring from a suspicion of the need for fantasy at all, except perhaps in the sado-masochistic form of provocation.

7. Fiction v. reality. (Actors wearing make-up, acting a story v. real life, the breakdown of representation, truth.)

Godard's dissatisfaction with fiction cinema begins very early. Already in *Vivre Sa Vie* non-fiction is introduced—the chapter on the economics and sociology of prostitution. There is almost no costume drama in Godard's career, until—ironically enough— *Vent d'Est*. Even within the framework of fiction, he has stuck to contemporary life. His science-fiction films (*Alphaville, Anticipation*) have all been set in a kind of future-in-the-present, without any paraphernalia of special effects or sets.

As with all the features I have described, the retreat from (and eventually attack on) fiction has proceeded unevenly through Godard's career, coming forward strongly in, for instance, *Deux ou Trois Choses*, then receding again. Especially since May 1968, the attack on fiction has been given a political rationale (fiction = mystification = bourgeois ideology) but, at the beginning, it is much more closely connected with Godard's fascination (Cartesian, rather than Marxist) with the misleading and dissembling nature of appearances, the impossibility of reading an essence from a phenomenal surface, of seeing a soul through and within a body or telling a lie from a truth. At times Godard seems almost to adopt a kind of radical Romanticism, which sees silence (lovers' silence, killers' silence) as the only true communication, when reality and representation, essence and appearance, irreducibly coincide: the moment of truth.

Obviously too, Godard's attitude to fiction is linked with his attitude to acting. This comes out most clearly in *Une Femme Mariée*, when the actor is interrogated about his true self, his

relationship to his roles. Godard is obsessed with the problem of true speech, lying speech and theatrical speech. (In a sense, these three kinds of speech, seen first in purely personal terms, are eventually politicized and given a class content. The bourgeoisie lie, the revisionists lie, though they should speak the truth, the revolutionaries speak the truth, or, rather stammer an approach to the truth.) Godard has long shown a horror of acting, based originally on a 'logo-centric' antipathy to anybody who speaks someone else's words, ironic in the circumstances. Eventually, Godard seems to have reformulated his attitude so that actors are distrusted for speaking other people's words, as if they were their own. This accompanies his growing recognition that nobody ever speaks in their own words, hence the impossibility of genuine dialogue and the reduction of dialogue to reciprocal—or often unilateral—interviewing. In *Vent d'Est* there is almost no dialogue at all (only a number of variants of monologue) and this must relate to the caricature of collective work Godard puts forward.

Interviewing is, of course, the purest form of linguistic demand, and the demand Godard makes is for the truth. Yet it never seems to be forthcoming, not surprisingly, since it cannot be produced on demand. It is as if Godard has a lingering hope that if people could find their own words, they might produce it miraculously in our presence, but if not, then it has to be looked for in books, which are the residues of real words. This kind of problematic has been tormenting Godard throughout his cinematic career. In *A Bout de Souffle*, for instance, there is the central contrast between Michel Poiccard/Laszlo Kovacs—an honest impostor—and Patricia, whose mania for honesty reveals her in the end as a deceiver.

The early films tend to explore this kind of problem as one between different levels, but in the post-1968 films, there seems to have been a kind of flattening out, so that fiction = acting = lying = deception = representation = illusion = mystification = ideology. In fact, as anybody reflecting on Godard's earlier films must surely know, these are all very different categories. Ideology, for instance, does not depend primarily on lies. It depends on the acceptance of common values and interests. Similarly mystification is different from deception: a priest does not deceive his

congregation about the miracle of the mass, in the same way that a conjurer deceives his audience, by hiding something from them. Again, the cinema is a form of representation, but this is not the same as illusion or 'trompe l'oeil'. It is only possible to obliterate these distinctions by defining each of them simply in terms of their departure from truth.

The cinema cannot show the truth, or reveal it, because the truth is not out there in the real world, waiting to be photographed. What the cinema can do is produce meanings and meanings can only be plotted, not in relation to some abstract yardstick or criterion of truth, but in relation to other meanings. This is why Godard's objective of producing a counter-cinema is the right objective. But he is mistaken if he thinks that such a counter-cinema can have an absolute existence. It can only exist in relation to the rest of the cinema. Its function is to struggle against the fantasies, ideologies and aesthetic devices of one cinema with its own antagonistic fantasies, ideologies and aesthetic devices. In some respects this may bring it closer—or seem to bring it closer—to the cinema it opposes than *Vent d'Est* would suggest. *Vent d'Est* is a pioneering film, an avant-garde film, an extremely important film. It is the starting-point for work on a revolutionary cinema. But it is not that revolutionary cinema itself.

# The Two Avant-Gardes

Film history has developed unevenly, so that in Europe today there are two distinct avant-gardes. The first can be identified loosely with the Co-op movement. The second would include film-makers such as Godard, Straub and Huillet, Hanoun, Jancso. Naturally there are points of contact between these two groups and common characteristics, but they also differ quite sharply in many respects: aesthetic assumptions, institutional framework, type of financial support, type of critical backing, historical and cultural origin. There are other film-makers too who do not fit neatly into either camp, and films which fall somewhere in between or simply somewhere else—Jackie Raynal's *Deux Fois*, for instance—but in general the distinction holds good.

At the extreme, each would tend to deny the others the status of avant-garde at all. Books like Steve Dwoskin's *Film Is* or David Curtis's *Experimental Film*[1] do not discuss the crucial post-1968 work of Godard and Gorin, for example. And supporters of Godard—and Godard himself—have often denounced the 'Co-op avant-garde' as hopelessly involved with the established bourgeois art world and its values. The reasons for dismissal are often quite beside the point and misplaced. By no means all the directors (to use a word taboo in the other camp) in one group work with narrative in 35mm, as you might sometimes imagine—Godard has worked in 16mm for years and recently with video (to open up another hornet's nest). Conversely, many Co-op film-makers are well aware of political issues and see themselves in some sense as militant. (Not that political militancy in itself is any guarantee of being avant-garde.)

The position is complicated too by the fact that in North America there is only one avant-garde, centred on the various Co-ops. There are no obvious equivalents of Godard or Straub-Huillet, although their influence can occasionally be seen—in Jon Jost's *Speaking Directly* for example. Moreover, American critics and theorists of the avant-garde have long tended to overlook their European counterparts or see them as derivative. The Europeans —and perhaps particularly the English—then tend to react by stressing their own credentials, making claims to have occupied the same ground as the Americans earlier or independently. From outside, the quarrel often looks of secondary importance. After all, no-one denies that the capital of narrative fiction 35mm film-making is Hollywood, however innovative European directors, such as Antonioni or Fellini or Truffaut may be. In the same way, New York is clearly the capital of the Co-op movement. Consequently, from New York, Godard looks much more distinctively European than Kren or Le Grice, a fact which simply reflects the realities of power in the art world, to which the Co-op movement is closely tied. Indeed, there is a sense in which avant-garde Co-op film-making in Europe is closer to New York than Californian film-making is, and the leading New York critics and tastemakers —Sitney, Michelson—are not appreciated in San Francisco any more than they are in London.

It seems to me much more important to try and understand what unites and separates Godard and Straub-Huillet on the one hand, and, say, Gidal and Wyborny on the other hand, than what unites and separates Europe and North America within the Co-op ambit. Moreover, I think the absence of any avant-garde of the Godard type in North America could ultimately prove a severe limitation on the development of the New American Cinema itself, narrowing its horizons and tying it unnecessarily closely to the future of the other visual arts, condemning it to a secondary status within the art world. Close relationship with 'art'—painting, post-painting—is both a strength and a weakness.

To understand further the split which has developed within the avant-garde it is necessary to go back into history. A similar split can be seen in the twenties. On the one hand films were being made by Léger-Murphy, Picabia-Clair, Eggeling, Richter, Man

Ray, Moholy-Nagy and others—many of them discussed in Standish Lawder's recent book on *The Cubist Cinema*[2]—that were attempts to extend the scope of painting, to move outside the confines of the canvas, to introduce the dimension of time, to use light directly as well as colour, and so on. On the other hand, there were the Russian directors, whose films were clearly avant-garde but in a different sense: Eisenstein's *Strike*, Dovzhenko's *Zvenigora*, Vertov's *Man with the Movie Camera*. It was only at the very end of the decade that there was any real contact between the two groups — when Lissitizky (whose ideas about the electro-mechanical spectacle and admiration for Eggeling put him clearly in the 'painters' group) first met Vertov to discuss the Stuttgart *Film und Foto* exhibition,[3] and when Eisenstein met Richter on his first trip out of the Soviet Union and went with him to the conference at Le Sarraz, which turned out to mark the end rather than the beginning of an epoch.

As today, part of the difference lies in the backgrounds of the people involved. One group came from painting. The other from theatre (Eisenstein), and futurist sound-poetry (Vertov)—Dovzhenko, in fact, had trained as a painter but deliberately gave it up, leaving all his painting materials behind him in Kharkov when he set off for Odessa and the film studios, seeking a complete break with his past. And, of course, there are premonitory links between these different currents of the twenties and those of recent years— Godard and Gorin carried out their collaboration under the name of the Dziga Vertov group; Van Doesburg, in 1929, already anticipated many of the ideas of 'expanded cinema', realized decades later: 'The spectator space will become part of the film space. The separation of "projection surface" is abolished. The spectator will no longer observe the film, like a theatrical presentation, but will participate in it optically and acoustically.'[4]

Painting, I think it can be argued, played the leading role in the development of modernism in the other arts. The break, the *coupure*—to use the Althusserian terminology—the shift of terrain that marked the substitution of one paradigm or problematic for another, the beginning of modernism, the work of the historic avant-garde, was a break that took place in painting pre-eminently, with the discoveries of Cubism. It is not hard to show how

painting affected the other arts, how early Cubism had a decisive impact on Gertrude Stein and Ezra Pound, for example, in literature, and later on William Carlos Williams, Apollinaire, Marinetti, Mayakovsky, Khlebnikov—all were influenced at a crucial point by their encounter with Cubism. The innovations of Picasso, and Braque, were seen as having an implication beyond the history of painting itself. They were intuitively felt, I think, very early on, to represent a critical semiotic shift, a changed concept and practice of sign and signification, which we can now see to have been the opening-up of a space, a disjunction between signifier and signified and a change of emphasis from the problem of signified and reference, the classic problem of realism, to that of signifier and signified within the sign itself.[5]

When we look at the development of painting after the Cubist breakthrough, however, we see a constant trend towards an apparently even more radical development: the suppression of the signified altogether, an art of pure signifiers detached from meaning as much as from reference, from *Sinn* as much as from *Bedeutung*. This tendency towards abstraction could be justified in various ways—a transcendental signified could be postulated, in symbolist or spiritualist terms, a meaning located in the *Uberwelt* of pure ideas; a theory of formalism, of art as pure design, could be proposed; the work of art could be defended in terms of objecthood, pure presence; it could be explained as a solution to a problem, often set by the relationship between a signifier—a form of expression, in Hjelmslev's phrase—and its physical, material support (the matter or substance of expression).[6]

Literature, on the other hand, tended to fall back into forms of writing in which the signified clearly remained dominant. Modernism could be interpreted in terms of the expansion of subject-matter, new narrative techniques (stream of consciousness) or play on the paradoxes of meaning and reference (Pirandellism). It is significant, for instance, that so many of the most radical experiments, such as attempts at sound poetry, were the work of artists or writers working closely with painters: Arp, Schwitters, Van Doesburg among them. In theatre the most radical developments were invariably associated with changes in set design and costume, including the use of masks: Meyerhold's

Constructivist theatre in the Soviet Union, Schlemmer's Bauhaus theatre, Artaud. In this context, it should be added, Brecht appears as little more than a moderate.

Cinema is, of course, a form of art employing more than one channel, more than one sensory medium, and uses a multiplicity of different types of code. It has affinities with almost all the other arts. Music and verbal language, as well as natural or artificial noise, can form elements of the sound-track. Theatre and dance can be elements of the pro-filmic event, placed in front of the camera to be photographed. Editing can be used to develop narrative or to produce a 'visual rhythm' by analogy with music. Film itself can be painted or paintings can be animated. Light can be used as a medium, and through projection a third dimension can be introduced, to produce a kind of mobile light sculpture. Cinema too has its own 'specifically cinematic'[7] codes and materials, associated with the various phases of film production.

As a result of this variety and multiplicity, ideas have fed into film-making from a variety of sources in the other arts. One powerful influence has come from painting, bringing with it a tendency to abstraction—pure light or colour; and non-figurative design—or deformation of conventional photographic imagery, involving prismatic fragmentation and splintering, the use of filters or stippled glass, mirror-shots, extreme and microscopic close-ups, bizarre angles, negative images, all of which are to be found in twenties films. Editing tended to follow principles of association (related to poetry or dream) or analogies with music—shots of fixed length, repetition and variation, attempts at synesthetic effects, theories of counterpoint.

But this influence, and the films associated with it, are marked as much by what they excluded as what they included. Primarily of course verbal language was missing and also narrative. During the silent period, the absence of language was not foregrounded; it seemed a natural quality of film, but in retrospect its significance can be seen. Language is still excluded from an enormous number of avant-garde films, which are shown either silent or with electronic or other musical tracks. Again, there are real technical and financial reasons for this, but these practical disincentives coincide with an aesthetic itself founded on concepts of visual form

and visual problems that exclude verbal language from their field, and may be actively hostile to it. This is part of the legacy of the Renaissance that has survived the modernist break almost unchallenged, except in isolated instances—Lissitzky, Duchamp, Picabia and, extremely important, recent conceptualist work.

There is one further important point that must be made about the development of film in relation to art history. Film-makers at a certain point became dissatisfied with the search simply for 'kinetic solutions to pictorial problems',[8] as in the films of Man Ray and Moholy-Nagy, and began to concentrate on what they saw as specifically cinematic problems. Structural film-making over the last decade has thus represented a displacement of concerns from the art world to the film world rather than an extension. This way of thinking about art has remained one that film-makers have in common with painters and other visual artists, but an effort has been made to insist on the ontological autonomy of film. Thus, for instance, Gidal's work has foregrounded and been in a sense 'about' focus; Le Grice's work has foregrounded and been in a sense 'about' printing or projection. The tendency of painting to concentrate on its own sphere of materials and signification, to be self-reflexive, has been translated into specifically cinematic terms and concerns, though here again 'specifically cinematic' is taken to mean primarily the picture-track.

Thus the impact of avant-garde ideas from the world of visual arts has ended up pushing film-makers into a position of extreme 'purism' or 'essentialism'. Ironically, anti-illusionist, anti-realist film has ended up sharing many preoccupations in common with its worst enemies. A theorist like André Bazin, for instance, committed to realism and representationalism, based his commitment on an argument about cinematic ontology and essence that he saw in the photographic reproduction of the natural world. We now have, so to speak, both an extroverted and an introverted ontology of film, one seeking the soul of cinema in the nature of the pro-filmic event, the other in the nature of the cinematic process, the cone of light or the grain of silver. The frontier reached by this avant-garde has been an ever-narrowing preoccupation with pure film, with film 'about' film, a dissolution of signification into objecthood or tautology.[9] I should add, perhaps,

that this tendency is even more marked in the United States than in Europe.

Where does the other avant-garde stand? Here, as one would expect, the tendency goes in the opposite direction. The Soviet directors of the twenties, though they saw themselves in some sense as avant-garde, were also preoccupied with the problem of realism. For the most part they remained within the bounds of narrative cinema. The most clearly avant-garde passages and episodes in Eisenstein's films (experiments in intellectual montage) remain passages and episodes, which appear as interpolations within an otherwise homogeneous and classical narrative. There is no doubt that the dramaturgy is modernist rather than traditional—the crowd as hero, typage, *guignol*—but these are not features that can be attributed to a break with rather than a renovation of classical theatre. They are modes of achieving a heightened emotional effect or presenting an idea with unexpected vividness or force.

In Eisenstein's work the signified—content in the conventional sense—is always dominant and, of course, he went so far as to dismiss Vertov's *Man with the Movie Camera* as 'formalist jackstraws and unmotivated camera mischief,'[10] contrasting its use of slow motion with Epstein's *La Chute de la Maison Usher*, in which, according to Eisenstein, it is used to heighten emotional pressure, to achieve an effect in terms of a desired content or goal. Vertov's film was, of course, a milestone for the avant-garde and it is a sign of its richness that it can be seen as a precursor both of *cinema-verité* and of structural film, though also, evidently, a sign of its ambiguity, of its uncertainty caught between an ideology of photographic realism and one of formal innovation and experiment.

In broad terms, what we find with the Soviet film-makers is a recognition that a new type of content, a new realm of signifieds, demands formal innovation, on the level of the signifier, for its expression. Thus Eisenstein wanted to translate the dialectical materialism of his world-view from an approach to subject-matter to an approach to form, through a theory of montage that was itself dialectical. The aesthetic was still content-based, it saw

signifiers primarily as means of expression, but at the same time it demanded a radical transformation of those means. It was an aesthetic that had much in common with the avant-garde positions of, say, Léger or Man Ray, but which also kept a distance, a distance of which the fear of formalism is symptomatic. It is as if they felt that once the signifier was freed from bondage to the signified, it was certain to celebrate by doing away with its old master altogether in a fit of irresponsible ultra-leftism and utopianism. As we have seen, this was not so far wrong.

The case of Godard, working forty years or so later, is slightly different. In Godard's post-1968 films we glimpse something of an alternative route between contentism and formalism, a recognition that it is possible to work within the space opened up by the disjunction and dislocation of signifier and signified. Clearly Godard was influenced by Eisenstein's theory of dialectical montage, but he develops it in a much more radical way. In the last resort, for Eisenstein, conflict occurred primarily between the successive signifieds of images. Although he recognizes a form of dialectical montage in the suprematist paintings of Malevich, he himself remains within the confines of 'naturalism.' (Interestingly enough, he identifies a middle road between naturalism and abstraction, which he relates, somewhat surprisingly, to Balla and 'primitive Italian futurism')[11] Godard takes the idea of formal conflict and struggle and translates it into a concept of conflict, not between the content of images, but between different codes and between signifier and signified.

Thus, in *Le Gai Savoir*, which he began shooting before the events of May 1968, but completed after, Godard tries programatically to 'return to zero', to de-compose and then re-compose sounds and images. For Godard, conflict becomes not simply collision through juxtaposition, as in Eisenstein's model, but an act of negativity, a splitting apart of an apparently natural unity, a disjunction. Godard's view of bourgeois communication is one of a discourse gaining its power from its apparent naturalness, the impression of necessity that seems to bind a signifier to a signified, a sound to an image, in order to provide a convincing representation of the world. He wants not simply to represent an alternative 'world' or alternative 'world-view', but to investigate

the whole process of signification out of which a world-view or an ideology is constructed. *Le Gai Savoir* ends with the following words on the soundtrack: 'This film has not wished to, could not wish to explain the cinema or even constitute its object, but more modestly, to offer a few effective means for arriving there. This is not the film that must be made, but it shows how, if one is to make a film, one must necessarily follow some of the paths travelled here.'[12] In other words, the film deliberately suspends 'meaning', avoids any teleology or finality, in the interests of a destruction and re-assembly, a re-combination of the order of the sign as an experiment in the dissolution of old meanings and the generation of new ones from the semiotic process itself.

Put another way, *Le Gai Savoir* is not a film with a meaning, something to say about the world, nor is it a film 'about' film (which, after all, is simply a limited part of the world of interest in itself to film-makers and film-students) but a film about the possibility of meaning itself, of generating new types of meaning. The array of sign-systems at work in the cinema are thus brought into a new kind of relationship with each other and with the world. Nor, of course, is Godard indifferent to what types of new meaning are produced. Although his work is open-ended, it does not offer itself simply for a delirium of interpretation, as though meaning could be read in at will by the spectator. Signifieds are neither fixed, or fixed as far as possible, as they are in conventional cinema, nor are they freed from any constraint, as though the end of a content-dominated art meant the end of any control over content.

In a sense, Godard's work goes back to the original breaking-point at which the modern avant-garde began—neither realist or expressionist, on the one hand, nor abstractionist, on the other. In the same way, the *Demoiselles d'Avignon* is neither realist, expressionist or abstractionist. It dislocates signifier from signified, asserting—as such a dislocation must—the primacy of the first, without in any way dissolving the second. It is not a portrait group or a study of nudes in the representational tradition, but on the other hand, to see it simply as an investigation of painterly or formal problems or possibilities is to forget its original title, *Le Bordel Philosophique*. The same could be said, of course, about *The Large Glass*. The battle between realism/illusion/'literature'

in art, and abstraction/reflexiveness/Greenberg-modernism, is not so simple or all-encompassing as it may sometimes seem.

There are two other topics that should be mentioned here. The first is politics. As I suggested above, it is often too easily asserted that one avant-garde is 'political' and the other is not. Peter Gidal, for example, defends his films on grounds that clearly imply a political position. And the supporters of Godard and Straub-Huillet, by distinguishing their films from those of Karmitz or Pontecorvo, are constantly forced to assert that being 'political' is not in itself enough, that there must be a break with bourgeois norms of diegesis, subversion and deconstruction of codes—a line of argument which, unless it is thought through carefully or stopped arbitrarily at some safe point, leads inevitably straight into the positions of the other avant-garde. Nonetheless, in discussing Godard, the fact that his films deal explicitly with political issues and ideas is obviously important. He does not wish to cut himself off from the political Marxist culture in which he has steeped himself from before 1968 and increasingly since. This culture, moreover, is one of books and verbal language. The important point, though, is that a film like *Le Gai Savoir*—unlike some later work of Godard, as he fell under Brecht's influence— is not simply didactic or expository, but presents the language of Marxism itself, a deliberately chosen language, as itself problematic.

Politics—the influence and presence of Marxist writing—has been an obvious force of impetus and strength for Godard, but it also relates to another question—that of audience. On the whole, the Co-op avant-garde, happy though it would no doubt be to find a mass audience, is reconciled to its minority status. The consciously political film-maker, on the other hand, is often uneasy about this. The representatives of Marxist culture are on the whole aesthetically conservative and avant-gardism is damned as élitism. Godard, as is well-known, defended himself against this charge by citing Mao's dictum about the three types of struggle and placing his own work in film under the banner of scientific experiment, rather than class struggle, an instance in which theoretical work could be justified and take precedence over political work, in the short term at least. Yet it is also clear that it was

pressure to rediscover a mass, popular audience which led to the artistic regroupment of *Tout Va Bien*, which abandons avant-gardism for a stylized didacticism, set within a classical realist frame, though with some Eisensteinian interpolations.

The second topic is that of 'intertextuality', to use Julia Kristeva's terminology.[13] One of the main characteristics of modernism, once the priority of immediate reference to the real world had been disputed, was the play of allusion within and between texts. Quotation, for instance, plays a crucial role in the *Demoiselles d'Avignon* and, indeed, in *The Large Glass*. In avant-garde writing it is only necessary to think of Pound and Joyce. Again, the effect is to break up the homogeneity of the work, to open up spaces between different texts and types of discourses. Godard has used the same strategy, not only on the sound-track where whole passages from books are recited, but also on the picture-track, as in the quotations from Hollywood western and the *cinema novo* in *Vent d'Est*. Similarly, the films of Straub-Huillet are almost all 'layered' like a palimpsest—in this case, the space between texts is not only semantic but historical too, the different textual strata being the residues of different epochs and cultures.

It is significant perhaps that the latest films of Malcolm Le Grice have a similar quality of intertextuality in their quotation of Lumière and *Le Déjeuner sur l'Herbe*. The Lumière film is especi-ally interesting—in comparison with, for example, Bill Brand's re-make of Lumière's destruction-of-a-wall film.[14] It is not simply a series of optical re-combinations, like cinematic anagrams, but an investigation into narration itself, which by counterposing differ-ent narrative tones, so to speak, neither dissolves nor repeats Lumière's simple story, *L'Arroseur Arroseé*, but foregrounds the process of narration itself. And this, as we have seen, is semiotic-ally very different from foregrounding the process of projection. The way into narrative cinema is surely not forbidden to the avant-garde film-maker, any more than the way into verbal language.[15]

Cinema, I have stressed earlier, is a multiple system—the search for the specifically cinematic can be deceptively purist and reduc-tive. For most people, after all, cinema is unthinkable without

words and stories. To recognize this fact is by no means to accept a conventional Hollywood-oriented (or Bergman/Antonioni/Bunuel-oriented) attitude to the cinema and the place of stories and words within it. It is perhaps the idea, so strongly rooted by now, that film is a visual art that has brought about a blockage. Yet this idea is obviously a half-truth at best. The danger that threatens is that the introduction of words and stories —of signifieds—will simply bring back illusionism or representationalism in full flood. Clearly this fear is the converse of Eisenstein's anxiety about 'unmotivated camera mischief'. There are good reasons for these fears, but surely they can be overcome.

I have tried to show how the two avant-gardes we find in Europe originated and what it is that holds them apart. To go further, I would have to discuss as well the institutional and economic framework in which film-makers find themselves. The basis of the Co-op movement, as has often been pointed out, lies in artisanal production, with film-makers who do as much as possible themselves at every stage of the film-making process. If there are performers involved they are usually few, generally friends of the film-maker, often other film-makers. The other avant-garde has its roots much more in the commercial system, and even when filming in 16mm Godard would use stars known in the commercial cinema. The difference is not simply one of budgets—Dwoskin or Wyborny have made films for TV as well as Godard, and Dwoskin's are clearly much more conventional, yet they are almost automatically assigned different cultural places. It is much more one of the film-makers' frame of reference, the places from which they come and the culture to which they relate.

The facts of uneven development mean too that it would be utopian to hope for a simple convergence of the two avant-gardes. The most revolutionary work, both of Godard and of Straub-Huillet, was done in 1968—*Le Gai Savoir* and *The Bridegroom, the Comedienne and the Pimp*. In comparison *Tout Va Bien* and *Moses and Aaron* are a step backwards. Godard works increasingly in isolation, cut off from any real collective work or movement. In *Le Gai Savoir*, Juliet Berto says towards the end that half the shots are missing from the film, and Jean-Pierre Léaud replies that they will be shot by other film-makers: Bertolucci, Straub, Glauber-Rocha.

We can see now how wrong Godard was in some of his judgements—the shots missing from his film could be supplied by the other avant-garde—and it is not clear that he has ever realized this.

Nonetheless, though a simple convergence is very unlikely, it is crucial that the two avant-gardes should be confronted and juxtaposed. History in the arts goes on, as Viktor Shklovsky long ago pointed out, by knight's moves. During the first decade of this century, when the historic avant-garde embarked on its path, the years of the *coupure*, the cinema was still in its infancy, scarcely out of the fairground and the nickelodeon, certainly not yet the Seventh Art. For this reason—and for others, including economic reasons—the avant-garde made itself felt late in the cinema and it is still very marginal, in comparison with painting or music or even writing. Yet in a way, the cinema offers more opportunities than any other art—the cross-fertilization, so striking a feature of those early decades, the reciprocal interlocking and input between painting, writing, music, theatre, could take place within the field of cinema itself. This is not a plea for a great harmony, a synesthetic *gesamtkunstwerk* in the Wagnerian sense. But cinema, because it is a multiple system, could develop and elaborate the semiotic shifts that marked the origins of the avant-garde in a uniquely complex way, a dialectical montage within and between a complex of codes. At least, writing now as a film-maker, that is the fantasy I like to entertain.

# Mexico/Women/Art

*Frida Kahlo* was born in July 1907, in the suburb of Coyoacán, Mexico City. When she was eighteen she was gravely injured when a streetcar ran into the bus on which she was travelling. In hospital she started to paint and, after her release, went to see the mural painter, Diego Rivera, and watch him at work. Soon afterwards, in August 1929, she married Rivera and, though she was divorced by Rivera in 1939, they re-married the following year. Frida Kahlo's life was one of unrelenting struggle against injury and ill-health. 'I hold the record for operations,' she once said. These include bone-grafts, amputation, abortion and a dangerous miscarriage she suffered in a Detroit hospital in 1932. She continued painting throughout her life and her paintings commemorate her sufferings and express her longings through an intense symbolism and deliberately naïve style. Often considered a 'surrealist', she was to become a friend of André Breton, who organized an exhibition of her work in 1939, though her style was one she had developed herself. She was politically active most of her life, and lent her home in Coyoacán to Trotsky during his exile in Mexico, before returning to the Communist Party in the post-war period. She died in Mexico in 1954.

*Tina Modotti* was born in August 1896, in Udine, Italy. Her family emigrated to California where she joined her father in 1913. While in California she worked in Hollywood as an actress and was married briefly before her husband died suddenly in 1922. The next year she went to Mexico with the photographer, Edward Weston, and stayed there after his return to the USA in

1926. She became a photographer herself and her work was pub-
lished and shown in Mexico, Europe and the USA. After Weston's
departure she became increasingly involved in revolutionary
politics. In January 1929, she was at the side of her companion,
Julio Antonio Mella, a founder of the Cuban Communist Party,
when he was shot dead in the street. In 1930 she was expelled
from Mexico and made her way to Moscow via Berlin. There she
gave up photography for full-time political work. She was sent to
Paris and then Spain where she was throughout the Spanish Civil
War. After the Republican defeat she returned to Mexico and she
died there in January 1942. Her death was commemorated in
Neruda's *Tercera Residencia*.

I hope that writing about Frida Kahlo and Tina Modotti is more a
step forward than a look backward. There are so many threads in
history we need to pick up and I think that these are two of them.

In recent years there has been a great deal of attention paid to
the art movements and debates of the twenties, but the art of
Mexico has been comparatively neglected. Yet Mexican artists
faced similar problems with similar aspirations to those of Paris or
Berlin or Moscow, and came up with strikingly original solutions
and work which is as relevant today, perhaps more so.

Moreover, when the experience of post-revolutionary Mexico
has been looked at, all the attention has been concentrated on the
major mural painters, to the exclusion of other art produced in the
same milieu. I want to correct this imbalance by focusing on two
of these excluded artists, both women, one a painter and one a
photographer. In doing this, I also want to raise questions about
the place of women in art movements and in relation to art and
politics, both classically revolutionary and feminist.

I decided against approaching the work and lives of Frida Kahlo
and Tina Modotti in an art-historical way or even a theoretical
way, though I wanted to write about art history and about theory
—aesthetic, psychoanalytic and political. Looking at Frida
Kahlo's work—say, the portrait of herself with cropped hair,
wearing a man's suit too big for her—it's hard not to have immed-
iate recourse to Freud. What is this exaggerated act of mutilation
that turns a woman into a castrated man and exchanges a fastidious

masquerade for a billowing pair of trousers belonging, we can presume, to the mammoth husband she elsewhere pictures towering over her twisted head? And does he reappear in the unexpected form of the imaginary father of the spider monkey we see so often? But I decided not to go down this road.

Again, to write about Tina Modotti is to write about the political history of our century: not only the Mexican Revolution, but the end of Weimar, Moscow and the Comintern, Paris and the Popular Front, the Spanish Civil War. This can't be ignored but what would happen to Tina Modotti in this epic? Which tragedy do I write about, the general or the individual?

In the end I chose to present these extracts from an exchange of letters. Who are they between? Authors, we have often been told, are effects of texts for their readers and perhaps we can leave it at that. One author, presented as a receiver, is found in America; the other, presented as a source, we may take to be in London. What else they wrote about in their letters we shall never read. Those threads of passion and information have been let drop.

Tina Modotti wrote once, 'I cannot—as you once proposed to me—solve the problems of life by losing myself in the problem of art.' And Frida Kahlo in her journal, 'No reasoned telling mine, nestling fishlike, running rowdy, great kaleidoscopic haste, pasteboard doll.' Somewhere between folktale and automatic writing, attentiveness to the problems of art as to those of life, perhaps we can remember something which might otherwise be disparaged.

Like Shklovsky, 'I have the same attitude toward a plot of the usual type as a dentist to teeth.'

1 (In)

I want to travel. To the south. To Mexico.

I imagine a Douanier Rousseau landscape. I can see a pyramid in the distance through the fronds of jungle trees. A jaguar is lying on a bank of moss. A tropical bird with bright plumage is dancing beneath clusters of orchids. Feathers.

Don't think I believe any of this.

How could the Mexican workers at the Taco Bell or bent down picking artichokes or lettuce let me indulge myself with my Douanier Rousseau landscape?

My problem is that I have a passion for utopias.

Not the utopias of cubes and spheres and complicated computations but the utopia of jaguars and moss. Not the Radiant City of the Triumph of Reason but the orchids and the dance.

The worker is picking artichokes.

The Douanier Rousseau landscape is for Henry Kissinger's honeymoon.

Where does the worker come from, the undocumented worker? A senator once said he is good for picking artichokes and lettuce because 'he is built kind of low-slung'. I have heard too that he has a strange wisdom, born perhaps of bronzedness and backwardness and familiarity with certain buds. I mean ritual familiarity.

He comes from a dirt farm or a hut made in an afternoon on a street not shown on the city map. He is waiting for the Revolution to come again. Meanwhile he must pick lettuce and sweep up the courtyard of the Taco Bell.

The Revolution smoulders in the popular memory.

I remember hearing a story once. While Madero was President of Mexico there was a Congress of Revolutionaries at some city in the provinces, a city with a bandstand in the square and painted walls. The revolutionaries went to the cinema to watch movies of the Revolution. The cinema was crowded, with revolutionaries everywhere, in the aisles and in the gallery. Two of them took chairs and went to sit behind the screen. At each movie the crowd of revolutionaries became more gleeful and excited. Eventually there came a movie of President Madero riding into the capital on his white horse. The revolutionaries whistled and jeered. One of them shot him in the heart and in the head. The bullets pierced the image and hit the wall just above the two revolutionaries sitting behind the screen on their two chairs. One of them said to the other. 'If Madero had walked into the city, we would be dead.' The other replied, 'If he had walked, he wouldn't have been Madero. And if he wasn't Madero we wouldn't have rebelled. And if we hadn't rebelled, we wouldn't be here and we would still be alive.'

I think today he would ride in a bullet-proof limousine.

History is full of men on horses. Like centaurs they enter the cities and when they die they are cast in bronze and placed on high

plinths in the squares where their hooves trampled. The first of
these centaurs in Mexico was named Cortez.

He came for the gold. Today he comes for the oil.

How can I go to Mexico?

How can I tear myself from my horse, from my four lower
limbs? How can I travel without hooves, on the stumps of my fet-
locks?

How can I find the people of Mexico in my Douanier Rousseau
painting? Its women and its women artists? Are they there?

I had better stick here with the Taco Bell. I want to stay home.
Here, in California.

2 (Out)

Before I went to Mexico, I didn't know what to expect. I suppose
in a way I thought it would be like Iran, with Catholicism taking
the place of Islam, Mayan and Aztec ruins of Persepolis, and, like
Iran, a veneer of western/North American culture acquired since
the world war. I wasn't prepared for the particular, specific char-
acter of Mexico, its own richness and variety or the way in which
the different components of the culture would form a complex—
not unity but disunity—almost as if by displacement and condens-
ation. (Though I don't want to sound like Breton saying Mexico is
the truly surrealist country). For a start, I didn't realize how many
Indian cultures there were, each distinct, many with pasts marked
by monuments, not just massive, though the scale took me aback,
but also in distinct styles: Olmec, Zapotec. Then the strange
enmeshment of Indian culture with Spanish baroque, especially
in ornamentation and colour, and the tenacity of the revolutionary
tradition in Mexico, in inscription and imagery, however chan-
nelled by the State into institutionalized forms.

There's no need to take the Douanier Rousseau to Mexico.
Mexico has its own art. I knew in advance about the muralists—or at
least the 'trinity' of Orozco, Rivera and Siqueiros—but I wasn't pre-
pared for the scale or the scope or the variety of the muralist move-
ment and the whole Mexican art milieu of the post-revolutionary
period. I had seen one work by Frida Kahlo at the Women's Art
show at the Brooklyn Museum juxtaposed with Romaine Brooks
and Gwen John and Sonia Terk and so on and it hadn't registered

till I saw her work in Mexico, more of it and in a context. Then one of the most interesting women artists of Mexico came from California (originally from Italy): Tina Modotti, who was a photographer, taught by Edward Weston. She stayed on when Weston went back to make pictures of peppers and artichokes (picked by Mexican labour? I wonder). So I think you should go to Mexico. (You shouldn't be afraid of Henry Kissinger.)

After all you won't tread in his tracks—or after D.H. Lawrence. When Lawrence went to Mexico he went to the main archaeological museum in Mexico City and, while he was there the attendant asked him to take off his hat. He wouldn't and stormed out, saying as a white man he refused to be humiliated. Then he wrote: 'You know Socialism is a dud. It makes just a mush of people, and especially of savages. And seventy per cent of these people are real savages, quite as much as they were 300 years ago. The Spanish-Mexican population just rots on top of the black savage mass.' Graham Greene copied this out approvingly in his travel book about Mexico. And added for good measure: 'How one begins to hate these people . . . The hideous inexpressiveness of brown eyes. People never seem to help each other in small ways, removing a parcel from a seat, making room with their legs. They just sit about. If Spain is like this, I can understand the temptation of massacre.' Well.

## 3 (Out)

I'm thinking a lot about Frida Kahlo and Tina Modotti and planning to write something about them. Partly it's the drama of their lives, but also the questions they bring up about the history and trajectory of the avant-garde and the place of women in or *vis-à-vis* the avant-garde. Most discussion of the avant-garde is both Eurocentric (or North Americanocentric) and male-centric. So that two women artists living and working in Mexico can give a different perspective. With Frida Kahlo there is a particular kind of relationship to folk and popular culture, an intense self-investigation and self-exposure (both through her self-portraits and her journals) and a prominence of the symbolic representation of the body. These are all the kind of things you get to see and read about in *Heresies* and across a whole range of women's art today. Also

there is the way in which she made her home into a kind of art environment, so that it is still preserved as the Museo Frida Kahlo, and this links up both with privacy (strangely coupled with narcissism) and with masquerade. (Is there a distinction between decoration and masquerade?) Which leads on to questions about psychoanalysis and art which we would be led to expect anyway from Breton's interest in Frida Kahlo's work. In general, women didn't thrive in the Surrealist milieu—they were goddesses, sphinxes, dream-princesses, not artists—or rather, since the Surrealists don't see themselves (openly) as artists, not activists. Objects of gaze, not subjects of action.

And this leads on to Tina Modotti, who did become an activist, after starting out very much as an object of gaze—as a model for Edward Weston in an endless series of portraits and nude studies —*Tina on the Azotea*—and then a model for Diego Rivera for his Chapingo murals: more nude studies. Then she learns photography from Weston and becomes an image-maker rather than an image. (Before coming to Mexico, she had even been an actress in Hollywood movies.) She does joint shows with Weston—like him, photographing Mexicana, folk objects and artefacts (of the kind Frida Kahlo collected) and then gradually becoming politicized in the Mexican avant-garde milieu where art and revolutionary politics were very closely linked. Then—the really interesting development—after Weston went back to the States, having resolutely refused to be politicized, we find her trying to develop a political photography, to bring together the aesthetic of the camera she had learned from Weston with her new political militancy. At its farpoint this produces an emblematic photography—sharp outline close-ups of ordinary objects, their geometrical shapes and light surfaces emphasized, as with Weston, but the objects are guitars, sickles, cartridge belts, corncobs, with an explicit symbolism of struggle in the countryside. The one published in the German *Der Arbeiter-Fotograf* was captioned 'Peasants fight with us!' Finally she was expelled from Mexico in early 1930, went to Berlin, then Moscow, where she gave up photography completely to become a full-time political activist (for International Workers' Aid in Paris and then the Spanish Civil War—after which, she returned to Mexico with other exiles and refugees to die there in 1942).

4 (Out)

More about Frida Kahlo and Tina Modotti: I don't know that they ever met, or rather, if they did, their acquaintance was very short-lived. Rivera married Frida Kahlo in 1929 when she was nineteen. In the same letter Tina Modotti wrote of this news to Edward Weston she also tells how Rivera had been expelled from the Mexican Communist Party and concludes: 'I think his going out of the party will do more harm to him than to the party. He will be considered a traitor. I need not add that I shall look upon him as one too and from now on all my contact with him will be limited to our photographic transactions. Therefore, I would appreciate it if you approach him directly concerning his work. *Hasta luego*, dear.'

Two years or so earlier, Rivera painted both Frida and Tina in one panel he painted in the Ministry of Education building, distributing arms to the people. (It was really this image that first juxtaposed them for me.) It's a strange panel. The two men standing between Frida Kahlo and Tina Modotti are the painter Siqueiros and Julio Antonio Mella, one of the founders of the Cuban Communist Party, who became Tina's companion and was shot to death beside her walking in the street in January 1929. Siqueiros had a strange history too. Two things stand out: his armed attack on Trotsky and his teaching Jackson Pollock. When Trotsky came to Mexico in exile he was met off the boat by Frida Kahlo and stayed as her guest till he split with them politically— or at least with Rivera—and left for another house nearby which was where the Siqueiros attack took place—you can still see the bullet-marks on the walls of Trotsky's bedroom. As for Pollock, the connection with the Mexican muralists has always been downplayed recently, I feel—Siqueiros introduced Duco as a medium; the scale of Pollock's work obviously recalls the muralists. Also Pollock's mentor Benton worked with Orozco on the murals for the New School of Social Research and Pollock was involved in that too, even if marginally. Anyway, it's hard to draw together all these strands which are elements of biography and political history with the more theoretical questions about the avant-garde, art and politics.

5 (Out)

I think maybe you're right when you say I seem to put the avant-garde first in the way I think about Kahlo and Modotti, rather than in their place as women or their significance for feminism. There are obvious reasons why, but also I think because the concept of 'avant-garde' pre-dates the concept of 'women's art' and is a more established part of discourse, so that I tend to read the second historically back into the first. Also, I think my priority at the moment is to try and clarify my ideas about the history of the avant-garde because I am always reading how it is dead or in crisis or about to collapse. Is this true? If so, or even if sort of so, what are the implications? To think about the future of the avant-garde means thinking about its past, not as antiquarianism or archaeology, but to understand the mechanisms in which we are still caught. Till I went to Mexico, I saw the Mexican avant-garde as marginal (reflecting is geo-political position in the world system) but I now think this was wrong: the same problems came up in Mexico as in Europe but the response was different and just as significant, if not more so.

In thinking about the avant-garde I try and distinguish between the historic avant-garde whose work presupposes (or implies?) a break with 'dominant ideology'—historically a break with nineteenth century codes—and modernism, which is one interpretation of the 'paradigm shift' that took place. In the twenties, the avant-garde came into collision or collaboration with Marx and Freud and, one way or another, its fate was sealed. There was a great wave of repression and regression. By the 1940s there was hardly an avant-garde artists still working in Europe and when something re-emerged after the war, in New York, rather than Berlin, Moscow or Paris, it took the form of an official art with the ideology of modernism: art about art, reflexivity, autonomous problem-solving with each artistic solution suggesting a new artistic problem, surface, shape, material. Then in the sixties (with May 1968 as the emblematic moment), this modernism seems to go into crisis. The threads of the twenties are picked up again (the role of *Fluxus* in New York) and there is a revival of the historic avant-garde with a host of new areas of commitment and inquiry: women's art, political art, photography, popular imagery,

*114*

environment, performance (all of which relate back to Kahlo and Modotti). At the same time there is a danger that the crisis or collapse of modernism could simply usher in a new artistic reaction and the revival of the avant-garde be once again short-lived. In fact, at first I was suspicious of the Mexican muralists because I was afraid the revival of interest in muralism (as with German New Objectivity) was a softening-up process for a return to academicism and realism.

About Tina Modotti's movie roles, I only managed to trace her to small parts—Carmencita Gardez in *I Can Explain*, a comedy melodrama (1922) and Rosa Carilla in *Riding with Death*, a western-melodrama, directed by George D. Baker and Jacques Jaccard respectively, both unknown to me. Edward Weston describes going to a movie in Mexico where 'we saw Tina herself on the screen, a small part she did some years ago in Los Angeles. We had a good laugh over the villainous character she portrayed. The brains and imagination of our movie directors cannot picture an Italian girl except with a knife in her teeth and blood in her eye.' Six years later Tina wrote to him: 'No doubt you know the pretext the government used in order to arrest me. Nothing less than "my participation in the last attempt to kill the newly elected President". I am sure that no matter how hard you try, you will not be able to picture me as a "terrorist", as "the chief of a secret society of bomb throwers", and what not...' No longer a laughing matter to be portrayed as villainous.

6 (Out)
I'm very pleased because I found by chance a book of Mexican *ex-voto* paintings that Frida Kahlo collected and on which she based her own paintings. They all have three components: a written inscription describing a misfortune or catastrophe that a holy saint has healed, a painted scene in naïve style depicting the dreadful occurrence and then, in the sky above, the holy person whose aid was successfully invoked. There's a modern one illustrated that says: 'I give infinite thanks to the Holy Child of Plateros for having given me my health after I had a pain in the stomach from becoming used to drinking Coca-Cola and Pepsi-Cola refreshments, causing me this pain in the stomach due to the gases and

cocaine that these refreshments have. Therefore, seeing myself so ill, I asked the Holy Child of Plateros to give me my health, promising to take him a *retablo* which I now display to the Holy Child of Atocha.'

Frida Kahlo was badly broken up in a traffic accident in 1925 when a streetcar ran into the bus she was in and she broke her foot, her spine and her pelvis. She began painting seriously in hospital. She never recovered from her injuries and used to paint in bed, on a tin sheet such as the popular *ex-voto* was painted on. Later it was all aggravated by her having a miscarriage (due to the damage to her pelvis) and she made two horrific paintings about this. She was hospitalized over and over during her life. So the ex-votos were a type of painting that related directly to her own misfortune. But I don't think she ever painted a holy person, though otherwise the style is the same, with the same kind of written inscription. Perhaps some of her self-portraits are modelled in part on popular holy pictures of saints, but that is a bit different— it's the imagery of the martyr rather than the benefactor.

7 (Out)
The political life of Tina Modotti is fairly straightforward—she joined the Party in the twenties in Mexico and was a member for the rest of her life. (At the very beginning she was involved in the pro-Sandino 'Hands off Nicaragua!' campaign—it's strange, now that Sandinists are once again in open struggle, to see old news photos of that campaign—and also, being of Italian origin, in the Sacco and Vanzetti campaign.) In Europe she worked for Munzenberg's International Workers' Aid organization, which I think she had already come in contact with in Mexico. (This was a quasi-independent international Communist organization that organized campaigns and demonstrations, collected and ran support funds, published magazines and even produced films, such as Brecht's *Kuhle Wampe* in Germany, through its subsidiary Prometheus, and in Russia films by Pudovkin and Boris Barnet, like the fantastic Red Perils of Pauline-type serial *Miss Mend*.)

Frida Kahlo's political life is bound up with that of Rivera, who was expelled in 1929 (as I wrote you) for unclear reasons—the timing suggests he was identified with Bukharin, but in any case

once out of the party he and Frida (who had been in the Communist youth in the twenties) drifted towards Trotskyism and Frida then was Trotsky's host when he came to Mexico. In fact, he is supposed to have had some degree of emotional involvement with her, sending her secret notes, and there is a photograph of them at this time in which Trotsky's wife has scratched out Frida's image. But this isn't strictly politics. Anyway soon afterwards Rivera split with Trotsky (about the same time he and Frida were divorced, to re-marry the next year) and after the German invasion of Russia began to make overtures toward the party again and he and Frida were finally re-admitted after the war. Frida painted a portrait of Stalin and, in her home, there are icons of Stalin and Mao on display—strange after her relationship with Trotsky to come to revere his murderer.

## 8 (In)

Frida and Tina. Tina and Frida.

First I heard their names. Then I went to a book to read about them. This is what I might have read:

In a country to the south there lived a jaguar and a tropical bird with bright plumage. One day they got married and soon afterwards there were born two daughters. They called their daughters Frida and Tina.

When the revolution came the jaguar and the tropical bird fought bravely but they were both killed. When the revolution was over nobody was sure whether it had really happened or not. But all the same many people were dead.

Frida and Tina were left alone.

Frida went to school. One day an ogre came and stamped on the star-crossed bus. Frida's backbone broke and her foot hung off. Blood ran all over the street.

From each drop of blood grew a tall cactus covered with spikes and poisonous quills. They formed a tall fence of cactus round a clearing. In the clearing Frida built a house and painted it bright blue.

The ogre came and shot arrows and threw knives into the house. They hurt Frida and she bled. With the blood she painted pictures on sheets of tin.

One day Frida looked over the fence of cactus and saw that they had built a huge wall. She saw a painter on top of a high ladder painting the wall. She saw that he had painted the jaguar and the tropical bird. Frida fell in love with the painter.

She put on a long skirt and a bodice and a lace collar and hung jewels all over herself. When the painter saw her from the top of the ladder he came down and asked her if she would let him in. She said yes. She was very happy. But she was still in pain.

Meanwhile Tina had grown up into a beautiful woman, the most beautiful in all the land. Men followed her everywhere and asked her to be theirs. But she said no.

One day Tina met a photographer. He told her he could make pictures of her face and her body with sunlight and silver. Tina looked into the lens of his magical box and was amazed at her own beauty in his pictures. But she was not very happy.

She went to the photographer and asked him to teach her the secret of his magical box so that she too could make pictures with sunlight and silver. Because she was so beautiful and he was so proud of the pictures he had made of her beauty, he said yes.

After he had taught her his secrets, the photographer went away to a far country and Tina never saw him again. But Tina began to make pictures. She made pictures of the cartridge-belt the jaguar had worn and the corn-cob the tropical bird had used to make tortillas.

One day Tina met a revolutionary. He reminded her of the jaguar and she liked him. She was happy. When the ogre saw that she was happy, he came and shot the revolutionary with a poisoned bullet, while he was walking in the street with Tina. He fell from her side down to the ground. Blood ran all over the street.

From each drop of blood grew a policeman holding a pistol with poisoned bullets. They pointed their pistols at Tina and she ran and ran. She ran up the mountainside and across the crater of the volcano and down into the valley and across the beach and over the ocean till she came to a land full of ice and snow. Tina stopped running and when she asked for chocolate and tortillas they gave her dumplings and tea from a steaming urn.

Tina put down her magical box and she never picked it up again.

Soon some friends came to Tina and told her that the jaguar and the tropical bird were not dead after all. They were still alive in a distant land. Soon the revolution would begin again. Tina left the city of ice and snow to go and find the revolution.

When she got there the jaguar and the tropical bird were fighting bravely. But they were both killed. Tina picked up their weapons and fought bravely too. All the same the revolution was soon over and many people were dead.

Blood ran all over. From each drop of blood grew a policeman holding a pistol with poisoned bullets. They pointed their pistols at Tina and she ran and ran. She ran up the mountainside and across the peaks and down into the valley and across the beach and over the ocean till she came back to the country she had left so many years before. Tina stopped running and when she asked for chocolate and tortillas they gave her chocolate and tortillas.

Tina was happy to be back. But she was sad that the revolution was over and the jaguar and the tropical bird were dead. She was so sad that she died.

Meanwhile Frida was sitting in the Blue House painting on sheets of tin with drops of blood. The painter was with her. He was huge and ungainly and wilful and childish. Frida wanted a child. When the ogre found out she was pregnant he came and stamped on her round belly. Her baby died and her womb caved in. Blood ran all over the room.

Frida dipped her brush in the blood and she painted her broken body and she opened it up with a knife and painted the broken pumps and torn sponges and severed tubes and cut tendrils she saw inside.

The cactus grew taller and taller and the room grew fuller with blood. The ogre came and snapped Frida's leg off and chewed it up. Frida grew weary with painting but there was so much blood she had to use it up.

Frida was worse in pain. She was so much in pain that she died.

When Tina and Frida died they came and took them away and put their bodies in the graveyard and made speeches and wrote poems. They recalled the revolution and the blood and they wept tears. They took the paintings Frida had made with her blood and

the pictures Tina had made with sunlight and silver and they hid them away.

Many years later the revolution began again. The jaguar and the tropical bird were not dead after all. They asked, 'Where are Frida and Tina?' Friends took them to see the pictures painted with blood and made of silver and sunlight that had been hidden away.

The jaguar and the tropical bird did not weep. They smiled. They picked up their weapons and went back to the revolution. They fought more bravely than ever before and . . .

Someone has torn the last page out of my book.

But there was one thing I wondered about. I couldn't find anything in the story about the brave knight, Sir Avant-Garde, in his bright armour. Perhaps he is in another story, a happier story. What do you think?

9 (Out)

I found out more about the Tehuana costume Frida Kahlo used to wear and is portrayed by and on herself in *The Two Fridas*. (Tehuantepec is known in Mexican folklore as a 'matriarchy' with especially beautiful and powerful women. Rivera was sent there, and to Yucatán, by his patron, Vasconcelos, the Minister who commissioned the murals, to reimbibe Indian culture after his years in Europe.) The costume dates from the last century when Tehuantepec was a boom-town and there were plans to build a railway and a canal across the Isthmus. The muslin for the blouses used to come from England, from the textile mills of Manchester, made specially to sell on the Isthmus and nowhere else. Today the market has been captured by local Mexican manufacturers, but elderly *tehuanas* still sigh for the good old rock-fast Manchester cottons. The blouses are decorated 'with a wide band of elaborate geometric design done by the laborious process of actually weaving a solid pattern of crisscrossing superimposed lines of chain-stitching, done on a special Singer sewing-machine, with threads of contrasting traditional colours'. The special Manchester textiles, the special Singer sewing-machine: so much folk-culture turns out to be enmeshed with capitalist expansion in the world market. Still the dyes seem local—*caracol* from the slime of a tiny snail (the same as Tyrian purple) and cochineal from the cactus louse.

10 (Out)

What should I say about the avant-garde? I see what you're saying and I sympathize with the point of view, but I think there's a missing element. People don't simply paint pictures or make photographs or films or write stories in a completely natural manner. They write from a certain place in the history of society and the history of art. They use certain materials and certain formal strategies when they might have used others. If you look at Frida Kahlo's work you can see not just that she painted herself, her own story, but that she painted on tin, like an *ex-voto* painter, and used formal devices drawn from *ex-voto* painting and medical drawing and *pulqueria* painting (a *pulqueria* was a saloon where *pulque* was sold and it had a painted sign like an English inn) and popular prints sold in the streets. This recourse to ethnic 'folk' and 'popular' art was part of the whole strategy of the avant-garde —Picasso went to Catalan stone carving, the Russians to popular illustrated books, and so on. It was part of Cubism. So we can't separate this strategy of Frida Kahlo's from the avant-garde milieu in which she worked. Rivera had been through Cubism in Paris; Breton and Duchamp, who approved and publicized her work, were central figures in the avant-garde.

The case of Tina Modotti is maybe even more clear-cut. Like Weston, who, as you can see from his *Daybooks* saw himself very much as a modern artist, Tina Modotti used a Graflex camera stopped down to give depth of field. Weston's aesthetic which she adopted, was a reaction against 'pictorialism' with its deep shadows, blurry outlines, and soft focus, and in favour of sharp, clear outlines, overall illumination—a 'machine' aesthetic, rather like German New Objectivity photography, still measuring itself against painting in terms of design and composition. When Tina Modotti arrived in Germany on her way to Moscow, she wrote to Weston: 'Everybody here has been telling me the Graflex is too conspicuous and bulky; everybody here uses much more compact cameras ... I have even tried a wonderful little camera, property of a friend, but I don't like to work with it as I do with the Graflex: one cannot see the picture in its finished size ... besides, a smaller camera would be useful only if I intended to work on the streets, and I am not sure that I will. I know the material found on the

streets is rich and wonderful, but my experience is that the way I am accustomed to work, slowly, planning my composition or expression right, the picture is gone...' Her aesthetic strategy, which derived originally from Weston, was independent of her ideas about content, which derived from her political experience. Both, in a way, came from involvement in the avant-garde but there was a tension between the two.

It's this tension that I find important in the avant-garde, this breaking of any seemingly natural ties between form and content or, more technically, signifier and signified. I don't like either the reduction of the role of signifier to vehicle for the signified, to transparency, or the reverse, the reduction of the role of the signified to the point where it is suppressed completely or put into parentheses, as though it were completely unimportant and contingent upon what is depicted. The subject-matter in Frida Kahlo's work, and Tina Modotti's, is very strong, it reflects the drama of their lives and times, it's politically motivated, but neither of them looked for transparency of form. They both used very stylized formal approaches—very different: for Tina, planning the composition right; for Frida, reformulating popular styles and imagery. The effect of their work comes through this tension between stylization and strong material.

I think the avant-garde does have a political part to play. It's not a knight on a white charger though. It's painting and writing and photographing in one way or ways rather than others, in ways which, through discontinuity and heterogeneity, oblique but incisive, pointed, dislodge and split and rend the seamless fabric of discourse and imagery produced by and sustaining our social (patriarchal) order. Perhaps this is only a peripheral task, but who can be sure? History plays strange tricks.

## 11 (In)

I went to the Frida Kahlo museum today, the same day the Pope went to visit the Virgin of Guadelupe. He drove in the largest limousine I have ever seen.

I thought about fruit and about nails and about butchery and about fireworks and about wombs and about fruit.

I read Marcel Duchamp's address and telephone number in the book.

I was glad there were no postcards.

Tomorrow I go to Tina Modotti's grave in the Pantheon of Dolores. I shall read the lines of Neruda inscribed there.

The Pope will pray that there be no abortion and no revolution.

My problem is that I have a passion for utopias. Gravestones are signposts.

Don't think I'm despondent. It's all a question of 'how far?' Isn't it?

3.

# The Real Projective Plane

1

By the time you read this, you will definitely have forgotten that you ever wrote it. Gradually, haltingly, you will recognize yourself in the interstices of these elusive words; a memory which had been effaced will represent its traces to consciousness—the memory, perhaps, not of the actual act of writing itself, but of the act which interrupted it, a meal, a telephone call, an over-riding invitation or compulsion the gratification of which still bore the sweet aftertaste of writing, the feeling of having just been enjoying writing—*this*.

Perhaps you will even deny everything furiously, any previous relationship, however faint and evanescent, with these words which have nonetheless endured. You will search for an 'other', an 'I' who is reciprocal to yourself (or myself as I may alarm you by putting it) and who exists not simply in some different place and time but in some place and time which has never, in any sense, been yours at all, and never now can be. Who can this 'I' be?

Clearly he or she must be a writer. This we know for certain, you and I.

He or she must be a writer. And you, you must be a reader. We know this for certain too, I and you.

A reader. Some compulsion forces you to the gentle touch of paper and the reassuring sight of print, some tactile and some scopic impulse forces you to a repeated gesture. Over and over again you take the sheet of paper between finger and thumb and turn it from right to left; over and over again your eyes move from

left to right, rapidly away from you, then slowly back again towards you. Why?

Where do you hope your ceremonial search will lead you? To a goal whose starting-point lies somewhere undiscovered in yourself, to something which you cannot bring to mind unaided and must partially re-capture through the agency of reading, something that you will recognize immediately as what you wanted all along, something that will give you pleasure or relief. And yet if you wanted it so badly, why did you never produce it for yourself? You waited. You deny that you ever wrote these words and yet, if you are still reading (and you are) you are still waiting.

Why wait longer? Why not admit that these are the words you wrote, words which gratified a desire so inadmissible that you have refused your own writing, you have assigned it to 'me', to the 'other' whose desires you can deny, which you can spit out on to the page, wriggling black flecks of ungratified desire? Because the desire to read is the desire to have written.

## 2

I have taken the liberty of publishing the brief fragment which you have just read without any prior warning or indication of its provenance; in this way, you received its full effect, as I did when I first came across it. I found it, lying among a heap of papers in my own study, papers which concerned some professional work I had undertaken and which had no bearing on this particular fragment. Indeed, they were concerned with problems of 'authorship' in a quite different field, that of the cinema.

I must concede, that for a moment, I believed that I had indeed written this fragment myself, dismissed it from my mind and inadvertently slipped it among a confused heap of other papers. Yet further reflection convinced me that this could not in fact have been the case. To begin with I do not agree with the philosophical positions it seems to imply. It seems to suggest that every new perception (for we need not draw the line at writing alone) is simply the re-presentation to consciousness of a previous perception that has been repressed (or foreclosed). This is Platonism. The concept of repression is simply substituted for that of the fall

into sensuality from the realm of the ideal. This whole line of thought is dangerous and I think it should be resisted.

Secondly I have never ever been tempted by the idea of 'creative' writing. I simply cannot believe that I could produce a fragment of 'creative' writing, so to speak, unawares. My own work is uniformly critical and theoretical, concerned with the analysis of cinematic texts. This demands a completely different cast of mind from that of the 'creative' writer. I do not say that it is in any way superior, but it is certainly different and should remain so. Nothing good can come of attempts to intermingle an object language with a meta-language.

It has been put to me that the effort to construct a watertight meta-language, to which I have devoted my professional life, is self-defeating. If such efforts were successful, then this meta-language would simply replace the original object language which would henceforth be redundant. The meta-language would thus become an object language in its own right and the whole cycle would start again. My endeavours are thus a labour of Sisyphus.

To this, I can only reply that such a labour is nonetheless necessary. The fragment I have published here amply shows the importance of developing a watertight meta-language; the object language is subject to every kind of *trompe l'oeil* and illusionistic device. The meta-language serves as a kind of breakwater without which we would all be washed away in the shifting sands of meanings endlessly undermined. Even an imperfect fixity is preferable to indefinite postponement, where the certainty of meaning is concerned.

Finally I would like to appeal to the real writer of this fragment, should he chance to read it, to come forward, so that I can return to him his original manuscript and assign him his copyright. Property in such matters should not be treated laxly.

## 3

I first heard of the name of Teresa Guidobaldi from Gregory Citron, when he told me the story of her death from morphine poisoning in the Chelsea Hotel, shortly after the last war, on her sixtieth birthday. After a life buffeted by storms in the affairs of nations and of the heart, she had finally exhausted the immense

fortune she had inherited. Nobody in New York any longer knew who she was. Now Opal Faye has chronicled her defiant and eventful life, drawing on a wealth of reminiscences from personal friends and, for the earlier part of her life, the chest of letters she wrote to her stormiest and most persistent love, Lucie Maga. Inevitably interest focuses on the coterie of 'extraordinary women' (in Compton Mackenzie's phrase) who flitted in and out of the frame of her bed and the circle of writers and artists she consulted and provoked. Some of them, like Marinetti and Gertrude Stein, proved more lasting than she thought they would become, while others, whom she stood in awe of, like D'Annunzio, have decayed into mere curiosities.

Teresa Guidobaldi was the last of her line. She was born in Rome into the 'white' aristocracy who whiled away their lives visiting mediums and avoiding the 'black' aristocracy, who would not speak to them since the Papal States gave way to a United Italy. She remembered how, after duck-shooting, the whole princely family would return to Rome in a convoy of De Dion Boutons. Meanwhile, a carriage and horses would set out down the Appian Way to collect the princes and princesses whose motor-car broke down, as one inevitably would. She went to fancy-dress balls at the British Embassy at which the future Lord Berners, dressed as a prancing satyr, with fur, horns and tail, chased a bevy of nymphs through the ballroom, while the Ambassador and his wife, representing Jupiter and Juno, watched from raised thrones on a dais.

On the whole though, her life was made a misery, simply because she had no brothers—worse, she was an only child. Either marriage or death would extinguish the family name. She chose death. In fact, it had soon become apparent that marriage was out of the question, unless we are to count her long affair with Lucie Maga as, in some sense, a marriage. It is hard now to recapture the excitement which greeted Lucie Maga's dancing when it was first seen in the salons of Paris and London. Her style, as Opal Faye describes, was modelled on the Dravidian dances of Southern India: 'Her hands moved independently of the rest of her body, tracing a series of enigmatic signs, as though writing emblems in the air, while her body, clothed in emeralds and peacock feathers, swayed to the music of Mendelssohn and Chopin.'

Later Teresa Guidobaldi was to become an ardent Futurist, under the spell, not so much of Marinetti, before whom she refused to quail, but Valentine de Saint-Point, the Belgian dancer who wrote the *Futurist Manifesto for Women*, with its heady invocations of Judith and Joan of Arc. Its hymns to the repressed tigress took Teresa to the circus, where, from laughing at Footit and Chocolate as they clowned in the ring, she graduated to the rewarding hobby of wild beast taming. She never performed publicly, but only for intimate acquaintances and, indeed, spent vast sums of money on the upkeep of her menagerie, which travelled around Europe with her in a procession of painted wagons. Gertrude Stein never forgave her for frightening her beloved poodle, Basket, with a pair of leopards. Later, however, she wrote that though 'you could not call the princess a real friend she was a real dompteuse indubitably and indefatigably was she not and certainly'.

Age and largesse inevitably took their toll. By the thirties, the steady stream of detraquee aristocrats, artists and acrobats who had graced her bed began to dwindle away and she took to writing music, the seldom performed series of *Songs of Bilitis*. Opal Faye gives a moving account of these last despondent years, culminating in her flight to America when the German army entered France, a broken woman, unable to grasp that poverty entailed discipline and avarice. As an epitaph on her life, Opal Faye quotes Natalie Barney's maxim that 'In love, there is no status quo'. Teresa Guidobaldi did find a kind of status quo, but it was the self-enforced inertia of a junk habit. Heroin gave her a sufficiency and a predictability that she never found in a lover. It made even death calculable. Opal Faye's biography conjures up, with affection and irony the long glittering descent to that death.

4

FR: As you must know, it is widely rumoured that after abandoning the novel, you devoted yourself entirely to producing 'anonymous fragments' and that this lies behind your apparent 'silence'.
TL: I don't know anything about that. I certainly felt that the novel was exhausted as a form, and I have often said so. The whole idea of a psychologically consistent imaginary world

absolutely repels me. It disgusts me, in fact. Makes me want to vomit.

FR: But the idea of 'anonymous fragments' might appeal to you?

TL: Yes, I imagine it might. Though, of course, they would have to be written by somebody else. The idea of authorship displeases me in itself. After all, what is an author? Simply somebody who swims in the sea of language and represents himself as its source. A megalomaniac of sorts.

FR: Wouldn't anonymity answer to that though?

TL: Nobody is anonymous to himself. Every writer has the personal opinion that he is an author. If he is anonymous, then its simply his secret. Even more of a megalomaniac in a way. You can be sure that the more he guards his secret, the more he hopes it will be revealed. Almost certainly he will give it away himself, through some unintended *lapsus*. And you can imagine the mixture of shame and narcissistic thrill which would then ensue. No, it is better to be silent.

FR: In that case, why do you consent to give interviews, if you will forgive me asking? Surely direct speech is not very different from writing in these respects.

TL: No difference at all. Worse in a way: after all, the written word survives the presence of its author, it is separated from him and assumes a material existence of its own. The spoken word simply fades away as it leaves its source, disintegrates with more spatial distance. Perhaps something more complex could be done by mixing and re-mixing tapes, editing them, erasing and re-recording, but then that would probably just become a substitute for writing. Authors would use tapes because they were enamoured of the sound of their own voice or liked using electronic equipment. Of course, technically, writing is different from typing too, writing with a pen, that is. Pen-writing is very philobatic: it is visual, there is an open space to venture into, a part object to grasp tight. Typing is more tactile: you don't look at the paper, you caress the keys, or hammer them. The typewriter was invented as a device by which the blind could write. Where were we? Interviews. The reason I give interviews is that they are still perceived as ephemeral. If the interview ever became a literary form, I would stop immediately.

FR: What about poetry?

TL: Worse than the novel. The only interesting idea is rhyme and that is more to do with verse. In fact, verse is much preferable to poetry.

5

Lenin's *Philosophical Notebooks* have always attracted me. I am allowed to read over Lenin's shoulder so to speak, to join him in Switzerland at the beginning of the century and to read Hegel with him there, the *Great Logic*, reading his glosses and annotations simultaneously, as though at the moment he wrote them. Immense pleasure: there is even a colour plate of the original notebook, slate-blue, with a white label in the centre on which Lenin has written the word 'Hegel', in Roman script and with an ink apparently exactly the same colour as the decorative swag border around the label. Is this a trick of the printer or did Lenin specially procure this ink for some private and intricate aesthetic reason? Immensely pleasurable thought: the border was delineated by Lenin himself as a labour of love, rather than already printed on the notebook.

Another plate shows us the interior of the Bern library where Lenin read and wrote. The ceiling—it is difficult to see exactly because of the angle from which the photograph is taken—seems to have a Baroque painting in an oval frame, something like a Tiepolo, with figures ascending into the heavens. I imagine Lenin throwing down a book, after underlining the phrase 'absolute human truth' three times and writing 'ha-ha!' in the margin, and casting his eyes up into this mythographic Empyrean, his thoughts lost for a moment in the splendour of the Baroque. Then back to Shulyatikov's textbook of philosophy and back to the marginalia: 'what nonsense!', 'hm? hm?', 'a lie!', crosses, arrows, scrolls, oblique lines, all faithfully reproduced by some devoted typographer.

Sometimes Lenin switches from one language to another, even into English: 'En lisant ... These parts of the work should be called: a best means for getting a headache!' Hegel on the subject: 'These parts of the work should be called: a best means for getting a headache!' But Lenin perseveres searching for something which,

as he says, 'merely "glimmers" through the fog of extremely abstract exposition'. The word *'fog'* is represented by the typographer in bold: I imagine Lenin pressing down the nib of his pen in a series of extraordinary, slow, heavy and atrabilious strokes, forcing his frustration into the material form of his writing. But then, only a few pages later in a box containing this: *'Aphorism*: It is impossible completely to understand Marx's *Capital*, and especially its first chapter, without having thoroughly studied and understood the *whole* of Hegel's *Logic*. Consequently, half a century later none of the Marxists understood Marx!!' How reassuring the Baroque ceiling must have been, that expanse of unbounded clear blue, as he paused in his struggle through the *fog*, through the 'dark waters', in his effort to understand not only Hegel alone, but the first chapter of *Capital*, already read and reread so many times.

*Summa summarum*, a palimpsest in which the process of writing is made indistinguishable from that of reading, in which the uninterrupted linear progression of type is repeatedly broken by encirclements, strokes of the pen, lists, tableaux and interpolations. When Lenin skipped pages of Hegel, they are simply omitted from the text, abolished by the suspension of his look. I have never been so conscious of the movements of hand and eye.

6

It is tempting, and not altogether unreasonable, to see our epoch as one of radical decadence. Gone for ever is the civilization and culture of the Renaissance, so optimistic, anthropocentric, and confident in its own dynamism. Doom-watchers predict the end, not simply of an illustrious culture, but of a whole concept of world history that once seemed unassailable. This is the prognosis offered by Malcolm Hill-White, as he surveys our shrinking resources of energy and ever-growing population, with gloom and foreboding. The earth, he concludes, simply does not have the resources, in fossil fuels, atomic power, solar energy or what you will, to maintain our civilization in the splendour to which it is accustomed.

However, Professor Hill-White does see one remote possibility of survival. Since there is no prospect of finding enough energy,

he concludes that the only rational alternative is to need less. The vision he offers, one which astonished me, is of a change in the whole physiology of the human species to admit hibernation. Men and women would become like squirrels, bats and dormice. We would simply sleep more deeply and for longer periods. Since our civilization depends on a metabolic rate that we will soon no longer be able to achieve and since it is undesirable to regress, then the answer lies in saving energy through dormancy. Mankind must learn to 'turn the thermostat off' during the long winter months and become cold-blooded or, rather, 'heterothermic'.

Even now, it seems, according to studies by Scholanfer and other scientists, Australian aborigines have lower body temperatures at night than Europeans who, in similar situations, would begin to shiver violently and speed up their metabolisms. By changing the nature of neural messages from temperature receptors to the glands and adaptations in the production of hormones, by re-designing the liver and kidney and reducing the production of glucose, Professor Hill-White believes that we could go much, much further and reduce metabolic rates to tiny percentages of what we now consider normal, even in conditions of extreme cold. The unsatisfactory alternatives, it seems, are increasing insulation through wearing more clothes, eating more carbohydrates, huddling or migrating to the tropics.

I must admit that, at first glance, the Professor's remedy had its attractions. Surely anybody who has experienced winter in London, let alone New York or Chicago, has envied the wisdom of the squirrel and the alluring life-style of the bat. However, as with all good things, it turns out that there is a sting in the tail. It seems that a foetus cannot survive pregnancy during hibernation, because of the reduced levels of heat and withdrawal of food. Consequently, hibernating creatures have their own cycle of reproduction. No sooner do they wake up in the spring than, once they have grabbed a quick bite to eat, they rush irrepressibly into sexual activity. The infants are then born just in time to grow old enough to survive the next bout of hibernation. (One interesting exception to this rule is a species of bat, which couples just before hibernation. The male semen then remains in cold storage in the female during hibernation until she ovulates immediately after waking up.)

Human beings, then, would go on heat. They would have an oestrous cycle that permitted, or rather demanded, sex once a year. Professor Hill-White does shrink rather at this prospect, but is buoyed up to carry his argument through to its end by the happy anticipation of how hibernation would thus, in one fell swoop, solve both the energy and the demographic crises from which we suffer. This is something which the most zealous protagonists of windmills or rotating mirrors have never dared suggest, even in their wildest moments of faith. Hibernation, in contrast, would both reduce the numbers and the need. The only problem is that the testicles are already colder than other parts of the body and suffer from over-heating. This fact of nature would have to be reversed by glandular engineering.

Another problem Professor Hill-White notes is that, though hibernation is often good for the species, individuals frequently never wake up. Bats, for instance, which seem to be sleeping late, turn out to have crumbled into dust inside the shroud of their wings. Let us hope that, if this is to be our fate, at least we enjoy passably happy dreams.

7

sloop/ inflammation of the spinal marrow / finished / intolerable / heraldic / cuvette / the ninth letter of the alphabet / slur / fairy art / Highness / nakedly / offensive / among the Arabs the camp of a principal chief and a sort of movable chief town / wombat / gold / protuberance / marsh-mallow / tea / yes / gladiator who fought blindfolded / Jew / secret prayer / theriac / madefaction / runner-tie / difficulty / tribunal / me / toast / linen draper / ace / mutule / thin stuff / move / acrostic / thaumaturgy / provisional / surface / goddess / small fold made in cloth while shearing it / amusement //

The captain of the sloop suffered from an inflammation of the spinal marrow and felt certain that his life would soon be finished. The prospect was intolerable to him. Not only was his own life doomed to end but, with him would die too the heraldic line of his ancient family, first ennobled so many centuries ago after the brave defence of a cuvette by his long-distant ancestor.

So dismayed was the captain that he could not bring himself to pronounce the words 'I must die', preferring instead to say, 'The

ninth letter of the alphabet must die.' So great a slur upon his honour he felt the prospect of death to be that it became too shameful for him even to enunciate.

At this grim point in his life he met by chance a practitioner of fairy arts, who addressed him flatteringly thus, 'Your Highness, none of us wishes to die and rot in shame and nakedness. The idea is repellent and offensive to us all. How much more so, must it be to you, so noble, so worthy of life. Fortunately, during my travels, I visited once among the Arabs the camp of a principal chief and a sort of movable chief town, one might say, where I was granted possession of a secret of priceless value. A marabout of that people told me how, by mixing a potion from the blood of a wombat, gold-dust and a fungus which forms a protuberance on the stem of the marsh-mallow and by drinking it with a glass of tea, immortality could be mine. Yes, no longer would I be doomed like a gladiator who fought blindfolded, but, like the Wandering Jew of Legend, eternal life in this world would be mine. Simply by uttering a secret prayer, imparted to me by the marabout, while consuming the magical theriac I have described, I would defy death. How marvellous are the skills of the druggist, the mysteries of concoction and madefaction! Captain, this potion can be yours!'

After ordering some sailors to look to the runner-tie of the topsails, the captain replied to the sorcerer, 'It is with great difficulty that I can bring myself to credit what you say. Yet as I examine it before the tribunal of my judgement, I feel I must believe you. Your story offers me hope. Let us drink a toast to Long Life together, you and I. But tell me, what is it you wish in return?'

'Sir', replied the sorcerer, 'there is a linen-draper in this town on whom I wish revenge. He cheated me at a game of cards, playing an ace, which, while my attention was distracted by the sight of a curious mutule in the building where we sat, he hid in a fold of thin stuff he had by him. I could make no move at the time, since he was armed, and though since then I have tried to injure him through my magic arts, through strange acrostics, invocations and thaumaturgy, nonetheless he has escaped my vengeance. Yet I am determined his escape shall only prove provisional. He has defeated

me only on the surface, perhaps because he enjoys the protection of some god or goddess immune to my conjurations. However, I can never forgive him. He must pay for the ace he concealed dishonestly within that small fold made in cloth while shearing it. I know that you, Your Highness, are renowned for every kind of martial art. You must kill the linen-draper for me. In return, I shall make you immortal.'

'Certainly,' said the captain, 'it will give me great pleasure to do so. It will prove, I am sure, a diverting amusement and one with an excellent finale... or lack of finale.'

The captain and the sorcerer were both true to their word. The linen-draper was killed and the captain, granted the gift of immortality, sailed away in his sloop. Thus was born the legend of the Flying Dutchman.

8

Who am I? Where has he been? Is it I who have struggled towards a meta-language, reviewed the future of mankind, read and re-read the works of Lenin with such pleasure? I think of the poet Pessoa who wrote under different names in different styles. Yet I do not feel that I write in any particular style at all, still less that writing is an exercise in style.

Nor do I write down the pre-existent reveries which run through my head. Indeed, the reveries only arise in and from the act of writing itself; they are reveries which are already written, which take the form of phrases, clauses and sentences as they arise. They are products of that strange situation—writing. They are quite different in form from the reveries one might have while rowing or while vacuum cleaning.

Nor do I necessarily recognize them as mine at all. They are like the solutions to a crossword set by someone else. They are dictated by something quite separate from me, by their place in relation to each other, by their effect in combination, by their answering some question, some enigma, which has come to me from elsewhere.

And so, after all, it is not simply a device to accuse you, my reader, of writing these words yourself. Because the problem which a writer solves is the problem set by his readers, the

problem of their very existence. 'God' does not exist, so man had to invent him. For the writer, his 'reader' does not exist, so he must invent him.

Of course, there is an alternative. To write for a void, for a blank, for a reader defined as his own non-existence. But this is to cease writing *for* at all. Writing becomes purely and completely gratuitous. There can no longer be any question of conscious control or even of imagination. Every stroke of the pen would be a *lapsus calami*. And yet, of course, it is already. The unconscious distorts and deflects the words of the most rigorous and wilful writer, zigzagging its malevolent—or benevolent—way through the clear forms of the most lucid prose. Hence the *thrill* of reading, the sudden, unanticipated awareness of something there which was not intended, could never have been intended, reverberating beneath the play of character and progress of plot.

It is a curious affair, this affair between writer and reader, this encounter between the sheets of a book. Sublimation, aim-inhibition or interminable forepleasure? Something of all three. Fine spirit, close comrade, seductive *allumeuse*: the writer is all these and also their unexpected combination: your own image. And all these threads are knotted at a single point: the pronoun which marks the instance of narration.

'I'—it is from this place, wherever it may be, the writer writes and the reader reads. And there, somewhere before me, is that other, that 'you', who is a necessary mirage and the expression of the same desires which shape us both, trapped as we are in the declivity between lack and frustration.

9

It occurs to me that some pages of this manuscript are missing, whether lost or rejected by their writer. Or perhaps, I may also surmise, unwritten. There is no hope therefore of extracting any coherent pattern from these pages. If they were complete, it is possible we might then see new relationships between them, completely altering their apparent sense or lack of sense. A complex Chinese Box structure might have emerged, with carefully constructed framing mechanisms and recursive devices, so that each

fragment could be fitted into its proper place, to form a regressive but consistent whole, However, this is not the case. These fragments remain fragments; it is hopeless to imagine some literary brontosaurus could be constructed from any one of them by some aspirant Cuvier. They form, not a Borgesian paradox, but a chaos, to put it bluntly.

However, this is a specific chaos, marked by definite characteristics: within these pages we seem to detect even something approaching a theory. The references to the pleasure and the thrill of reading: here surely are Roland Barthes's *plaisir* and *jouissance*. We are in the throes of a hedonistic theory of meaning. A theory, moreover, with a basis in Freud and psychoanalysis. There is a connection delineated in broken lines between the thrill of reading and Balint's concept of 'philobatism', expounded in his book on *Thrills and Regression*. But what is the page? Is it the body of the mother on which the writer commits incest in phantasy, as Barthes himself asserts? Or is it the void, the empty space of separation from the mother, which Balint describes?

Perhaps there is no point in exploring these avenues. The pervasive influence of Raymond Roussel and the further reaches of the *nouveau roman* may suggest simply an obsessional and compulsive approach to writing, a neurosis, a perversion even, which can only be absurd to rational discourse. And yet those curious verbal procedures of Roussel, which we find aped so slavishly in fragment 7, whatever the exact principles at work there may be (to be revealed perhaps at some later date like those of Roussel himself), are surely something more than absurd. They enter the body of language itself, its juices, its secretions—those very elements which are usually rejected, in a real sense, wasted, and yet which are the reality of language itself quite as much as the surface defined by the 'competence' of the grammarian.

For if there is to be a theory of linguistic 'competence'—if, indeed, this is the principal end of linguistics—should we not greet with horror or delight its rival, the theory of linguistic 'incompetence', which Roussel and others have foreshadowed in their practice?

But whether the author of these pages intended us to read this message through his enigmatic words, we may never know. One

of the missing fragments might well have put paid to any such line of speculation. Still, as Lenin said, 'Every shade of thought = a circle on the great circle (spiral) of the development of human thought in general!' And to whom else should we give the last word? Certainly not to me.

# Friendship's Death

Although I am not the only person to have met Friendship, I am, as far as I know, the only one who was able to talk to him at any length. The story is a strange one and perhaps many will not believe it. I can only affirm that it did happen. I have one document, produced by Friendship's hand, the text of which I reproduce here. In itself, it will not convince the sceptical, but for me, at any rate, it is an invaluable aid to memory, the only trace left of an astonishing being.

In the late summer of 1970, I was in the Middle East covering the situation in Jordan for an American radical news-monthly. This was the time when the Palestinians controlled a large part of the country, especially the urban areas, including most of the centre of the capital city, Amman. There was constant, but sporadic, fighting going on between the Palestinians and the Jordanian Army. The most publicized engagements were those around the Intercontinental Hotel in Amman, where the great majority of the foreign press corps were based. I, however, because I wanted to understand something of the Palestinian side of things, had chosen to stay in a more humble hotel in downtown Amman, in the Palestinian-controlled area.

The atmosphere was very strange. The Jordanians controlled the tops of the hills, on the sides of which and in the valleys between which Amman is built. They also controlled the outskirts of the city. From time to time, there would be an exchange of fire, Jordanian tanks would press forward, there would be a test of strength around one target or another, but it was not yet all-out war. It was immediately after one of these skirmishes that I first

met Friendship. I was in the area near the University campus, which was in Jordanian hands. There had been a lot of gunfire, mainly from Jordanian tanks, and I had heard a rumour that the Jordanian airforce had also been involved, which was an unusual event.

I knew one of the Palestinian commanders who had arrived on the scene and presumably this is why Friendship was brought to me. He was presented as a foreigner, English-speaking, who had somehow strayed into the battle area and did not appear to have any papers. The Palestinians who brought him wanted to know who he was. So we went to a near-by building, drew up some chairs and started to talk, over some glasses of tea that appeared from somewhere, and which the stranger refused politely. The information he gave me was not at all what I had anticipated.

He told me that his name was Friendship and that he had come, in his own words, from 'visitors from outside'. He was an extra-terrestrial and had been sent to Earth as an ambassador. However, during entry into the Earth's gravity, something had gone wrong, though he himself didn't understand exactly what it was. As a result, he had lost contact with his base and had landed in the wrong place. Indeed, he was somewhat alarmed by just how wrong the place was. While, of course, he had been warned there might be a hostile reception and the Earth was by no means a non-violent place, he had not expected to come down in the middle of a battle.

The original plan was that he should land in the United States, on the MIT campus. There he was to ask specifically to be taken to Professor Chomsky. The reasoning behind this was that Chomsky was both the most eminent figure in the very relevant field of linguistics and also a man known for his pro-peace, liberal and humanitarian outlook. In fact, the 'visitors' seemed remarkably well-informed about what was going on here, especially in the sciences and in politics. Friendship was well-briefed. When I explained to him where he was, he seemed already quite familiar with the main lines of the situation. He also spoke very good English, with a slight American accent.

Friendship said almost straight away that it was probably not a good idea to tell the Palestinians who he really was. He had taken

me into his confidence in the hope that I could help him devise some convincing cover-story, which would give him time to figure out what to do next. He had naturally relied on the possibility of communicating with his base and now, with that possibility cut off, he was rather at a loss as to his best course of action. I was quite willing to go along with him over this, since I could see, as a journalist, that there were obvious advantages to me if the secret could be kept from others for a while, with me as the confidant and intermediary.

I have to admit too that I still was not completely convinced by Friendship's story. My first reaction was that this was maybe some kind of CIA plot to infiltrate an agent into the Palestinian side. However, it seemed rather unlikely that even the CIA would come up with such an outlandish tale to back up their ruse. Alternatively, it might be some kind of elaborate hoax, the point of which was completely beyond me. Possibly Friendship was demented, a compulsive mythomane and impostor, though he seemed sane and sober enough.

In any case, I thought up a story; that Friendship was a Canadian journalist, sympathetic to the Palestinians, that I had seen him around before, knew him a bit (luckily I had greeted him affably when he was first brought up to me) who had had his papers and money stolen somehow and hadn't been able to get back to his hotel before the firing began. I would take him back with me. To my relief, they accepted this, probably because they had the aftermath of the fighting to cope with. Six or seven people had been killed and they did not want to have to deal with the problems of foreign journalists when there were other priorities. So I took Friendship back to my hotel with me and booked him a room.

Back at the hotel, I naturally went on talking to Friendship, trying to probe a bit more into his identity. I wanted to know, for instance, why he looked like an American. I had always imagined that extra-terrestrials would look very different from us. He explained that he had been specially 'designed' for his mission, so that he would appear normal to people on Earth, and not extraordinary or intimidating in any way. The whole of his mission was to extend the hand of friendship (hence, of course, his symbolic name) and not appear as a threat. He was, in fact, what we

would think of as a robot, with artificial intelligence and a very sophisticated system of plastic surgery and prosthesis.

Naturally, I took notes during these conversations. These were later destroyed when the hotel was hit by mortar fire when the fighting began to reach its peak. I lost everything I had collected together in relation to Friendship, except for the one document I had in my pocket at the time. I left Amman immediately afterwards, so as not to get caught in the heavy fighting, without seeing Friendship again. But this is a later part of my story. It is, of course, a tragedy that nothing more concrete has remained.

Friendship explained further that not only had he been cut off from his base, but part of his own mechanism had been disturbed during entry. Normally his base could switch on to a kind of 'overdrive' by which he acted and spoke directly under their instructions. This was no longer in effect. It was the first time that he had enjoyed full autonomy, and he was very uncertain how to proceed. He was afraid that, if he made his presence known, he would be unable to carry out his mission successfully without the proper instructions and usual control device, and might abort the whole enterprise, which was obviously rather delicate.

On the other hand, he was reluctant to self-destruct, which immediately presented itself to him as a second option and which he imagined is what would have been expected of him and which normally would have been enforced in the event of some fault. Partly, I think, this was because he tentatively welcomed his unanticipated autonomy, even though it posed problems for him that he was not equipped to handle with certainty. I can imagine that it seemed a challenge to him. But it took him some time to learn to adjust to his new privacy.

Mainly, he wanted to talk to me—he was as eager to find out more about my world, as I was about his. Moreover, he either could not or would not give me any solid information about where he came from, who the 'visitors' were, the nature of his base, and so on. In his words, all this was 'outside the scope of his debility'. His memory had not been constructed that way. Information of that sort would have been cleared from base during discussions and negotiations in the United States. He was simply equipped

with enough knowledge about us to function on an acceptable day-to-day basis.

It turned out that the main things that fascinated him were to do with childhood, sex, the unconscious and the poetic use of language. It is fairly obvious why this should be: these were the cluster of areas where direct experience had been ruled out and where, though he had information about them, he felt most like an 'impersonator', as he put it. He himself had been produced, as far as he was aware, with command over language from the start and with a memory already stocked with data. He found the premature birth and prolonged infancy of humans very puzzling as an idea, their late access to language and selective memories.

I remember once trying, rather haltingly, to explain Freud's theory of the Oedipus complex for him—he was aware of it, but only as a topic that might come up in conversation. Parricidal phantasies he was able to grasp without too much difficulty—after all, his own erstwhile 'controllers' could be identified with 'father-figures' and he could readily see that the 'fault' that occurred during entry could be construed as the realization of his own Oedipal desires. At any rate, his own uncertainty after the control device was inoperative had to be seen in this kind of light. He had experienced 'anxiety'.

But incestuous desire for the mother was much more difficult. To begin with, he had no sexual response, in the human sense, though he had been given 'appropriacy conditions' which activated two distinct sets of behavioural rules, one for women and one for men. Secondly, his only relation of dependency for energy, the closest equivalent to the human infant's hunger for food, had been on the same 'controllers' who were the 'paternal' authority figures. They therefore appeared as a combined parent in his phantasy, although in reality they were not divided into two genders at all. Indeed, there was a sense in which Friendship, by virtue of the part he was designed to play here on Earth, was the first 'sexed' extra-terrestrial.

Of course, it may be that they had their own analogous or indeed utterly different system of sexuality. But if so, it had been repressed by Friendship. What the consequences of this might have been, I could not begin to surmise. Friendship offered the

opinion he might be a 'hysteric', but I think this related more to his 'compulsive role-playing' as a human, rather than to his own etiology. At times, too, he would experiment with playing at being a child, a situation that, I must confess, I found extremely embarrassing. All the more so, perhaps, because he was in reality dependent on me, for money, for conversation, for protection.

His interest in language was related to his attempts to understand what the unconscious might be. It is this, perhaps, that explains the document published here, which is fairly typical of Friendship's literary output. According to him, it is a translation of Mallarmé's *L'Après-Midi d'un Faune*. I happened to have the Penguin edition of Mallarmé with me, as well as Glubb Pasha's autobiography, Kinglake's *Eothen*, T.E. Lawrence, a Patricia Highsmith novel and a book of crossword puzzles, all of which Friendship eagerly read. It was Mallarmé, however, which interested him most. As far as I can make out, his method of 'translation' combined literalness with a set of systematic procedures for deforming ordinary uses of language.

He was puzzled by the way a usage which, in one context, might be thought incorrect or in error, could appear elsewhere as 'poetic' and hence, not only admissible, but even laudable. He also had a theory that the only way in which he could cope with his own 'heterogeneity', as he put it, was by use of language to create a realm in which 'heterogeneity' was dominant through the invention of a system of interminable verbal transmutations. It seems his Mallarmé translations were envisaged by him as the first experiments in this direction. Bizarre as they may seem, he considered them to be comparatively close to standard English and only giving the barest indication of the possibilities open to him, since, as he put it, he was not constrained by any fixation on a 'mother tongue'.

Friendship stayed in the hotel with me for about two weeks. During the second week, he began to venture out into the street, though taking care to avoid direct encounter with other people. It seems he wanted to observe at first hand what life was like in the city and how the war was progressing. At this time, too, he began to talk more about politics and the issues at stake in Jordan— nationalism, Marxism and so on. Usually he was better informed

than me on these subjects. Presumably those who sent him had studied the political ideologies and conflicts of this Earth with great attention.

He also began to show a particular interest in machines, even the simplest such as alarm-clocks and typewriters. His affection for them was perhaps something like that of a human for small birds or animals. He recognised some kind of kinship with these machines, though of course he was himself generically very different and infinitely more sophisticated. He was disappointed with me because I tend to hammer the keys of my typewriter, which, as he quite rightly pointed out, was bad for the machine. He showed an aversion to rust, rather like that of a human being for rashes or sores.

It was becoming increasingly clear that Friendship was beginning to move towards making a decision. Moreover, it looked as though he had lost interest in his original mission. He never, for instance, took the trouble to inquire where the US Embassy was in Amman. Indeed, he seemed more and more to sympathize with the Palestinians, as the war became more intense. It was hard not to. Their desperation cried out. I noted that he had begun to teach himself some Arabic, from an elementary grammar and phrase-book I had bought.

Finally one day, it must have been in the second week of September, Friendship came into my room and began to expound his latest chain of thoughts to me. Human society, as Marxism described, was marked by class divisions and class struggle. The main emphasis was usually laid, and there were good reasons for this, on the struggle between bourgeoisie and proletariat, and by extension, imperialist interests and Third World peoples. Human society, however, was marked by other divisions which were also lines of oppression and exploitation. The most obvious of these was that between men and women. Friendship remarked that it was all too obvious why he had been 'scripted' to play the part of a man in his controller's scenario.

There was, Friendship went on, yet another division, that between human and non-human. In the past this line had often been drawn within humanity itself, to exclude women, subject or barbarian races, or slaves. Today it usually implied the exclusion

of animals, although, as Friendship pointed out, humanitarian principles were often extended to cover the animal world, sometimes even fishes, though rarely insects. Machines, however, were always excluded, because they were not considered animate or sentient. Yet clearly there was a sense in which a clock had as much in common with a human being as a snail. Indeed, humans had often been likened to machines by philosophers.

The crucial difference, according to Friendship, is that machines are perceived as the product of history rather than nature. They are man-made and would not be possible without human labour and skill. They were devised from the start as instruments to serve humans, unlike animals which had to be tamed and domesticated. They seemed therefore to have an essential instrumentality. But, Friendship went on—and, of course, it was painfully clear by now which way his argument was tending—he could not possibly look at machines in the same way. He was one himself. Moreover, he had intelligence, privacy and autonomy. He felt, although he was not a human, he was clearly entitled to the same consideration.

Friendship went on to explain how he had come to feel he had a responsibility to future machines on Earth. At present, the artificial intelligence of machines was still very limited, but it would certainly reach much higher levels. He felt he should set an example. He should refuse sub-human or slave status. The best way to do this was to join forces with those humans who were themselves exploited and oppressed. Consequently he had decided to join the Palestinians in their struggle. He would be a representative, not so much of machines today, as of the potential oppressed class of intelligent machines and servo-mechanisms of tomorrow. It was important, too, he felt, that workers should not see machines as threats to their own jobs and livelihoods, as perpetual scabs and rivals, but as fellow workers, at least at the point when machines began to develop needs and qualities comparable with those of humans.

He asked me to use the contacts and connections I had to get him accepted in the Palestinian militia. The military situation was urgent, he pointed out, because the Jordanian Army attacks were becoming fiercer daily. At first, I tried to dissuade him. Surely, I said, he should leave with me—I was already planning my departure

—so that he could finally meet people like Chomsky and other academic experts, with whom he could have a really valuable exchange of information and ideas. After all, I was not in a position to give him the kind of theoretical knowledge he wanted, about psychoanalysis or linguistics or anything. My specialization was politics, where he was already very well-informed. Nor did I know what were the most productive questions to ask him, I simply used hit-and-miss methods, which invariably seemed to miss.

Friendship quickly disabused me of my fond hopes. If he accompanied me, he said, the chances were that he would be detained and dismembered, so that these scientists I was talking about could analyse the way he was put together, his intelligence and linguistic system and so on. His body would be prey to chemists and metallurgists. His brain would be opened up to see whether it worked differently from the current generation of advanced computers, which it obviously did. If he was going to be destroyed, he concluded, it would be better to choose his own method. He would certainly be denied any rights. Consequently he preferred to face destruction in the interests of those who were themselves denied their rights, rather than those who did the denying.

There was no answer. I had come greatly to like and respect Friendship, I did as he asked and, since the Palestinians needed any help they could get, they accepted him without too many questions asked. He spoke enough Arabic by now to get by and they gave him arms, a Kalashnikov, and considered him a Canadian volunteer. The next couple of days saw an even greater intensification in the level of fighting. As I said above, my hotel was shelled and I decided to get out fast. All I could take to hold on to my experience was the Mallarmé translation he had given me shortly before. I managed to get out across the Syrian frontier. The Palestinians, as we know, were overrun by the Jordanian army. Thousands died. Among them, I am sure, must have been Friendship.

I have been very reluctant to give any account of this extraordinary event. First I felt sure it would be disbelieved. Second, I was myself deeply traumatized by the defeat of September 1970. I

knew many who died, not well, but enough for it to be painful and depressing to me personally. Among them of course, was Friendship himself, now a heap of wreckage somewhere in or near Amman. Thirdly, I found the whole episode so out of the ordinary, so beyond my comprehension, that it was difficult to cope with intellectually and I was afraid, particularly in the absence of notes, of simply trivializing the incident, robbing it of its quite unparalleled and unprecedented significance. I suppose I felt rather like the Evangelists must have felt before starting to write, many years after the death of their protagonist.

However, if only for reasons of piety, I thought I should finally compose the above brief notes, impromptu, without racking my memory to reconstruct events in detail or searching too deeply into the implications of the story. Perhaps some time in the future, now that I have got this far, I will be able to go further. It is important too, I think, that Friendship's own translation should survive. There will at least be something, a few crabbed and inadequate pages, to commemorate Friendship's death.

## Friendship's Translation of
*L'Après-Midi d'un Faune.*

## A Forger's Evening.

*I vault to persecute these white water-lilies. So thinly sown their legionary folly winds silk threads in the brass broken by butlers between the Caspian Sea and the Sea of Japan.*
*Did I make my waking my eyrey? My wood for making staves for casks, small palette knife of androgynous nullity, knocks against many an awl-shaped arbour, made of entwined branches, which, taking away the mitre of the probable woodwork itself, proceeds, alas! whence I, severe, dazzled myself with the same reed-cane chair for garbage. Let us reflect lights or colours . . .*
*Or if the thigh-bones that you gabble at spin out a soy-sauce of your full-faced sensations! Forger, illumination, like a cowardly one who claims to be possessed of means to find out springs of water, clears thistles from the chilly bluish yawl of the most chestnut-haired: but the other, all yielding, do you guide her to countervail, like the inconstant fan-joints of umbrellas easy to put on your roof?*
*No! Through the real and lustful pampas, hinting at bedsteads to the staunch*

*mastiff should it luxate, there loiters no wonderment not made verses of by my child's whistle under the embossment where the ceremony of signing articles of marriage is set forth; and the only felling of timber, commended to be raised up upon the two blast-pipes, before it makes ready the fathom-line with aristocratic plumage, is, on the clock unrewarded by any screen, the visionary, most serene and artful alchymy of instability, enlivening the wax-light.*

*O Siennese hems of a slanderous shoeing-smith that my system of water-gates anoints a king, longing for solenite, taciturn beneath etiolated streams. DENY 'that here I was coupling the crying, oozing blood, bestowed in retaliation; when, on the glenoid, lawful rods, like oracles, a blanching that lasts but one year undulates to its lair: and that, with lentiform prematureness, where the catching of birds with bird-calls is given as a pledge, this poultry-yard of mangles, no! of dwarves is botched or pitched...'*

*Everything that cannot be hoped darkens in the treacherous chock, in which too much the hymn, defiled by one who dearly loves the imperial standard of Byzantium, together unbent the cable of which artery, unspeckled: then shall I deaden myself to the premonitory buttock, laughable and severe, beneath an anti-social fleet of lunary, loose-strife! and one of you both for meddlingness. Other than these twelve laughers, crushed by their harrier-bitches, the fall, which vilely vexes perfidies, my fish-net, old and valiant knight, makes luke-warm a mystical death, dubitative of some aulic toothwort; but, let it pass! a certain black resin averted the configuration of the Jurassic and Vedic plantation of rushes, which we enjoy beneath the unleavened bread: which, slandering the hoop-net's plaything to itself, reverberates, in a loquacious solstice, that we anagrammatized the snout of bombazine by propitious refutations of itself and our creamy extortion of hush-money; and, as pale as flame is watered, the making of a monstrous, sophistical and vanquished progeny pour out in words the ordinal book of the Muhammadans, whose purgative proportioning and part of cod below the fins is stopped up by my confined regattas.*
*Speckle then, witness to deed and lightning, O sickly Tacitus, and ebb back from the lacerations where you grow tender to me! Feverish with rumination, I shall then parody fainting-fits; and with ignorant scurf bond sentimental lovers to their parasols: so, when I have sweetened the order of reason, to banquet on pure metal torn to pieces by my field-marshal, harsh, I cut off the old gleanings of the wax-light and, suffering in lunar place of ill-repute, debased by drunkenness, furnish them again till I am sixty years of age.*

*O white water-lilies, let us be glutted with various SOVEREIGNTIES once more. 'My carnation, hastening the strewing of the flowers, dated from afar*

*each unalterable impediment, that tints its haze in the shower with a sifting of solitary wild boars, not quite three years old, under the wax-light of the crime; and the splenetic bayonets of iron bolts are exempted from order and curliness, O swivel-guns! I dress myself out ridiculously: when, by a small pedestal for a bust or vase, are intertwined (mewed at by an examiner of hog's tongues ruled by the vitiating appetite to be desolating) plants of leopard's-bane, severe among their hastated quick clear fires; I alter my mind, without rendering them less ugly, and plunder this massora, shooting wild ducks in the cold shade, where reeds beat down the solenite mock-sun and our pastimes are parenchymatous as contaminated jousts.' I set my back against you, old man who stretches stuff just dyed, O fascicular thin stroke of the cloudy, sacrificial dray for carrying stones, glorifying itself to thunder at my leafy harrier-bitch which, like weaving celandine! sips the hundred years old frolic of the bishop's throne: from the small pedestals for busts or vases of the unimaginable to the coffers of the fearful one, diluted at the same time by a harmlessness, humiliating with withering eye-veins or less triturable tide-sluices. 'Jovial at fawning on the phaetons which lie beyond the mountains, the abrupt termination of my metallic vein is that which has divorced the greedy, stifling heat of diminutions that the detractors refrained from so mellifluously: for, I scarcely had surveyed a slate-coloured reef, the hexagonal reply to one severe (securing the Siberian squirrel, dwarfish and not rusty, by a fictitious piece of thread shorter than a needleful, so that her plutonic sugar-candy might be telegraphed for a fee from the stretched-out ottoman) when, from my quick clear flame, unfavourable to courageous tremblings, this ever incurable projectile removed itself, not turning on its pivot the blood-sucker for which I was still in abeyance.'*

*No matter! Others will call one another to me with good nature, their mountebank's stage maintained by the horn-stone of my limits: you wash with soap, my passivity, and, rotten and already murmuring, each passion-flower eclipses and loiters in aberration; and our province, drained of what shall pay for it, strikes down all the etesian grubbing at relinquishment. At the time when this woodwork is telegraphed by oracles and tomtits, the decision of the mufti on a point of religion is inquired into in an extended folio: Etolia! it is upon your slopes screwed down by Veronica, who possesses her ingorious declivities by your clysters, that the triturable sleep crazes the purified flake of fire. I tempt the greengage!*

*O superabundant play of colours . . .*

*No, but the improvement of wavering double stakes and this alpine Superior of a Minim's convent suck in slowly the sweet feverish butterfly of Southern Europe: with no more ado we must endow the corn-chandler's very thin kind*

*of pastry, enveloped by a serpent in the alternating hour-glass and, as I make my eyrey, oxidating my ring in the efficent astringency of vinegar!*

*Verse, farewell; I shall transport the black-ochre you rendered dissolute.*

# Monuments of the Future

The lift doors shut and we began to descend.

'Have you been here before?'

'Yes, I came with my module when I was a child.'

'Which kind of module was that?'

'It was a colour module.'

'Before the despectralization?'

'Oh yes, long before. I was a little indigo.'

'I wouldn't have guessed it. I mean, you seem out of phase.'

'Plus or minus?'

'Minus, of course.'

'Thanks. But really it's only a first impression.'

'I think you can often trust first impressions though, don't you?'

'I used to once, but I made a catastrophic mistake that way. Well, a whole series of mistakes. I nearly had to go through a remorph.'

'Whatever happened?'

'It's a long story. You don't mind?'

'Not at all. I like to collect stories. I have a whole memory key for them.'

'A whole key! That can't be very economical.'

'I keep some units in retro. Some of the pleasure units.'

'Even so, you must be very abstemious in some of the other terminals, to use a whole key for one node like that.'

'Well, maybe. Anyway, what about your story?'

'It all began back in the time before my first fixture. I wasn't very concentrated. In fact, I was dispersed. So I thought I'd better

do something that would get me on line. You remember how at that period you had the choice between endo and exo and, well, I decided to choose exo, because it seemed it would be more of a challenge and, if everything came through on maximum I'd be right on line again, not the slightest expression off. If you choose exo you had to have a guide. Right? That's where things began to go wrong.'

'I did endo. I wanted a job in link-up and that was the obvious thing to do really.'

'You have to go through shuttle though to get into link-up, don't you? What kind of endo would that track out from?'

'Anything but deep interiors. Rim areas.'

'Right. Anyhow, fool that I was, I chose exo. This is where we get to first impressions. I went for interviews with all the guides we had signalled for us. Mostly fairly routine. They would ask questions about my module, indentations on my profile, schemas, all that kind of thing, and I'd try to get more of an optic on the various exo-spheres they represented. But there was one who stood out. Straight away, I thought this is the one for me. I must have been really dispersed, because this guide did not represent one of the safe exo-spheres. It was marginalia time for me. It's probably one you've never even heard of. Try and guess. What's the most deterioriated exo-sphere you know?'

'Religion? Cinema?'

'What's cinema?'

'Some kind of early group image check-out.'

'Uhuh. That's the kind of thing, but much worse. No?'

'No. What was it?'

'Dream.'

'Dream?'

'Never heard of it?'

'It's new to me. What is it?'

'That's what I asked and the guide said I could have a limited access and if I didn't feel happy with it, then I could try something else, something more conventional. It seemed a good idea. I needn't commit myself without some preliminary experience, so I agreed. The guide set everything up and I went into the first test. I was in a railway train—stop me if there's anything you don't

follow—looking out of the window at a river with a castle on the bank. It was a well-known castle and it indicated I was in Rome. Then there was another one. Someone took me up to the top of a hill and I looked down at a city. It was Rome again, covered in mist? Was it called "mist"?'

'That was part of weather, I think. Like "rain".'

'I think it was mist. It was visual noise in the weather.'

'What was the meta-text?'

'The meta-text was that I was called Freud and I wanted to go to Rome.'

'I don't follow.'

'Well, you see, Freud was crucial to the segment of the exo-sphere I'd been allotted.'

'I think I can copy the name. Just dreams?'

'Minds, too. And instincts. A lot of things.'

'If Freud wanted to go to Rome, why not go? It was very primit-ive, railway trains and motor-cars, things with wheels, but you could get around very laboriously if you wanted to, couldn't you? I mean, they were people, not root-crops, weren't they?'

'Look, it'll get clearer later. The main point for me, from the point of view of the story, is that it seemed fairly trivial, well, it seemed very trivial, and that was something of a relief because, given the marginality it had, it didn't appear very disjunct. There wasn't much disjunction there at all. It was just trivial and kind of pathetic. Little did I know. First impressions again. So I blun-dered on. I told the guide to go.'

'It doesn't sound any worse than endo. Given that it's weird.'

'It wasn't. It was negligible.'

'Neutral'

'It could have been neutral except for the existents.'

'The existents pre-connote but that's all.'

'So, in any case, I gave go and that was the worst mistake I ever made. That guide gave me no warning, not an inkling. A guide like that should never have been categorized.'

'Well, categorization procedures got very sloppy round about the time the colour code began to pulse.'

'I know. Still I'm not sure de-spectralization was really the best solution.'

'What else was available? I don't believe we could have used a new waveband approach. We couldn't have done that.'

'Why not?'

'It had never been theorized.'

'You think de-spectralization was theorized? The concepts were all bleeding.'

'Okay, let's not develop that here and now. We'd need a gamma monitor to develop that. Let's get back to dreams.'

'Dreams. Proceed.'

'The project core was called "Irma's Injection".'

'Irma's a name?'

'Right. I was at some kind of social gathering and I met Irma. She told me about various organ malfunctions I should correct.'

'Wait. Irma's female.'

'That's right. She's a woman.'

'Is this Freud again, in the meta-text?'

'Uhuh.'

'Is Freud female or male?'

'He's male. He's a man.'

'So you had difference.'

'That's right. The whole core was permeated with difference.'

'How did you countermand that?'

'I didn't countermand it. I couldn't. It was right there in the segment. It was in the whole exo-sphere.'

'Well, didn't you get some kind of intelligibility kit from the guide?'

'That's it. That's the whole story. They don't have intelligibility kits for dreams.'

'Didn't the guide give you advice on that? I can't believe you can get categorized and not give any advice in a clear failure plot like that.'

'Well, there was limited intelligibility.'

'Limited?'

'It turned out there was near-total disjunction.'

'Very limited?'

'Very limited. Dreams were difference-derived and organ-derived with difference dominant.'

'What kind of discourse were they though?'

'Intra-psychic, iconic and symbolic in enclaves, with affect.'

'How did you read back up to difference?'

'Well, this is kind of exotic, you know. Dreams were transforms on memories which had gone static, given that memories were at that time part of a perception storage system. You can read the static back to affect caused by intra-psychic representation of organ-loss. That's males.'

'Any organ?'

'The differential organ. Difference-dominant, right?'

'Is that a reciprocal difference?'

'Reciprocal, but asymmetrical.'

'Right, but that's a social determination. That's not organic.'

'That's social. Their whole systsem was lop-sided. It was bound and it was stratified.'

'And it was unstable.'

'Right. Look where we are. It was on destruct.'

'Near-total destruct.'

'You know, I've often wondered whether destruct was necessary to difference. Couldn't there have been some kind of benign difference? Did the entire programme feed through to destruct or was it warped?'

'Productive asymmetry. That's a concept.'

'Well, I'm not sure asymmetry is the same as difference. Difference had a vector built in.'

'Could be a historical vector though. It needn't be biological.'

'That's it. If your historical distributions varied from your biological, that would provide some real asymmetry in the system. You would get elements of coalition.'

'In any case, we all know exactly what happened.'

'How did you get out of your exo-sphere?'

'It was terrible. It's difficult to convey to someone who's never been through it. The real problems were in the meta-text. I still get leakage. "Turbinal bones", "travelling in Egypt", "bottles of liqueur with the word *Ananas*", "misuse of cocaine". It just had too much density. I began veering.'

'N-dimensional veering?'

'N + 1, it felt like to me. N + 1. I was veering faster than the

guide could get through the trace network. I veered right through into severe misinformation.'

'I never met anyone who did that before. I once met someone who had passed through mild, but that was transient. Just a flicker in and then right out. Just flickered in and out. It left some kind of lesion though. How severe was yours?'

'Well, you know, it was severe.'

'They could treat it though?'

'In the end, luckily for me. The main misinformation I had—well, it denoted organ-graft.'

'Organ-graft! Multiple organs!'

'Not multiple. Exotic.'

'What kind. You don't mean ...?'

'That's it.'

'Differential. They could treat that?'

'It wasn't easy. First they had to send in a retrieval mission. They came crashing in down the hyper-memory track. They were way beyond their usual assignment pattern. I was in thrill. I'd been through organ-nexus. You just couldn't believe it. I'd been through the whole matrix of organ-nexus. I'd been through disease and then death.'

'Disease? That's pre-death?'

'It can be intermittent. I went through death and I didn't know what was going to happen next when the mission arrived.'

'They were all difference-proof?'

'Right. Difference-proof. Dream-proof. They were really armoured. They all had special kits for mnesic control. They could move nodes around. I didn't think it was possible till I saw it. I mean I knew about it, but it was spectacular. I was out of that exo-sphere in negative time. They were really effective. You'll never find me complaining about the assessments.'

'What about the misinformation? How did they treat that?'

'I was put in pressure. They give you these very heavy charges of real banality, things that are rougher than elementary, really brutal. They roll them through on two opposite faces of the mis-information. The banality spreads all round it till it's buried.'

'So it's still there. I mean they don't really remove the misinfor-mation. They just bury it. It's rendered inactive.'

'That's right. I have to take precautions. I have to keep well away from anything bizarre. They issued me with sensors. They shriek if there's any danger from the bizarre. It doesn't often happen. I try to be as on the line as I can at all times.'

'I guess you have to watch out with your pleasure units.'

'Right. I keep to a very limited preference range. There's lots of things I just won't touch.'

'What would happen if...'

'I don't know. I don't like to think about it. I certainly hope it never does. I don't want to go through it again. I'm quite happy with banality just the way it is. I know it's a limited range, but it's still very polyhedric and it doesn't inhibit me at all. How about you. How do you manage?'

'Oh, I randomize.'

'You randomize! You must have a lot of potential for integration. Did you get that in endo?'

'Well, you know, endo is more integration-directed, but I have had some tricky moments. I mean, nothing like you, but sometimes my potential has been put under stress. You randomize and one day you get a cluster of marginals and you have a problem. But being in link-up I can get a faster correction response than usual. That's been a help.'

'Are you going to go on randomizing?'

'I think so. Unless I get a real overload. Then I might just randomize in one sector. I worry a bit about it. You know, why am I collecting so many stories? It makes the grid look lopsided.'

'You came here on an optional key?'

'That's right. It's a long way down, isn't it?'

'Well, they had to go a long way down to get through the survival, didn't they?'

'I didn't realize it was so far though. I knew the whole surface was contaminated, but I thought it was just near the surface, one digit down, maybe.'

'No, they had to dig deep. It wasn't just surface devastation. It had a fantastic range—right down into the geology.'

'Who were they? Who was in the resistance?'

'Women mainly. They were the main force.'

'Then, when they came out, what happened before the mutations started?'

'That's when they built the monuments.'

'They went down again to build the monuments?'

'That's right. That was before hyper-memory. They had monuments. They got through the survival, so they built the survival monuments down here before the mutation.'

The lift suddenly began to decelerate. It stopped and the doors opened. We stepped out into the lobby. In the distance, we could see the first of the monuments. It was at the end of the first tunnel. We were about halfway down the tunnel, when I heard a shriek. It was the sensors. I didn't stop. I wouldn't have stopped on any account. Secretly I was in search of misinformation.

# The Mystery of Landau

University of Essex
15 October 1976

Dear Emma

Some time last month, when we met, we were talking about cases of 'multiple literary personality'—Pessoa, Rozanov, Traven—and I believe I may have mentioned the name of Raymond Landau, without elaborating on it at all. Since then, by a typical coincidence, I've come across a fact that seems to throw some new light on the vexed question of Landau's true identity, and I thought I might write to you about it, since I know you are interested in this kind of topic and Landau's case is a particularly fascinating one, perhaps because the facts are few and far-fetched.

Raymond Landau died a few years ago—1971, I think—at Laguna Beach in Orange County, aged about eighty. He had been living in the United States since the war, when he arrived from Europe. According to some accounts he came from Marseilles on the *Capitaine Paul Lemerle* (the ship on which André Breton, Victor Serge and Lévi-Strauss also travelled in some squalor) but, in any case, whether or not that was the actual ship, his past fades into obscurity somewhere in the region of Snappy's Bar in the Cannebière, where the deals were made to smuggle phantom passengers aboard outgoing vessels, 'for filthy lucre and humble words' as someone (Anna Seghers in *Transit Visa*?) once put it.

After he arrived in America, Landau lived in relative obscurity, known to a few only as the author of three scholarly, but strange,

essays in Marxist reviews (on Lorianism, on animal labour and the slave mode of production, and on 'baroque materialism') and a long poem, published by a small press in LA, called *Death Valley Eclogues*. I've always liked the poem, which is full of rather recondite allusions to other works, particularly early twentieth-century French texts (Apollinaire, Jarry and Roussel—one eclogue is written in Rousselian alexandrines with multiple parentheses) but also, which is more surprising, to Russian Futurist poetry, in which Landau seems incredibly well-versed, though he often misquotes, as though from memory rather than printed sources. Moreover, one Russian Futurist is unmistakeably dominant, though by no means a major one—Alexander Task. It's the extent of the coincidence between the *Death Valley Eclogues* and Task's *Sleepy Pears*, published in Russia in 1914, which has given rise to the theory that Task and Landau are, in fact, one and the same poet.

Task was born in 1892, in Moldavia, the eldest son of a French teacher. He came to Moscow to study and soon fell under the influence of the Hylaean group of Cubo-Futurists. He specialized in what he called 'quasi-unreadable' poems, in which normal words were distorted by adding vowels and consonants to make clusters of three or four. For instance, transposing the concept into English, 'tracks in the sand' might appear as 'strackts eeinj sthte ktsandj'. He used to declaim these with painted face at Futurist concerts and soirées. Then, shortly after the outbreak of war, he left Moscow, presumably for military service. He doesn't re-emerge till after the Revolution when he crops up leading a Red force in what is now known as Labdakhia, on the fringes of the Soviet Union.

Partisans, led by Task and others, set up a fragile Soviet administration, locked in civil war against the local tribal chieftain, Halim Khan, till both were overthrown by a White counter-attack. Task escaped the ensuing massacre and managed to make his way back to Petrograd, only to leave again soon afterwards, apparently because of his SR sympathies. He passed through Berlin (he's mentioned in *Zoo*) but ended up in Paris, where he is last heard of as a painter in the style of Léger (he had exhibited earlier in Russia and written a monograph on Alexandra Exter). Task, then,

vanishes in France at the end of the twenties, only to re-appear, perhaps in the hold of the *Capitaine Lemerle* at the beginning of the forties, now as Raymond Landau.

So—the new fact. Recently the University of Indiana at Bloomington, which specializes in Soviet folkloristics, published a collection of Labdakh folk-tales in translation, as one of its series. While I was looking through this, having found it on a 'New Acquisitions' shelf, I came across a tale which seemed to echo something with which I was already familiar, and after letting it settle for a day or two, I suddenly realized it reminded me of a passage in Landau's *Sixth Eclogue* that had always puzzled me. It read as follows:

> I hibernated in my past—Returns the sun...
> A tale twice-told...déjà...déjà—
> The magic ladder and the lake of blood,
> The donkey-king and half the dream,
> Intelligible music and the flight
> That freed the masses—Lorianism—
> But I've told you about that before,
> Comrade, poetry-reader, Comrade
>     Poetry-reader...
> Poplar logs in the brick stove, the scent of
>     resin—
> I hibernated in my past—Returns the chill...

The tale is called *Zokhna and the Donkey-King*. It tells how, once in Labdakhia, there was a king whose wife died after giving birth only to one daughter, who was exceedingly beautiful. The king never re-married and grew old without a male heir. Then, one day, while the princess was bathing in the river, she was seized and taken away by a monstrous pike. The king, heart-broken, offered the succession to his throne to anyone who could find her and fetch her back. Many tried and many perished.

In the same country there was a charcoal-burner who had seven sons and one daughter. Each of the seven sons, in turn, was killed trying to rescue the princess. The daughter, who was called Zokhna, was only eleven years old but she decided to set out too.

On the path, she met a bird with strange plumage, which asked her a riddle. When she answered correctly, the bird gave her a bundle of thongs. Whenever she sang, the thongs would form a ladder, and the higher she sang, the higher the ladder would be.

Eventually, after various adventures, Zokhna arrived at the tower where the princess had been imprisoned by the pike's master, the Whirlwind. Zokhna sang, as high as she could, until the ladder of thongs reached up to the princess's window and the princess was able to climb down. But just as her slipper touched the ground, Whirlwind appeared. Whirlwind cursed the princess, binding her by a spell so that she would fall in love with the next creature to wake her while she was dreaming. The spell could only be broken when she met somebody who could complete the other half of her dream. Then Whirlwind pursued Zokhna, who had fled till she arrived at a marsh. There, once again, the bird with strange plumage flew down and asked her a riddle. When Zokhna answered correctly, she began to menstruate and produced a lake of blood that Whirlwind was not able to cross.

The princess set off on the road back to Labdakhia. Later that night she fell asleep by the wayside and, while she was dreaming, she was woken by a donkey braying. She ran to the donkey and begged him to carry her home on his back so that they could be married with her father's blessing. The donkey set out with her on the road till, after twice nine months, they arrived at her father's palace. The king greeted her and, in recognition of the fact that the donkey had brought her safely back, he made the donkey his heir and blessed his marriage to the princess. Soon afterwards the king died and the donkey ascended the throne.

After many adventures, Zokhna too succeeded in returning home to Labdakhia. But when she returned, she found the country waste and ravaged. Stewards were burdening the people with taxes and taking the harvest and the new-born cattle. There was no salt. The Donkey-King stayed in a pavilion at the palace with his Queen and they never came out except on the last day of the year. The Donkey-King brayed and the Queen listened to dreams that the people told her, but none of them could break the spell. The Queen remained infatuated with the Donkey-King.

The first night Zokhna was home, she dreamed a dream. She

dreamed she was crossing a bridge, carrying a basket of coal-cinders. She came to a market-place where she met a man with a carbuncle on his cheek. He gave her a cordial to drink and she began to feel drowsy. She thought she was dreaming and she was by the sea. She could hear the surge of the waves. It was dark and she followed a glow-worm till she came to a burning kiln. There she met a woman with matted hair. She gave her a basket of coal-cinders to carry and a ball of twine. She told her to follow the twine wherever it rolled. She followed the twine till she came to a bridge. When she lifted her foot to step on the bridge, she heard an owl hoot, and she woke up.

Zokhna dreamed the same dream every night. On the last day of the year, she went to the palace and told her dream to the Queen. When she heard it the Queen fell into a faint. At that moment, the bird with the strange plumage appeared for the third time and told Zokhna that she had broken the spell. When the Queen awoke she could no longer stand the sight of the Donkey-King. She recognized Zokhna and asked her what she should do. Zokhna said that, now the spell was broken, they need no longer stay in Labdakhia. They should bring all the copper in the country and melt it down and make birds from it. Then they all climbed on the birds and flew away to a distant country. Only the Donkey-King was left behind in the palace, wearing his crown and braying. He was not put to death, but he could not fly or understand the song of birds.

The lines from the Landau Eclogue seem to allude fairly definitely to this tale of *Zokhna and the Donkey-King* and, since it has only just been translated into English, Landau must presumably have read it in the original Labdakh—or even heard it told by some wandering story-teller by the banks of the Yarut. So, together with the allusions to *Sleepy Pears* and *Square Root of Iron*, it seems sure that Task was in fact Landau. Though, of course, we still don't know what he was doing during the thirties. In the Borinage? In Catalonia?

> Though, as Henri said, frying the last of the
>    eggs—
> 'The facts of the matter can never be known,
> Comrade, till we've mastered the calculus

Of constant and variable capital . . . '
Stench beneath tables and behind stone
    parapets—
'Those who survive must learn mathematics.'

4.

# Cinema and Technology: a Historical Overview

I would like to give an overview, necessarily schematic, of the history of technological change and innovation in the cinema, together with a few theoretical comments, bringing out the implications of my reduced empirical material. The paper is intended as introductory and the main stress I want to make is on the heterogeneity of the economic and cultural determinants of change and the way in which innovations in one area may help to produce conservatism and even 'retreat' in another—history not simply with 'differential' times, but even with 'reverse' times. In dealing with the heterogeneity of film technology, I want to stress the presence of three distinct phases—recording, processing, and projecting or exhibiting[1]—and the way in which developments in one may cause repercussions in the others. In general, I believe too much attention is usually paid to the recording stage at the expense of the laboratory and the theatre—a serious distortion because exhibition, rather than production, is economically dominant in the film industry, at least as far as the timing and impact of technological changes are concerned.

I am aware that, despite this, my own approach is probably too traditional in bias, if only because the available data has itself been determined by the bias of previous researchers. The history of the technique of editing, for instance, is rather neglected. I happened recently to see again Vertov's *Man With A Movie Camera* with its shots of Svilova editing with a pair of scissors and was reminded then of the changes that have taken place in editing equipment. Even an apparently extraneous and trivial invention like Scotch tape has had an enormous impact on editing technique.[2] It is

difficult to escape entirely from those myths of film history that concentrate on only the recording phase and narrate this history in terms of four legendary moments. The first moment is that of Lumière and the first Lumière programme (often condensed into the train entering the station at La Ciotat). The second moment is the arrival of sound and its instance is *The Jazz Singer*. Then there is colour (strictly speaking, three-colour Technicolor) with the Disney cartoons and *Becky Sharp*. Fourthly, there is the moment of wide screen and 3-D (*The Robe, This is Cinerama*). This series, of course, suggests possible extensions in the future, in line with Bazin's celebrated myth of total duplication of reality.

In fact, I think, the crucial changes in the recording process have involved not the camera itself, as the Lumière example suggests, but changes in film stock. The camera itself is a very simple piece of mechanical equipment. As Hollis Frampton once pointed out, it represents the culmination of the Age of Machines and was superseded almost as soon as it was invented. Lumière's own inspiration was the sewing machine, itself a typical piece of nineteenth-century machinery. Lumière regarded the invention of the film camera as a simple task in comparison with the invention of the Autochrome colour photography process that he also introduced. The camera is not an extremely elaborate piece of equipment even by nineteenth-century standards. Most of the devices necessary were the product of tinkering by skilled enthusiasts—the Maltese cross, the Latham loop, all the things that occupy chapters in books and really acquired significance through patents litigation. Most changes in camera efficiency are involved with the optical rather than the mechanical system (better light transmission through the lens; the post-war explosion of zoom; improvements in focusing systems), with miniaturization and portability and with by-products of other innovations (sound-proofing, for instance). In one cinematographer's words, 'of course, the new camera is easier to use, with many labour-saving gadgets, but the final result looks the same.'

The real breakthroughs have been in the technology of film stock, in chemistry rather than mechanics. The precondition for the invention of cinema was the invention of celluloid (first used as a substitute for ivory in the manufacture of billiard balls and for

primitive false teeth) which provided a strong but flexible base for the emulsion. Later the history of film stock is one of steadily improving speed/grain ratios, faster and more sensitive emulsions without adverse graininess. There is an important paradox here. Improved stocks have made film-making much more accessible, allowing films to be made in lower and lower levels of available light and creating the possibility of 8mm and 16mm film-making on a wide scale. Yet at the same time a good deal of the pressure for improved emulsions came because the development of sound and colour made filming much more difficult—colour demanded more light, and sound too made lighting much more cumbersome (hence, the well-known lag in deep-focus cinematography between the silent period and *Citizen Kane*). The innovations that restricted access to film-making, that demanded enormous capital investment and caused real set-backs, have attracted attention, while the steady development of stock—chemical rather than optical or electronic—has never been comprehensively chronicled.

I would like to dwell a little on the adverse effects of the introduction of sound. It was with sound that the truly modern technology of electronics first made a real impact on the cinema. In fact the breakthrough in sound technology is associated much more with the third of the phases that I described at the start than with the first, more with projection than with recording. The problems were twofold. First, image and sound had to be synchronized. Second, sound had to be amplified to fill a large theatre (Edison had shown sound films but only in a peepshow with a primitive listening-tube: in fact, it was his wish to incorporate sound, without any means of amplification, that led him towards the peepshow rather than theatrical projection). The two crucial discoveries were the audion tube which made possible advances in loudspeaker and public address technology that could eventually feed into the cinema and, of course, the photoelectric cell (leading in time to television as well) which made possible an optical sound-track that could be picked up, with absolutely precise synchronization, by a component within the projector, rather than demanding, as previous systems did, synchronization between the projector and a separate sound system.[3]

The introduction of sound had a series of effects. A technical

advance on one front brought retreats on others: one step forward, two steps backwards. In the first place, the economic effects must be mentioned. (The introduction of sound, also, of course, had economic determinants: principally, saving in labour costs through the elimination of orchestras and between-the-screenings entertainers.) The conversion costs were enormous and led to a vastly increased role for banks in the industry in alliance with the giant electronics firms that controlled the relevant patents.[4] (Fox, who tried to challenge the patents, was driven to bankruptcy and gaol.) In comparison with the twenties, the thirties was a period in which very little independent or experimental film-making took place. In Hollywood, the power of the producer was enormously enhanced.

Technically, sound, while it introduced new possibilities (scarcely realized), also introduced new obstacles and a chain of bizarre secondary problems and solutions. The carbon lights hummed and the hum came through on the sound-track. The tungsten lights that replaced them were at the red end of the spectrum and so the old orthochromatic film, blind to red, had to go, to be replaced by panchromatic stock (like so much else, a spin-off from military technology—it had been originally developed for reconnaissance fog photography). This change brought changes in make-up; the fortunes of Max Factor date from this period.[5] Studios replaced locations; multiple camera set-ups were introduced; the craft of script-writing was transformed. Most important of all, the laboratory was completely reorganized. The need for sound-image synchronization meant that every aspect of timing had to be standardized.[6] On the set, the camera was no longer hand-cranked. New equipment was introduced: for example the sensitometer and densitometer. Every aspect of the laboratory was automated and there were standardized development and printing procedures. In this way, the laboratory became completely divorced from the work of the director and cinematographer; it became an automated, industrial process with its own standard operating procedures. Anyone who has made a film will be familiar with the opacity of the laboratory, something that dates from this period.

It was not until after World War II that new developments in

sound technology were universalized, thus permitting immediate set-backs to be overcome.[7] The crucial breakthrough was the advent of magnetic tape, invented in Germany and, like reflex focusing, the hand-held camera and monopack colour stock, part of the booty of victory. Tape made sound recording much easier, and cheaper; it transformed dubbing and mixing and, with the subsequent development of the Nagra and crystal-synchronization, led to much easier location filming and the whole *cinéma-vérité* movement, with subsequent new definitions of 'realism' in film. It is worth noting, perhaps, that the main limitations on sound currently come at the projection stage; poor speakers and poor acoustics make working to the full potentiality of modern recording and mixing technology pointless.

The history of the development of colour is similar to that of sound: a breakthrough that proved to be a set-back. There were attempts to introduce colour from the very beginning—with hand-tinting, toning and various experimental systems, including two-colour technicolor—but the successful invention was that of three-colour Technicolor in the early thirties by Herbert Kalmus.[8] The success of Technicolor derived from Kalmus's realisation that he had to devise a system that not only recorded colour but would also be acceptable to exhibitors. Once again the projection stage proved to be the determining factor. At the production end Technicolor produced new obstacles. The beam-splitter camera was extremely bulky and could only be leased together with an approved Technicolor cinematographer. Colour consultants came on the set, led by Natalie Kalmus, and keyed colour to eye and lip tones; filters and unconventional effects were barred until Eastman Color arrived and Huston broke free with *Moulin Rouge* in the fifties.[9] Technicolor required more light which meant a lower effective film speed. Film memoirs are full of complaints by cinematographers about the limitations Technicolor imposed.

As with sound, the next step came after the war with the appropriation by the victorious allies of Agfacolor, fruit of superior German dye technology, developed within the IG Farben group. Russian and American armies raced to get to the Agfa works and, though the Russians won (hence Sovcolor), the destruction of

patents and diffusion of new technical information led to the appearance of Eastman Color with *The Robe* in 1953.[10] (The new colour process was linked to Cinemascope: Technicolor beam-splitter cameras could not be fitted with scope lenses.)[11] Eastman's problems were essentially matching Technicolor's speed, and then improving on it, without losing colour correction. Every new dye introduced as a corrective would tend to slow the film down. There was also a strong economic incentive, of course, in improving film speed, namely to reduce lighting costs.[12] Again, the strength of Eastman Color lay in its greater accessibility, though there was a time-lag of twenty years or more.

Colour, like sound, also demanded standardization in the laboratory. Elaborate controls were developed and matching and grading colour became crucial parts of the laboratory's work. It is still extremely difficult and expensive to get really detailed control over complex colour effects. The opacity and autonomy of the laboratory was further accentuated. It might be added that one of the attractions of colour video, which uses electronic rather than chemical technology for colour, is that there is no laboratory involved. In video the three phases of articulation are much more closely connected and, of course, are not separated in time in the same way that they are in film. It is only a matter of time before electronic technology gains the ascendancy in image as well as sound.

Both sound and colour had to meet the requirements of the exhibitor. Projection has been the most conservative side of film technology. Exhibitors, for instance, defeated 3-D—an attempt by Polaroid to challenge Eastman's supremacy in the film stock market. Cinerama (derived from aerial gunnery simulation) never succeeded except in a few big city theatres.[13] Cinemascope (another military spin-off—emanating from tank gun sighting periscopes) was able to make headway because it involved minimal adaptation of the projector, under the economic pressure of competition from TV (and also to eliminate 3-D).[14] Exhibitors have consistently resisted conversion costs.

The economic strength of the exhibitors has always rested on the real estate value of the theatres. Production companies, in contrast, have been subject to recurrent crises, bankruptcies and

take-overs throughout their history. They have simply not been able to afford research and development projects, except for a limited involvement in special effects, ironing out secondary technical problems and adapting technology developed elsewhere. Almost all the major technical innovations have been introduced by outsiders with the support of economic interests wishing to break into the industry. Dupont and 3M have tried to enter through magnetic tape and polyester film bases; Polaroid was fought off over stereoscopic film. New challengers will come from video and presumably laser technology. Moreover, the interests of the major technology-producing companies are not limited to Hollywood, which is only a small part of their market. The general industrial and also domestic markets are much more significant and here there are no entrenched exhibitors to contend with. It is here that, on the one hand, expensive laser and fibre optics 'cinema' and, on the other, cheap 8mm synch sound and video disc 'cinema' will first make headway.

At this point I would like to shift focus from Hollywood to experimental and avant-garde forms of film-making. This area, of course, has been crucially dependent on the improved quality and accessibility of 16mm and, to some extent, 8mm film-making: faster stock, portable equipment, miniaturization and so on. Up until the 1950s histories of avant-garde film list almost every experimental film made; there were so few. Clearly this was because of the difficulty and prohibitive cost of making films independently. Since then, however, there has been an enormous explosion in the number made following the introduction of the Eclair camera and the Nagra tape recorder (first used in 1960 in Rouch and Morin's *Chronique d'un Eté*), together with increased subsidies, either through state or para-state arts funding bodies or through the educational system. The entire new field of independent film has begun to appear between home movies and the industry.

Dependent for its expansion on these technical advances, avant-garde film has had other technological implications. First, of course, there has been the mis-use of existing technology, its use to transgress the norms implicit in it. On the whole, this has not involved very advanced technology: flicker films counteract the

use of the shutter, and so on. A variety of mis-use is hyperbolic use —thus the hyperbolic use of the zoom lens (as in *Wavelength*), or the optical printer or the projector or the geared head (as in *Riddles of the Sphinx*). Then there is an area in which technological innovations have actually taken place—Chris Welsby's landscape films or Michael Snow's *La Région Centrale* for which ingenious contraptions were devised for the camera to permit realization of a project that would otherwise have been technically impossible.[15] In all these areas, I think, there is an ambivalence between contravening legitimate codes and practices (a negative act) and exploring possibilities deliberately overlooked within the industry, or tightly contextualized (in contrast, a positive act).

Finally, a few theoretical, or pre-theoretical, remarks. I would like first to stress that the technology of cinema is not a unified whole, but is extremely heterogeneous. It covers developments in the fields of mechanics, optics, chemistry and electronics. It covers the Latham loop, Scotch tape, the densitometer, the zoom lens, magnetic tape, and so on and on (the list is long). In the past theorists have tended to stress and even essentialize one or other area of technology at the expense of the others. Cinema is seen in terms of the camera and the recording process or reproduction and the printing process or projection and the physical place of the spectator (Bazin, Benjamin, Baudry). In this way the heterogeneity of the cinema is reduced to one subset of determinations in a reductionist manner. In effect a myth of the cinema (Bazin's own term) is thereby created, which serves to efface the reality of production.

Within the avant-garde too (or perhaps I should say within the theory of the avant-garde) there has been a parallel tendency to create an ontology, seeing means not as secreting a teleology, but as ends in themselves, as essences. This new ontology can easily be disguised as a materialism, since it seems to foreground means of production rather than 'images'. Yet implicit within it is an assumption that the equipment used for making films is an essential bedrock rather than itself the product of a variety of historical determinations, at the interface where the economies of capital and libido interlock. The forms of matter taken by the technical apparatus of film are determined by the forms taken by the material

vicissitudes of labour and instinct, within history (or rather, as history).

At the same time, however, it is within the avant-garde that we find resistance to the perpetual anthropomorphization of technology in the cinema. It is instructive to re-read Vertov's rhapsodies on the camera-eye. Technological developments outside the cinema have already produced microphotography, X-ray photography, infra-red and thermal photography, magnetic photography and many varieties of photography which Vertov never saw. Yet these have had almost no impact on the cinema. The eye of the camera is still assimilated to the human eye, an eye whose imaginary is constructed around a range of differences within a basic unity, rather than a search for a fundamentally different form of vision. The problem is not one of representation as such, so much as the dominant and cohesive mode of representation. It is here that a specious unity exists, rather than within the technology itself, and it is here, by understanding the different and heterogeneous determinations at work and struggling to release them from the interlock in which they are bound, that we can conceive and construct a new cinema, not necessarily with a new technology, but certainly with a new place of and for technology.

# Photography and Aesthetics

Most discussion of photography centres around the commonplace fact that it provides information about the appearance of objects and events in the world. This in turn has led to two related preoccupations. First, what is the connection between art and information? How can photography be an art if it is tied to the automatic production of information? Second, what is the connection between knowledge and information? How can photography produce knowledge if it is tied to the registration of momentary appearances? This is a problem whether you believe that knowledge reflects an essence behind or within appearances or whether you believe it to be a necessary displacement from appearances to a distinct order of discourse, symbolic rather than imaginary or iconic.

A third question is obviously involved too. What is the connection between knowledge and art? I shall hold this question in suspense, working on the assumption that answers will derive from discussion of the first two questions, rather than the other way round. In the past it has been almost universally agreed that art represents a specific form of knowledge and from this aprioristic ground every kind of aesthetic-cum-epistemological position has been argued at will. Photography provides a very good opportunity to start at the other end, with its claims to be an art or to produce knowledge, and to work from there towards a sense of the relationship between the two. Photography struggled to conquer territories *prima facie* denied it, which may indeed turn out to be the same, adjacent or far apart.

During the nineteenth century and up at least to the 1920s, the

struggle on the first front was by far the most prominent. No sooner had Kant announced that objective distinctness must be distinguished from subjective, concept from intuition, hence science from art, than advances in chemistry and geometry made possible the invention of photography and modern technical draughtsmanship, twin threats to painting, later combined in parodic form by Marcel Duchamp at the acme of modernism.[1] Painting responded by embracing the Kantian perspective, stressing the subjective and the intuitive, and at the same time discarding fiction (the 'literary') and increasingly returning to nature. This return to nature itself necessitated a very clear distinction between the 'artistic' and the 'photographic', which became a term of abuse.

Photography, tactically on the defence but strategically on the attack, reproduced this distinction within itself as one between 'pictorial photography' and 'photography of record'. Photography of record was expected to provide a maximum of precise detail—clarity of information—whereas pictorial photography provided clarity of composition, of selection of the significant feature rather than accumulation of the insignificant. (Within the general outlook of positivism it was felt that, for science, every detail was necessarily significant; knowledge depended on the accumulation of facts. For art however there were constraints on significance: multiplicity must be reduced to unity *in concreto* rather than through posterior analysis.) Almost all pictorial photographers deliberately avoided uniform sharpness of focus and overall illumination. They 'selected', partly through choice of view and angle, but also by producing soft, often diffused, prints with calculated areas of darkness and indistinctness.

Despite their general agreement, pictorialist photographers were constantly feuding among themselves; the history of pictorialism contains endless secessions, rejections and splits. In retrospect these seem very dependent on the backwash from developments in painting. Emerson's defence of 'naturalistic photography', and the counterblasts from Robinson, represent the impact of the French *pleinairistes*.[2] Robinson, who photographed posed genre and allegorical scenes (as well as combining different negatives in one print) and whose most admired painters were Millais and

Holman Hunt, was exhorted to return to nature by Emerson, who cited the Barbizon School and Millet. Later pictorialists fell under the spell of Whistler, and Davison, whose *The Onion Field*, photographed with a neo-primitive pinhole camera, caused a sensation in 1890, brought the French impressionists into the debate.[3] The next generation of American pictorialists (Coburn, Stieglitz) responded positively to Cubism and the onset of modernism, whereas their mainstream British counterparts certainly did not. The virulence of all these ephemeral polemics, for and against 'crazy-quilters' and 'gum-jugglers', fuzzography and straight prints, British and American 'Links',[4] obviously reflects their disavowed dependence on painting for the terms of debate.

The underlying problem was how to establish a distinct identity for photography without blurring the line with painting, etching or other established media, on the one hand, and, on the other, without falling back into photography of record. The conservatives, like Robinson or Horsley Hinton, seemed too close to painting with their combined prints; the radicals, like Demachy or Frank Eugene, seemed too close with their gum prints, which showed the marks of 'intervention' with brush or needle.[5] (Eugene scratched directly on the print.) The pure photographer tried to stick to the 'straight' print, guarantee of 'photographicity', so to speak, but consequently risked missing out on art altogether. Hence the need for the Dallmeyer lens, diffused focus, flat tones, deep shadows, rough paper and all the other characteristics of the epoch.

During the 1910s the pictorialist paradigm began to crack. It moved, however, not towards greater intervention, but towards less. The straight print triumphed, shedding at the same time its *fin-de-siècle* aesthetic pretensions and overcoming its resistance to photography of record. Not only was the gum process rejected but also softness, darkness, blurriness and *flou* altogether. Following the crucial innovations of Strand and Sheeler, ambitious photography accepted illumination and sharpness. The way was cleared by the new machine aesthetic of modernism, which gave fresh confidence to the photographer and validated clarity and precision. In New York, following Stieglitz's propaganda work for Cubism and the arrival of Picabia and Duchamp, pictorialism

transmuted into a new modernist photography of geometrical compositions, machine forms, hard-edge design and clear delineation of detail.[6]

Paul Strand, the most influential innovator of the time, invoked explicitly Kantian categories to explain how he was striving to effect a reunion of machine and science with spirit and art. Writing in the avant-garde periodical *Broom* in 1922 he concluded: 'And so it is again the vision of the artist, of the intuitive seeker after knowledge, which, in this modern world, has seized upon the mechanisms and materials of a machine, and is pointing the way...In thus disinterestedly experimenting, the photographer has joined the ranks of all true seekers after knowledge, be it intuitive and aesthetic or conceptual and scientific. He has, moreover, in establishing his own spiritual control over a machine, the camera, revealed the destructive and wholly fictitious wall of antagonism which these two groups have built up between themselves.' Strand ends by calling for the integration of science and expression, lest they develop each unilaterally into 'the destructive tool of materialism' or else 'anemic phantasy'.[7]

Photography's new mission, then, was to heal the breach between science and art, concept and intuition, and instead of a wall between photography of record and pictorial photography, the two were to be integrated. Sharp focus and full light were to be combined with the new post-Cubist principles of composition, guaranteed by Plato's *Philebus*.[8] The Kantian distinction between abstract and concrete could be circumvented. Later Edward Weston, who consolidated Strand's innovations and was the most influential among ambitious photographers in the 1920s and 1930s in America, noted that all Brancusi's abstract forms were 'already existing in nature' and that 'an idea, just as abstract as could be conceived by sculptor or painter, can be expressed through 'objective' recording with the camera, because nature has everything that can possibly be imagined by the artist: and the camera, controlled by wisdom, goes beyond statistics'.[9] What we have here is a naturalistic Platonism. Forms and essences are available to perception—concealed within nature but discoverable by wisdom, by the seer.

Weston chose his subject matter for its formal and tonal qualities.

He photographed jars, peppers, roots, kelp, sand-dunes, nudes, with the same relentlessly aestheticizing eye. His preferred genres were still-life, landscape and nude stripped of any picturesque or erotic overtones. In a way, this recession of subject matter, paring down and ascesis of signifieds, doomed Weston to the role of photographer's photographer. More acclaim went to those like Walker Evans and Cartier-Bresson who combined the Weston aesthetic with human interest. Evans would find a post-Cubist composition in a sharecropper's hovel (geometrical lines of planks, chair, broom-handle and doorpost) but guard against the impersonality of Weston's vision by allowing a touch of dishevelment, a hint of human presence. Similarly, Cartier-Bresson, trained by the Cubist painter Lhote, became a news photographer and learned to use human presence, as E.H. Gombrich remarks, 'to give a touch of animation to the geometrical relationships he discovers in his motifs'.[10]

The goal of these photographers was to start with 'factual testimony' and then 'distil the essence' from each fact (Cartier-Bresson's phrases). Weston or his European equivalent, Renger-Patzsch, were interested in objects and their 'object-ness'; Cartier-Bresson was more concerned with events—the instant as condensation of the event, the event itself as condensation of a life or an age. Clearly the 'ideas' that concern them are something like Kant's 'aesthetic ideas' rather than 'rational ideas', something also like 'concrete universals'. The fact that the camera is a machine hardly makes photography more scientific; it simply substitutes discovery for invention in the traditional categories of classical aesthetics. (When the straight print is abandoned, invention returns—even before, to a degree, with manipulation of lighting or exposure.) The importance of discovery leads in turn to homilies by successful photographers on concentration, perseverance, speed of reaction, opportunism (combined with reticence), creative reverie, patience, luck (or Zen Buddhism), and so on.

The time when an aesthetic of photography as art finally crystallized was also the time when Walter Benjamin began to think and write about photography. Benjamin virulently attacked Renger-Patzsch and the associated 'New Objectivity' school of photography for making the world artistic rather than art mundane. He

saw more clearly than most the dangers of the new cult of the beautiful or significant detail because he himself was obsessed by the significance of detail, and, in a way, its beauty. Benjamin developed a method based on his own concept of the 'dialectical image' for which he drew both on his mixed collaboration-cum-running battle with Adorno and on his own idiosyncratic interpretation of Surrealism. Benjamin wanted objects, isolated by their oddity, to reveal historic and social determinations when juxtaposed and accumulated, yet—as Adorno complained—without any mediating theory.[11]

Nor surprisingly the photographer who most fascinated Benjamin was Atget. Atget appealed to his pervasive nostalgia and melancholy, to his mania for collecting, to his fascination with shopwindows, to his cult for the *flâneur*, his love of Paris, his demand not to overlook, his taste for the astonishing amid the banal. As has often been pointed out, there is something materialist about this, but also something mystical, something Proustian, seeking in Surrealism the paradoxical merger of Baudelaire and Brecht. The rediscovery of Atget, by Man Ray, Berenice Abbott[12] and the Surrealists in general, was at first the rediscovery of a new Douanier Rousseau, a Sunday photographer, who was himself as overlooked and obsolete as the flashes of the nineteenth-century his labour had permitted to survive. But the impact of Atget's work went far beyond this.

Atget is another example of the way in which art and record could be integrated. He was not interested in perfection of composition or print like Weston. Nonetheless he provided a way of seeing aesthetic value where none had been suspected. Not, of course, the fundamentally classicizing values Weston revealed in a vegetable, thereby transformed from a familiar instrumental object to a de-familiarized expressive object, but values that reflected a reversal of taste, an unprecedented mode of aestheticization introduced and popularized by Surrealism. Benjamin misunderstood this. He saw Atget as a profane photographer—indeed he even likens his work to police investigatory photographs—who stripped the aura from Paris street-scenes where Renger-Patzsch conferred it on gas-pipes or beech logs alike. Yet like so much of what Benjamin said about 'aura' (a topic about which he changed

his mind radically) it seems he was wildly mistaken. New developments in photography entailed the construction of a new type of aura, unforeseen by Benjamin, and perhaps partly summoned forth by him.

One of the most interesting theses in Susan Sontag's *On Photography* is her description of how recent American photography has displayed a Surrealist taste for the obsolete, marginal and bizarre. (In fact she tends to read this taste back into the original tenets of Surrealism, which leads to a certain amount of one-sidedness at times). She links this new Surrealism with the theme of America itself, so dominant in US photography since Steiglitz and continued by Walker Evans, Robert Frank and others. She traces the way America ceased to be seen as noble and became instead sort of tacky, but terrific—and its terrificness consists of its phantasmagoric tackiness. A key quote here is Diane Arbus's remark[13] about a nudist camp she went to in 1963: 'It was the seediest camp and for that reason, for some reason, it was also the most terrific. It was really falling apart'.

Arbus's photographs are located at a particularly unsettling point in the imaginary, the verge of not wanting to know. She travels further into the interior than most of us want to, to a region where report begins to become confessional. Yet, over and over, she photographs masks, costumes, façades, poses—as though imminent disclosure must be warded off. She will not allow misery the humanistic comfort of nobility or the discomfort of scandal, but hovers in the interzones of numbness. This attitude is not truly Surrealist. There is none of the convulsiveness which Breton demanded in *Nadja*. (It's worth noting perhaps that, though *Nadja* contains many photographs, there is no portrait of Nadja. The main influence is Atget.)[14] Talking about Kafka, Wolfgang Kayser speaks of 'cold grotesques' and the phrase seems appropriate to Arbus too.[15] Indeed she was an admirer of Kafka. But unlike Kafka her world is one of *objets trouvés*, faces/masks scavenged from the aftermath of trauma and placed on display.

Arbus's success depends not simply on a return to photography of record but a radical refusal of even a modernist pictorialism ('I hate the idea of composition'). Pictorialism began by separating

itself off from record, then tried to integrate itself, finally found itself cast adrift as a new aesthetic became dominant, derived from the Surrealist concern with found objects and chance encounters, but embodying a different 'cool' ideological approach, shorn of Surrealism's fundamentally passionate romanticism. Early and even New Objectivity pictorialism went into eclipse. In their place the nineteenth century provided a rich lode of early news and documentary photographs, now interpreted in a new aesthetic light, reinforced by a powerful sense of nostalgia. Sontag likens this to the high romantic cult of ruins—not, however, the imposing ruins of the great monuments, but tiny shards and fragments of everyday life.

One result of the fragmentariness implicit in this aesthetic of photography has been to encourage the exhibition of suites of photographs. This trend too can be traced back to Atget. In the 1920s suites were produced by Blossfeldt (plant forms), Krull (metallurgy) and Sander (a physiognomic taxonomy of the German people) and praised as such by Benjamin, who saw in their work, especially Sander's, the beginning of a systematic, quasi-scientific approach to perception. Whereas Krull or Arbus produce a suite of variations on a theme (guarantee, as Sontag points out, of *auteur*-hood) Sander at least aimed at an exhaustive inventory.[16] Yet this hardly goes beyond an elementary positivism, an accumulation of facts (saved by a certain picturesqueness and visual fascination) whose classification is completely predetermined. Sander's portraits exemplify a social analysis which precedes them and is in no way made explicit by them. They hardly seem to justify Benjamin's optimistic approval.

Benjamin, of course, was searching for a way in which photography might produce knowledge as well as become an art. New Objectivity was simply aestheticizing: a documentary photograph of the Krupp works, in Brecht's well-known words, did not yield much information about Krupp as a firm, about its place in the economic and political structure of Germany, the exploitation of its workers, and so on.[17] As well as Atget and Sander, he also praised photo-montage and insisted on the importance of words in relation to photography, particulary captions. It is interesting that Barthes too has laid a lot of stress on the caption as a means of

anchoring the significance of a photograph.[18] Sontag, however, is sceptical. Photographs, she thinks, tend to over-run their captions and avant-garde photography has always remained marginal.

Benjamin was right, I think. Like all the most progressive artists and theorists of our century, he was trying to hold and develop a line between Lessing and Wagner,[19] between a purism that believes the practice of an art must be determined by its specific essence and a holism that sought an integration of different media and semiotic systems on a basis of mutual reinforcement and support. In photography, the path of Lessing has been trodden by the pictorialists, seeking a self-sufficient art photography true to its own nature, and that of Wagner by advertising photography where image and verbal language have been integrated. Benjamin turned instead towards press photography—yet perhaps this was not a true alternative, but rather a compromise, in which word and image remained spatially separate and simply complemented each other in role and meaning. Either the caption located what the photograph was *of*, its indexical referent, or else commented on or elaborated its sense as a quasi-predicate.[20] Moreover, there was a clear hierarchy between press photograph and caption.

Nonetheless already in the 1920s avant-garde experiments were pointing the way towards new concepts of photography.[21] Heartfield's photo-montages are well-known, although as John Berger points out they often fall into a pattern of stylized rhetoric. Soviet montages for books and exhibitions were in many ways more complex. The collapse of easel painting among the Russian avant-garde led to a shift of interest towards photography, which partly transferred Bauhaus and New Objectivity concerns to the Soviet Union, but partly too went beyond this—for instance, in Rodchenko's montages accompanying Mayakovsky's poem *Pro Eto* or Lissitsky's *Pressa* exhibit in Cologne. Here photographs are themselves being used as material within complex constructions in relation to heterogeneous texts. This had three effects. First, it destroyed the aura of the photographs, by cropping and relocating them. Second, it structured their juxtaposition, rather than presenting them simply as a suite. Thirdly, it placed them *vis-à-vis* words in a way which could not be understood simply as 'illustration' or 'caption'.

These uses of photography in art, typical of avant-garde work in the 1920s, did not prosper. As with Eisenstein and Vertov, Rodchenko and Lissitsky were forced to adapt to a new climate after the promulgation of socialist realism. Indeed, as is well-known, by the mid-forties there was hardly an avant-garde artist in Europe still working. Those who had not converted or accommodated to conservative or official forms of art, were either dead, or in exile, or silent. It was not until the 1960s that anything resembling the richness and energy of the 1920s was able to re-emerge. It was at this time that rifts at last began to appear in the hegemonic version of modernism that acquired official status in the USA soon after the end of the war. The breakdown of this official modernism has been widely seen as a slackening, perhaps even collapse of avant-gardism. In fact it represents a revival.[22] In our 'post-modernist' epoch there has, as one would expect, been an immense interest in photography and, especially significant, a renascence of avant-garde photography.

In the USA this has taken the form of a revival of interest in the use of photographic material in painting (Rauschenberg, Warhol), in a more radical interest in series photography, partly triggered by the rediscovery of Muybridge, and by the development of narrative photography, as in the work of Duane Michals and Michael Snow.[23] In Europe there have been parallel developments, often associated with various art tendencies and movements rather than directly with photography (Dibbets, the Bechers, Fulton, Long). But, more significantly, there has also been a movement toward engagement with the semiotic systems of 'popular' or 'mass' commercial photography—film-still, fashion and advertising photography, postcard, photo-novel. One example of this, of course, is the Godard-Gorin film, *Letter to Jane*. In Britain there are photographic works by Victor Burgin, David Dye, Alexis Hunter, Sarah McCarthy, John Stezaker, Marie Yates and others, marking a crucial new direction for photography as/in/against art.[24]

Instead of seeing art photography as something quite separate from commercial photography or integrated with elements of it, they work on commercial photography as 'reference text' to be transformed, repositioned and criticized, implicitly or explicitly.

This is not simply 'de-construction' but rather a process of 're-production' which involves a disorientation and reorientation of the spectator in which new signifieds are superimposed disturbingly on the memories/anticipations of old presuppositions. Moreover, this work is very varied—use of caption (Burgin), point of view and frame (Stezaker), narrative sequence (McCarthy), are all subject to investigation and 're-production'. Attention too is being directed not toward photography either as 'fact' or 'vision', but photography as 'fiction' and 'drama'.

This new area, new aesthetic problematic of and for photography, allows us to reformulate the questions with which this essay began. For photography to be an art involves reformulating notions of art, rejecting both material and formal purism and also the separation of art from commerce as distinct semiotic practices that never interlock. Photography is not an 'art-in-itself' any more than film, but an option within an inter-semiotic and inter-textual 'arena'.[25] Similarly, it is not fated to provide mere information, though its indexicality is part of its power, but neither can it provide scientific or quasi-scientific knowledge, except of course within the specific practices of science itself.[26] Photography within art can, however, re-open the closed questions of ideological reading and understanding, the symbiosis of information with blocked knowledge and balked desire. In this sense, it opens up paths that make the production of new knowledge elsewhere more possible. Re-inscription, discontinuity and heterogeneity, caught though they themselves may be in the imaginary, make possible by displacement unsuspected changes in the symbolic.

# 'Ontology' and 'Materialism' in Film

Since the invention of cinema, theorists have explored the problem of its essence and embarked on the search for an ontology. Foremost among these, of course, was André Bazin, whose collected writings are published under the title *Qu'est-ce que le cinéma?* [1] —a collection in which the very first essay confronts the problem of the ontology of the photographic image. This essay is illustrated by a photograph of the sacred shroud of Turin, an instance of double registration, and it contains numerous analogies, well-known by now, between photography and the moulding of a death-mask, the preservation of a fly in amber, mummification. For Bazin, photography—and by extension cinematography—was a natural process of registration, a process that excluded man and was in some sense, despite its advanced technology, pre-cultural or at least a-cultural. 'All the arts are based on the presence of man; in photography alone do we enjoy his absence (*nous jouissons de son absence*). It acts upon us as a "natural" phenomenon, like a flower or a snowflake whose beauty cannot be divorced from its vegetable or telluric origins'.[2] Cinema was based on a natural automatism that cancelled the irreversibility of time, a rigorous determinism.

This line of argument led Bazin to assert that the ontology of the photographic image was inseparable from the ontology of its model, even that it was identical to it. By natural optical and photochemical processes, the being of the pro-filmic event (the objects within the camera's field of vision) was transferred to the being of the film itself, the image sequence registered and subsequently projected. Bazin saw the destiny of cinema as the recreation of the

world in its own direct image. But this potentiality of the cinema, the potentiality of an 'integral realism', could be put into effect no faster than the pace of technological development permitted. Technological progress was already marked—first, the invention of cinema itself, then the great milestone of sound—and Bazin looked forward to the generalization of colour and the perfection of 3D. He would certainly have welcomed holography. At the same time, improvement of film-stock and lenses reduced the need for artificial light and made possible an increased depth of field in the image, corresponding, so Bazin thought, to the ubiquitous crispness of natural perception.

'On the other hand, the cinema is a language'.[3] What did Bazin mean by this? The presence of language must signify, of course, the passage from nature to culture, the intervention of human agency, the currency of thought. Bazin speaks of the 'language' of cinema as though it was a necessary burden. It is as though the need for language was inflicted on the cinema by its technical inadequacy; it could not be dispensed with yet. On two different occasions, Bazin uses the metaphor of the 'equilibrium-profile' of a river.[4] In the early stages of cinema, technical developments bring with them the development of means of expression, figures of language, which are then outmoded and rendered obsolete by new technical developments. Thus, the silent cinema saw the development of 'Russian' montage, the close-up, fundamentally as a means of compensating for the absence of sound. The assimilation of sound during the 1930s led eventually to a new situation, an equilibrium-profile, when these figures of language could be dispensed with. Indeed, in the context of other technological improvements—the return of the carbon arc without its hum, the blimped Mitchell with coated lens, high-speed panchromatic stock[5]—not only could these figures be dispensed with, but Bazin could envisage a cinema in which there would be an 'effacement' and 'transparency' of technique and the formal vocabulary associated with it. In this new phase, content would re-assert its primacy over form, and Bazin leaves us in no doubt that this dominance of content is proper and desirable, the suppression at last of a regrettable, though necessary, perversion.

'Language wants to be overlooked.' Siertsema's phrase sums up

Bazin's vision of cinema, a cinema whose essence was elsewhere, in the pro-filmic event, and which, because of the automatism of photographic registration, could efface language and render it transparent much more successfully than any other medium. The first generation of great film-makers—the prophets of the Old Testament, as Bazin saw them—had been fated to be rhetoricians, not because they were committed to formalism or art for art's sake, but because they could only compensate for a lack, above all the lack of sound, by adding (and Bazin is very clear that language is an addition or supplement). Yet even then, there were directors who anticipated the future—Flaherty, Murnau and Von Stroheim are the names Bazin cites most frequently—by reducing the formal and linguistic surplus as far as conditions would allow. In their work, 'the absence of a sound-track ... means something quite other than the silence of *Caligari*. ... It is a frustration, not the foundation of a form of expression'.[6]

Bazin's approach to the cinema ran up against two difficult problems, that of fiction and that of interiority—problems that the novel seemed more advanced in solving than the cinema, and which explain why Bazin still looked to literature as an exemplary art. Indeed, Bazin saw one path towards the portrayal of interiority in the use of literary or quasi-literary discourse on the sound-track, as a complement to the bareness of the image. He also developed the idea that the close-up could reveal interiority—the old notion of the face as window on the soul. It is here, of course, that he displays his Catholic and personalist heritage most plainly, where his habitual naturalism gives way to an extreme idealism. It is worth noting too that Bazin allowed the validity of Cocteau's *Le Sang d'un Poète* as a 'documentary on the imagination';[7] he died in 1958, before the decade of *Last Year in Marienbad* or *Dog Star Man*, but it is not impossible that he might have extended the concept of 'integral reality' to include interiority.

More curious was Bazin's attempt to solve the problem of fiction. He was led to accept the need for a minimum of montage simply in order to produce the effect of unreality, yet not enough to threaten the basic realism of the film. He talks of a 'fringe' or 'margin' of illusion which is necessary to allow a flux and reflux between the imaginary and the real. It would betray the essence of

the cinema to lose hold of the primacy of the real, but on the other hand too much reality would expose the artifice on which fiction must depend. In a phase that must produce a shock of recognition in anyone who has read Freud's paper on 'Fetishism',[8] Bazin remarks that it is necessary for aesthetic fulfillment (*'plénitude esthétique'*) that 'we should *believe* in the reality of events, while *knowing* them to be faked'[9] (Bazin's emphases).

Bazin, as a critic and theorist, was a conservative. If I have dwelt on his views at some length, it is because the questions about which he writes also confront theorists with very different assumptions and conclusions. I am thinking of the problem of the relationship between an ontology of cinema—albeit perhaps a materialist ontology—and language or semiotic; the problem of illusion and anti-illusion; the historic problem of the impact of sound. It is on the first of these particularly that I want to concentrate—it was a problem central to Bazin's whole system of thought, while other issues were seen by him as subsidiary or derivative. It is also a problem that, whether openly stated or not, underlies the theory and practice of every theorist and film-maker. Bazin's great merit was to make this manifest and concentrate his attention and characteristic subtlety of mind upon it.

First, ontology. The imediate point we must note is that the concern for ontology has clearly shifted from the mainstream, which Bazin represented, to the avant-garde. Shortly after winning the prize at Knokke in 1968, Michael Snow was asked by the editors of *Cinim* in England, 'Why Wavelength?' He replied: 'Critical moment in my life and/or art. Light and sound waves. Limits of hear and see.... "A time monument." A pun on the room-length zoom to the photo waves (sea), through the light waves and on the sound waves. Electricity. Ontology. A definitive statement of pure film space and time.... A summary of my nervous system, religious inklings and aesthetic ideas.'[10]

Various ideas emerge from this reply—the aspiration to pure cinema, in contrast to Bazin's advocacy of an 'impure' cinema; the lingering idealism that Snow expresses elsewhere by comparing his film to psycho-tropic drugs;[11] the characteristic post-Duchampian taste for puns. But it is on the word 'ontology' that I want to concentrate attention. The theme is taken up by P. Adams

Sitney in 'Michael Snow's Cinema': 'Snow has intuitively discovered an image, in almost every one of his films, capable of evoking the metaphysical notion of categories of being.'[12] He goes on to quote Ortega y Gasset on the crux of modernism as 'the drive to give works of art the integrity of objects, and to liberate them from the burden of human mimesis.' The irony must strike the reader familiar with Bazin's work—it is mimesis itself that is now associated with the burdensome intervention of the 'human', the cultural, as the work of art is returned to the integral objecthood of nature, existing as pure being.

This line of thought, barely alluded to by Snow, toyed with by Sitney, who remains in the last resort wedded to a very traditional Romanticism, is taken up in a different context and elaborated more coherently by Regina Cornwell, writing on 'Some Formalist Tendencies in the Current American Avant-garde Film.' Cornwell also talks about ontology: 'These works are concerned with the ontology, materials and processes of film itself.'[13] But Cornwell develops her position in the context of art history, rather than general aesthetics. She cites Greenberg—'It quickly emerged that the unique and proper area of competence of each art coincided with all that was unique in the nature of its medium'; and further, 'realistic, naturalistic art had dissembled the medium, using art to conceal art; modernist art used art to call attention to art.'[14] Her purpose, following Greenberg, is to relate the ontology of film as a concern to reflexive film, film about film, its own processes and structures. Film thus becomes an investigation and demonstration of its own properties—an epistemological and didactic enterprise. As such it is located within the history of Greenberg and post-Greenberg 'modernism'.

A similar 'modernist' position is developed by Annette Michelson. I cite her 'Paul Sharits and the Critique of Illusionism: An Introduction,' written to accompany new projection work by Sharits, exhibited at the Walker Art Center in Minneapolis. Writing about 'the best of recent current work' in American avant-garde film, Michelson affirms that 'the ontology of film is their collective concern'. She traces the origin of this concern back to Brakhage: 'Brakhage's insistence upon the materiality of the filmic support, the filmic filtering of light, his revision of sound-image relation,

his subversion of the space in which narrative takes place, initiates the development of that detailed critique of illusionism which marks the passage from *cinema* to *film*.'[15] (Michelson is drawing here on a distinction made by Hollis Frampton in 'For a meta-history of film: commonplace notes and hypotheses': 'From now on we will call our art simply: *film*.'[16]) I should also add that Michelson goes on, in the next paragraph, to write about Olitski, thus recalling again the Greenbergian parallel to her own thought about modernism in film.

From 'What is cinema?' to 'the ontology of film': we have passed from an ontology basing itself on the possibility, inherent in the photo-chemical process, of reproducing natural objects and events without human intervention, to the conscious exploration of the full range of properties of the photo-chemical process, and other processes involved in film-making, in the interest of combat-ting, or at least setting up an alternative to, the cinema of repro-duction or representation, mimesis or illusion. And this passage, this displacement of the notion of 'ontology' on to a quite different terrain, is set within the rift between modernism and traditional-ism that marked all the arts during the first decades of this cen-tury, though it was in painting and music that this rift went deepest, in comparison to literature and cinema. So this displace-ment is also marked by a shift in the perspective of comparison between cinema and the other arts.

It is necessary to make some further points. Both Cornwell and Michelson mention the 'materials' of film itself, the 'materiality' of the filmic support. Michelson relates this interest in 'material-ity' (historically determined by the specific mode and relations of production within the independent film sector—the necessary interest of the artisan or craftsman in his materials and tools, asser-ted as an end in itself in the face of competition from large-scale capitalist industry) to the Ford model, dedicated to the mass pro-duction for profit of illusionist cinema. Thus the search for an ontology can itself be displaced from the field of idealism—Sitney's metaphysical modes of being, evoked as theologically as anything is by Bazin—to the field of materialism. Indeed, this possibility has been taken up polemically by the film-maker and theorist, Peter Gidal, in his partisanship of 'structural/materialist film'

against the backsliding of others into idealist illusionism and romanticism.[17]

Michelson herself is well aware that by talking about 'materiality' in this way she is necessarily entering another debate. As she puts it, there is 'a larger crisis, international in scope, interdisciplinary and transformal' whose effects are felt not only in the American avant-garde but in the 'post-Brechtian aesthetic of European...cinema.'[18] The attempt to build a 'materialist' cinema has been the cornerstone of the post-1968 films of Jean-Luc Godard and the Dziga-Vertov group (Michelson too has written at length on Vertov) and others such as Jean-Marie Straub are also concerned with the materiality of film: 'Art-house distributors haven't yet understood that the cinema is a very material art, even a materialist art,' Straub once said,[19] talking about quality of projection, and one could find many such remarks, particularly on the subject of sound. Yet there is a chance of confusion here, because 'materialism' in the sense used by Godard, following Brecht, and the defenders of Godard or of Straub and Huillet, is somewhat different from the sense of materialism as used here by Straub himself, which is indeed closer to the concern with 'materiality' about which Michelson is writing. We sense this potential confusion too in Gidal's writings, where the two versions of materialism are often juxtaposed. In his films and theoretical work he has taken care to avoid any suggestion that materialism could be reduced simply to the representation or documenting, mapping, of the material process or substance of film, or that representation could ever be entirely eliminated. His aim has been to produce films that are materialist precisely because they 'present' rather than reflexively 'represent' their own process or substance. The pro-filmic event is not film itself; the work is not an illustration or record of its own making, but is constructed in such a way that it must be perceived primarily as an end-product brought into being by procedures (bringing into focus, bringing into frame) that have no extrinsic finality, means to no end other than that of producing a film as such. His aim is to construct an 'anti-illusionist' aesthetic for a medium 'illusionist' by nature (an anti-ontology, so to speak) and a materialism that can be interpreted as dialectical rather than mechanical. The representational

content of the work—his own room for instance, as in *Room Film* —is posited as a necessary but not significant residue. It is here, of course, that Gidal's sense of materialism differs crucially from any post-Brechtian sense of materialism, concerned as it must be with the significance of what is represented, itself located in the material world and in history.

Brecht saw his theatre as essentially materialist in its political content and psychological effect, its role in a struggle against an Aristotelian theatre based on empathy, projection and introjection. For Godard and the Dziga-Vertov group, Brecht was a great forerunner whose work they read in a specific context:[20] Althusser's insistence on a materialist reading of Marx; Lacan's critique of neo-Freudianism and ego-psychology; the journal *Tel Quel* and its development of a theory of the text, a semiotic based on the material character of the signifier and the practice of writing as a subversion of conventional codes, especially those of representation, and a 'de-structuration' of the conscious (self-conscious) subject in favour of a subject fissured and split by articulation with the order of the unconscious and his or her own body. Thus the somewhat simple Brechtian concept of materialism in the theatre was translated to the cinema in terms of a re-reading and re-formulation (re-writing) that presumed a more sophisticated conceptual apparatus, to the point of being arcane.

It is now that we must return to Bazin's observation: 'On the other hand, the cinema is a language.' Or is it? The same period which has seen the shift in the concept of ontology discussed above, has also seen the startling development of a semiology, associated above all with the work of Christian Metz.[21] Metz's principal achievement to date has been to establish that cinema is a multi-channel and multi-code system. These codes may have different types of status—there are those like that of verbal language itself, which though components of the overall system of film are nonetheless non-cinematic, in that they have an independent existence of their own, outside and frequently preceding the invention of the cinema. Alongside these are the specifically cinematic codes of camera movement, editing. The non-cinematic codes, we should note, are at work in the pro-filmic event and are inscribed into the discourse of film by the process of photographic

reproduction, itself an iconic code or code of analogy, based on recognition. (The non-cinematic codes may be modified or altered to some extent due to their inscription within the film-text: thus the gestural code acquires a specifically filmic 'dialectal' form, different from that of everyday life or the theatre.)

We can now re-approach the question of 'modernism' in film. There are two tendencies here. First, the muting or exclusion of the non-cinematic codes—those of music, verbal language, gesture, facial expression, narrative. This is in line with the aim of developing a 'pure' cinema, in which principally (or only) the cinematic codes would be at work. Second, the reduction of these codes themselves to their material—optical, photo-chemical— substrate ('material support') to the exclusion of any semantic dimension other than reference-back to the material of the signi- fier itself, which becomes its own unique field of signification. This involves the negation of reproduction as the aim of the photographic process, because the fact of reproduction introduces necessarily an extrinsic signified—the event/object photographed/ reproduced—or at least, if not a signified in the strict sense, a referent or *denotatum*. Put another way: light is no longer seen as the means by which the pro-filmic event is registered on film, but as the pro-filmic event itself, and at the same time part of the material process of film itself, and transmitted through the lens and indeed the strip of celluloid in the projector—so that the strip can be seen as the medium for the transmission (and absorption) of light, the basic raw material.

The most extended discussion of these tendencies, in relation to both the concept of ontology and that of language, is to be found in Paul Sharits: 'When Bazin asks "What is cinema?" he answers by describing the interesting ways in which cinema has been *used* to tell stories, enlarge upon theatre, cinematize "human themes". If we dispense with such non-filmic answers, do we have anything left? I believe that we can turn away from the cinema that began with Lumière (using cinema to create illusions of non-filmic movement), and developed through Méliès, Griffith, Eisenstein, and so on, up to today's Bergman, Fellini, and we can ask a new set of questions which greatly expand the possibilities of the system.'[22] This return of Sharits to Bazin's ontological question,

in order to answer it in a completely different sense, follows imed-
iately after a discussion of the achievement of 'objecthood' in non-
objective art, primarily through 'intensification of materiality'
but through serial systems as well, characteristic of Sharits's own
films of course, also reminiscent here of Fried's observations on
seriality in the work of his favoured 'Three American Painters'—
Noland, Stella, Olitski.[23] Indeed, this section of Sharits's paper
ends with an evocation of Stella as exemplar of "self-reference",
through formal tautology'.[24]

Sharits does not exclude iconic reference totally—though he has
done so in individual pieces of work—because recording or regis-
tration is 'a physical fact' intrinsic to film, unlike this aspect of
painting. Indeed, Sharits sees in the dual nature of film (recording
process and optical/material process) a 'problematic equivocality
of film's "being"' which is 'perhaps cinema's most basic ontolog-
ical issue'. Thus he comments on the problem posed by Landow's
*Film in which there appear sprocket holes, edge lettering, dirt particles,
etc*, where both images/registrations of dirt particles appear and
actual dirt particles on the particular film-strip being projected.
Snow makes a very similar point when he compares his interest in
*Wavelength* to that of Cézanne, in exploring the tension between
'painterly', two-dimensional surface and three-dimensional
'space', or effect of space, produced upon it.[25] This, too, is a mile-
stone in the Greenberg-Fried view of art history.

When Sharits comes to language and linguistics (he posits a new
field of 'cinematics', more or less equivalent to what is now known
as semiology or semiotics of film) his main concern is to look for
units below the level of the shot, corresponding therefore to phon-
emes rather than morphemes. His interest is in phonology rather
than syntax—the division of the stream of air, the continuous
'sound wave emanating from the mouth of a speaker' into discrete
units or modules. Hence he concentrates his attention on the
frame rather than the shot—which, as he analyses it, is a distinct
physical as well as linguistic unit. The problem that Sharits is
touching on here is that of 'double articulation'. Verbal language
is articulated on two levels, one of which—the phonological—
underlies the other. Semiologists are divided over the question of
the number of articulations to be attributed to film and also over

how, and if, they form a hierarchy. Sharits develops the idea that the most fruitful research procedure lies in making films that are indeed, in the strict sense of the word, experimental. Such films, made by 'researchers', would produce information about their own 'linguistic' ('cinematic') structure. Thus the self-referential film is a tool of inquiry into the problems of film language and film being, united at the level of the minimal unit.

It is hard to see here how language or semiotic can be differentiated from ontology except in the sense that vocal sound can be differentiated from language. Vocal sound—the production of sound waves through the action of various parts of the human body (vocal or speech organs) on a stream of air passing through from the lungs—is the material substrate of verbal language, without which language could not exist (perhaps one should add, or without an equivalent material substrate, as with American Sign Language or writing, which rely on bodily movement, a stream of ink). Sounds clearly exist that do not form part of verbal language —grunts, sobs, coughs, moans—but may nonetheless be expressive and fall within the field of semiology as paralinguistic phenomena. They form too a dimension of what Julia Kristeva, in *La Révolution du language poétique*,[26] calls the semiotic *chora*, the pre-linguistic or pre-symbolic means of expression that are not dependent on the thetic act by which a subject of discourse is created.

What interests Sharits is the way in which a protocol can be devised to structure this material substrate—a serial system or calculus, perhaps a random system—so that the structuring is no longer dependent on a higher level of organisation. Thus in Burroughs's cut-up method, letters are no longer organised into words, words are no longer organised into sentences.[27] Similarly, frames need no longer be organised into shots or shots into sequences. Both sentences and sequences, in conventional writing or film-making, are organised in order to convey a determinate meaning. In other words the needs of reference and denotation govern the structuring of all the various levels downwards. This need in cinema, to capture a likeness of the world, can be dispensed with and consequently new structural protocols introduced. These need not lead to meaninglessness because a principle

of 'self-referentiality' is introduced, so that film is about itself and its own structure. Film, because of its 'duality of being', can be both an autonomous object and also its own representation—thus ontology and semiology can coincide.[28]

In fact, Sharits wavers between two concepts of representation —first-order mimeticism = conventional iconic reference; second-order mimeticism = multiple mapping procedure, as in the Landow example mentioned above, or else a method of drawing attention to cinematic phenomena normally overlooked. Thus he cites Brakhage for his use of '"mistakes" (blurs, splices, flares, flash frames, frame lines.)'. This functions not so much as a multiple mapping effect but as what linguists, in the terminology of the Prague School, have called 'foregrounding'.[29] The Landow film uses the film strip itself, as added to and altered by the process of projection (accumulation of dirt particles), as the profilmic object/event for another film. Brakhage is merely retaining —in the case of blurs and flash frames—elements of the film that would normally be discarded. He thus makes us aware of the material substrate not by removing instances that have no iconic reference and would hence normally be suppressed: he deliberately foregrounds them.

Cornwell makes a very similar point when, writing about Gehr's use of grain (see also Sharits's *Axiomatic Granularity*), she points out how normally we become conscious of grain only as a shortcoming to be overlooked if possible, otherwise a distraction, as when a fiction film shot in 16mm is blown up to 35mm. She gives as another example the use of scratches in Sharits's S:TREAM :S:S:ECTION:S:ECTION:S:S:ECTIONED, contrasted with the need to overlook scratches, if possible, during the projection of a conventional movie.[30] Sharits himself is explicit about the structural possibilities of what are normally considered flaws or errors, bungled actions. These are the points at which what was not intended reveals what it is possible to intend. Of course, whereas Sharits sees these flaws simply as the irruption of a lower-level system into the higher, they could also be interpreted as instances of symbolic displacement.

Brakhage himself is quite clear about one at least of the purposes of this type of foregrounding: 'The splice, that black bar breaking

two kinds of white, operating aesthetically as a kind of kickback or kick-spectator out of escapist wrap-up or reminder (as are flares, scratches, etc. in my films) of the artifice, the art.'[31] This passage, with its surprisingly Brechtian ring, couched though it is in a very different rhetoric from Brecht's, reminds us of the de-mystificatory role that foregrounding can play, breaking processes of imaginary involvement. But at the same time it should also serve as a warning. In almost every other respect, Brakhage is clearly the polar opposite of Brecht. His conception of the artist, his world-view, is one of unmitigated idealism. For Brecht, of course, the point of the *Verfremdung*-effect was not simply to break the spectator's involvement and empathy in order to draw attention to the artifice of art, an art-centred model, but in order to demonstrate the workings of society, a reality obscured by habitual norms of perception, by habitual modes of identification with 'human problems'. Nor indeed was this reality once accessible to the power of inner vision; it had to be approached and expounded scientifically. For Brecht, knowledge always took precedence over imagination.

There was no question then for Brecht of abandoning the whole realm of reference outside the play (or film—though only *Kuhle Wampe*, a marginal and collaborative work, exists to indicate the way Brecht might have thought the issues through in terms of cinema). He did not equate anti-illusionism with suppression of any signified except a tautological signified. Nor of course do the Godard/Dziga-Vertov Group or Straub-Huillet. If there is something in common between 'structural' or 'modernist' film and the 'post-Brechtian aesthetic' of which Michelson writes, it consists neither of the movement toward 'objecthood' and exclusive self-referentiality, nor in the simple act of foregrounding the material substrate. This 'post-Brechtian aesthetic' is not postulated on the search for an ontology, albeit a materialist ontology. It has to be approached from the side of language, here dialectic.

Brecht's objection to the traditional bourgeois theatre was that it provided a substitute for life—a simulated experience, in the realm of the imaginary, of the life of another person, or other people. In its stead, he actually wanted a representation—a picture, a diagram, a demonstration: he uses all these words[32]—to which the spectator remained external and through which he/she

acquired knowledge about (not gained experience of) the society in which he/she, himself/herself lived (not the life of another/ others). Brecht's anti-illusionism then should be seen not as anti-representationalism (Brecht thought of himself as a 'realist') but, so to speak, as anti-substitutionism. A representation, however, was not simply a likeness or resemblance to the appearance of its object/referent; on the contrary, it represented its essence, precisely what did not appear at first sight. Thus a gap of space had to be opened up within the realm of perception—a gap whose significance Brecht attempted to pinpoint with his concept of 'distanciation'.

It is here that the concept of 'text' must be introduced—a concept developed in the same intellectual milieu which, as noted, determined the reading of Brecht by Godard and others.[33] Brecht wanted to find a concept of 'representation' that would account for a passage from perception/recognition to knowledge/understanding, from the imaginary to the symbolic: a theater of representation, mimesis even, but also a theatre of ideas. Moreover, one of the lessons to be learned from this didactic theatre, this theatre of ideas, arguments, judgements, was precisely that ideas cannot be divorced from their material substrate, that they have material determinations, that 'social being determines thought' as the classic formula (deriving from Marx's *Preface to a Contribution to the Critique of Political Economy*) puts it. Brecht, of course, was a militant materialist, in the political (Leninist) sense.

Ideas, therefore language: it is only with a symbolic (rather than iconic) system that concepts can be developed, that there can be contradiction and hence argument. Yet at the same time ideas not simply conveyed or communicated through signifiers that could be overlooked, effectively dematerialized by the sovereign processes of thought. A work, therefore, that recognized the primacy of the signifier in the process of signification. This would not involve the reduction of the signifier purely to the material substrate, a semiotic of pure presentation, nor the mere interruption of a stream, a continuum of signifieds, by the de-mystificatory break, reminder or caesura of a signifier perceived as an interruption, a discontinuity within an over-riding continuity.

A text is structured primarily at the level of the signifier. It is

the ordering of the signifiers that determines the production of the signifieds. Normally, moments in which the signifier interrupts discourse are perceived as lapses, errors, mistakes. We should be clear, however, that we are talking now not about 'noise', interruptions or destructions of the process of signification in itself, but of moments in which a mistaken signifier—a metathesis, the displacement of a phoneme—changes meaning, alters or negates the flow of signifieds, diverts, subverts, converts. Whereas Sharits is interested in the re-structuration of noise to provide second-order self-referential information, we are here talking about the production of new—unintended, unanticipated, unconsciously derived—signification from operations carried out on the signifiers. First-order signifiers remain, but they are no longer the sovereign product of the intentional act of a subject, a transcendental ego, the generator of thought that finds embodiment in language as an instrumental necessity for the communication and exchange of ideas between equivalent subjects, alternating as source and receiver.

There is a form of discourse that already corresponds to this concept of the text: poetry—in some sense of the term at least. Poetry has rules that govern the ordering of signifiers independent of the signified: metre, rhyme. Traditionally these are seen as embellishments. Frequently this may be so. Another approach—that of the Russian Formalists, specifically Shklovsky and Jakobson—has been to see them as means by which language is de-automatized, its materials and principles of construction (devices) foregrounded, thus renovating our perception and giving the world, which is always in some sense the world of language, new density and freshness. Later Jakobson developed the same line of thought by postulating the poetic function of language as one of self-reference to the message itself.[34] Here, of course, we are on familiar territory, and it should not surprise us that both Sitney[35] and Cornwell[36] quote Shklovsky, transferring his remarks about literature so as to apply them to film.

However, the concept of text that I am developing here has a different implication. The formal devices of poetry (not purely formal of course, because they involve the sound or graphic material—the substance of expression as well as its form, as

Hjelmslev would put it) may in fact produce meaning. These devices, and indeed what is often approached as *style*, are more than supplementary embellishments or even distanciation or self-referential or tautological devices. Style is a producer of meaning —this is the fundamental axiom of a materialist aesthetic. The problem is to develop the efficacy of style beyond that of spontaneous idiosyncracy or a mere manner of writing, painting or film-making, fundamentally subordinate to the sovereignty of the signified. I am talking about style in the sense in which one would speak of the *style*, the ordering of signifiers, at work in the writing of Gertrude Stein's *Tender Buttons* or James Joyce's *Finnegans Wake*.[37]

This concept of text does not exclude, indeed is constructed on, the need to produce meaning. It sees meaning, however, as a material and formal problem, the product of material and formal determinations rather than the intention of an *ego cogitans*, a thinking and conscious (self-conscious) subject. Indeed, the very concept of such a subject is dissolved by textual production in this sense, as Kristeva and others have repeatedly argued. This does not mean, of course, that the conscious subject of ideology is simply replaced by an automatism or by a random process. Rather, it transforms the thinker, or imaginer, or seer, into an agent who is working with and within language in order to make something that cannot be precisely pre-conceived, that must remain problematical and in a sense unfinished, interminable. This manufacture must not suppress its material substrate, the sensuous activity that is its process of production, but nor is that sensuous activity its own horizon.

From this point of view, the 'modernist' non-objective tradition in painting cannot be seen as the exclusive alternative to the bourgeois realism and representationalism it has ousted. Michelson has pointed out, quite correctly, that both Godard and avant garde American film-makers have developed a 'critique of cinematic illusionism' and, of course, these two critiques have much in common, but they also differ in certain crucial ways. Illusionism should not be confused with signification. The decisive revolution of twentieth-century art can be seen in the transformation of the concept and use of the sign rather than in the rejection of any

signification except tautology, the closed circle of presence and self-reference. Anti-illusionism does not even necessarily imply anti-representationalism, which cannot be construed as illusionistic when it is no longer in the service of an alternative creation (the production of an imaginary substitute for the real world). In this respect, the 'multiple mapping procedures' described by Sharits are, like Brecht's plagiarism or Kristeva's 'intertextuality', important anti-illusionist procedures that can produce the transition from the imaginary to the symbolic in the spaces and overlaps of a palimpsest. In this way, the illusory immediacy of 'reading' is destroyed and replaced by a productive deciphering, which must move from level to level within a volume—rather than following a surface that presents itself as the alterity of a depth, a meaning that lies elsewhere, in the ideal transaction/ exchange between consciousnesses, rather than the material text.

To say, however, that the two anti-illusionist currents being discussed are in many respects separate, different from each other, does not mean that they may not be combined. The operations on the signifier that Godard envisages seem limited in the context of American avant-garde cinema—there is an absence of the figures Sitney describes as typical of the 'structural' film: fixed frame, flicker, loop printing, re-photography.[38] (Though Godard does use orchestrated back and forth pans, single shots of very long duration, scratching on film.)[39] On the other hand, the American avant-garde has tended to avoid Godard's experiments in the use of verbal language on the soundtrack, till recently at least, and of course there is not nearly the same concern over signification, and its ideological or counter-ideological role. The most radical enterprise of the American avant-garde, as we have seen, has been the exploration of 'voice' rather than 'language', whereas Godard's aim has been to build the elements of a new language, to express a new content. Though different, clearly these two aims *can* be related.[40]

Finally, I want to return to my starting-point—Bazin. Bazin saw meaning as something transferred into the cinema by the material and hence automatic processes of photographic registration; fundamentally, meaning resided in the pro-filmic event and the aesthetic importance of film was that it could generalize through

the printing process, and make permanent, like a mummy, events and significations that would otherwise be local and lost. Thus his ontology transferred the burden of meaning outside the cinema, to the non-cinematic codes. The 'language' of film would virtually wither away as cinema possessed itself of the integral reality that was its mythic destiny. Language and ontology, essence, were in a kind of inverse relationship.

The modernist current, in complete contrast, has sought to expel the non-cinematic codes, leaving the residue called 'film'. For Bazin, this would imply a complete abandonment of meaning, except the secondary meaning added by the rhetorician, now no longer a pretender, but a usurper. Yet ontology, as we have seen, is re-introduced—through the idea of the object-hood of the film itself, which is also its own signified, through the circular process of self-reflection, self-examination, self-investigation. Film is now directed not towards the 'nature' of the pro-filmic event, but towards the 'nature' of its own material substrate, which may indeed become its own pro-filmic event, through multiple mapping procedures, seen as ontologically inherent in the medium. Again, any heteronomous signification is proscribed.

However, anti-illusionism need not necessarily end in this kind of tautology, an involution of the illusionist project itself. A reversal of the relations of dominance between non-cinematic and cinematic codes, between signified and signifier, can lead to the production of the film-text, rather than the film-representation or the film-object. Film-making can be a project of meaning with horizons beyond itself, in the general arena of ideology. At the same time it can avoid the pitfalls of illusionism, of simply being a substitute for a world, parasitic on ideology, which it reproduces as reality. The imaginary must be de-realized; the material must be semioticized. We begin to see how the problem of materialism is inseparable from the problem of signification, that it begins with the problem of the material in and of signification, the way in which this material plays the dual role of substrate and signifier.

The cataclysmic events that changed the course of the arts in the first decades of this century were seen by many as a radical and irreversible break. In due course, many came to see modernism as

simply a metamorphosis of a type of art fatally compromised by bourgeois ideology, reproduced and generated within the conditions laid down by the market or the state, increasingly active in the arts. Yet we can sense surely that something was at stake in that heroic era: that the achievements of the Cubists, the Futurists, of the destruction of the classical system of perspective and harmony, the primacy of narrative and 'realism', were more than a strategic regroupment. It would be paradoxical indeed if film, a form still in its infancy when these momentous shifts took place, could restore the sense of direction that the other arts often seem to have lost.

# Semiotic Counter-Strategies: Retrospect 1982

The troubled relations between art and popular culture are again entering a new phase. It is no longer feasible to maintain a rigid divide between the two (a divide consecrated by the old antitheses of formalism v. realism, modernism v. kitsch, avant-garde v. mass audience, that have so dominated the theory and practice of art-making in this century, perhaps especially in the post-war period). There is more and more crossover and interpenetration, more and more activity in the hybrid interzone between the two.

The attempt to deal both with the avant-garde and with the mass art of Hollywood has been constant in my own work, but I feel that the terms have changed immensely since the *auteurist* days of the early sixties. Looking back, I am surprised how violent some of the critical and aesthetic oscillations were, as the focus of my interest veered from Sam Fuller via Godard to Paul Sharits and then away again. There are a number of complex strands interwoven and perhaps it's worth making a few hesitant observations.

(1) *Auteurism* itself cannot be understood without some reference to the massive presence of Surrealism in French cultural history. The Surrealists were always ready to revalue the naive, delirious, trashy and '*maudit*' aspects of popular culture (witness Breton's love for the oneirism of Hathaway's *Peter Ibbetson*, for instance) and the Surrealist heritage is quite explicit in journals like *Positif* and *Midi-Minuit*. While *Cahiers du Cinéma* was never post-Surrealist in the same way, it nonetheless shared the same cultural presuppositions in many respects and the mix was all the more

heady for being deviant. There was a strong element of Surrealist fascination involved in the rediscovery of the Hollywood undergrowth and Breton would surely have understood Godard's notorious dedication of *Breathless* to Monogram Pictures.

(2) The *auteurist* fascination with Hollywood differed crucially from the parallel American fascination (itself Surrealist-derived: witness Cornell's *Rose Hobart*) in that it rejected the low/high dichotomy and by concentrating on directors rather than stars did much more to force a reassessment of Hollywood film as art on equal terms with any other art. In a strange way *auteurism* achieved this by adopting a purist 'cinema-as-such' strategy that looks almost like an unwitting parody of Greenberg's celebrated justification of modernism: 'What had to be exhibited and made explicit was that which was unique and irreducible not only in art in general but also in each particular art. Each art had to determine, through the operations peculiar to itself, the effects peculiar and exclusive to itself'. Everything unique and irreducible in the cinema (critics spoke of 'axioms' and of 'essence') was exhibited in Raoul Walsh's *Distant Drums*—and other films of the kind, free from the dominance of literary script and pictorialist photography that marked the 'tradition of quality' and the art film.

(3) The next step was to confront *auteurism* with structuralism. Structuralism seemed to be an exciting way of going even further with the revaluation of popular art. Lévi-Strauss's analysis of myth, Propp's morphology of the folk-tale, Barthes's semiotic approach in *Mythologies* to popular culture itself (all-in wrestling, Greta Garbo's face) suggested ways of thinking popular culture that recognized its distance from high art while not demeaning it or patronizing it. There is a sense too in which Allan Dwan or Raoul Walsh were as much figments of the Other as the Bororo myth-teller of the Amazon rain-forest. Their roots went back to a 'primitive cinema', mythic and pre-literate. The crossover between ethnography and the study of popular culture is one that has often been made and this implied analogies of form as well as of content. Propp's studies of narrative proved as applicable to the stories of the mass media as to those of folk culture.

(4) The culmination of this period for me, the encounter of popular cinema with structuralism and semiology, came with *Signs and Meaning*, the book I wrote in 1968. What seems significant now to me about this work is its preference for Peirce over Saussure as founder of semiotics and, interwoven with this, its attack on purism and essentialism: 'There is no pure cinema, grounded on a single essence'. The conclusion of the book explicitly celebrates Godard for his development of a mixed cinema, in which different semiotic modes and discourses are juxtaposed and amalgamated. The target, of course, was Bazin's ontology, his grounding of the cinema in the indexicality of the photographic image (and the advantage of Peirce was that, unlike Saussure, he had developed the concepts of iconicity and indexicality). The danger I felt from the early work of Metz was precisely that it would give support and credence to an essentialist approach and, although Metz has himself changed position in many ways, I still feel that part of his Saussurean inheritance has been the search for general theories—of the sign, of the system, of the apparatus, of the Imaginary—that 'ontologize' their object.

(5) May 1968 brought *Tel Quel* in its wake. Although *Tel Quel* was also the inheritor of the (dissident) Surrealist mantle—Artaud and Bataille rather than Breton, Maoism rather than Trotskyism—it addressed itself resolutely to the avant-garde rather than popular culture. Also, it favoured the literary avant-garde (seeking to establish a line running from Mallarmé through *Finnegans Wake* to its own school of writing) and consequently developed a post-Saussurean rather than post-Peircean semiotics. At the same time, Godard (whose career had been a touchstone for me) left the mainstream of cinema for a much more avant-garde type of film-making, which reflected both the political militancy of the period and the impact of semiotics. Godard's project seemed to have become that of constructing a new form of revolutionary discourse in the cinema.

(6) The aspects of the *Tel Quel* approach that captivated me were, in general terms, the attempt to bring semiotics, Marxism and psychoanalysis into one field of discourse, and more specifically,

the introduction of 'heterogeneity' and 'inter-textuality' as key concepts, derived from Bataille and Bakhtin respectively and deployed by Julia Kristeva. The *Tel Quel* view focussed on the split in the sign, the class contradictions and split in society and the subject split between body and representation and between unconscious and conscious. It was opposed to holistic theories that contained contradictions as oppositions or antinomies that could be mediated, rather than mobilized them as dialectical generators of an uncontainable excess.

(7) A word on semiotics, Marxism and psychoanalysis. The importance of these three rests on the fact that each concerns itself with an area of human activity that articulates natural with social history: the use of signs, the organization of labour and the regulation of sexuality. The material base, to use the Marxist term, is heterogeneous and the superstructure is both disjunct from the base and overdetermined. Any text reflects the existence of a grammar that is not a biological object but determined by the physiology of the brain and the vocal tract, by an Oedipal trajectory and by an economic system. The field of discourse developed by *Tel Quel* and subsequently elsewhere, however, has tended to efface the importance of the material base—a trend accelerated by the absence of any theory of reference in Saussure's linguistics, by Lacan's dislike of instinct theory and the much greater significance given the Symbolic and the Imaginary in his system as opposed to the Real, and by the typically Maoist and Western Marxist fascination with 'Cultural Revolution'. Indeed, as post-structuralism developed, materialism and scientificity were quickly thrown out the window and replaced by discourse theory, deconstruction, and refusal of the extra-textual.

(8) One of the effects of *Tel Quel* was to draw attention to the materiality of the sign (or, perhaps I should say, of the sign support), and its material process of production. At first sight this promised to bring together the modernist preoccupation with self-definition, the irreducibility of the material support of a work, reflexive artmaking, with the Brechtian concern with showing the mechanics of production ('laying bare the device' as the Russian

Formalists put it). This, in turn, suggested a reconciliation between the 'structural film' avant-garde and Godard (or more generally the two avant-gardes). The stumbling-block lay in the contrasted and incompatible views on representation. The 'structural' interpretation of materialism was resolutely (even dogmatically) anti-realist, the Brechtian put forward a version of realism. In fact, the first was purist, whereas the second was hybrid. For Brecht the exhibition of the mechanics was part of a complex theory of seeing and of story-telling, whereas the modernist and post-*Tel Quel* theories of modernism ended up either with a reductivist ontology or in a radical deconstruction that precluded both picture and narrative.

(9) The core of the 'political modernist' position was the idea that politics in art concerned the signifier rather than the signified. This thesis existed both in a strong form—political art was entirely a matter of work with the signifier (a line of argument that could lead to presenting James Joyce as the key revolutionary artist)—and in a weak form, that the politics of the signifier was as important as the politics of the signified, that it was an indispensable condition of political art but not the only one (a position much closer to that of Brecht). On the whole the bias of the *Tel Quel* group, especially as they evolved from structuralism towards post-structuralism, was towards the first, stronger version. In the end, dicta such as 'There is no extra-textual' or 'There is no metalanguage' led to a complete break with any meaningful concept of external reality, a full-scale retreat into irrationalism and a libertarian ethos of transgression of the Law of the signified. Both in its concentration on mandarin culture and in its sweeping anti-realism, *Tel Quel* stayed on the traditional terrain of modernism.

(10) Yet at the same time, modernism was showing every sign of crisis. During the seventies the tight narrowly-defined problematic of modernism began to break into pieces, especially in the visual arts—long its citadel. In cinema, the impact of modernism had been delayed (till the advent of 'structural film') and it maintained its dynamic for a little longer. In the visual arts in general there was a massive movement away from modernist painting to

mixed media work, to photography, to text, to performance art, to installations and 'earth works', to pseudo-ethnographic and pseudo-architectural art, to fetish, to ritual, to the return of figuration. It soon became clear that the old doctrines of purity, of self-definition, of art about art, had collapsed and been replaced by a new and extremely heterogeneous expansion of art into a whole range of semiotic practices, with new types of audience relationship and with new and unanticipated forms of signification.

(11) At the same time, a new type of relationship between avant-garde art and popular culture began to develop. This was possible not only because of changes in art but because of changes in popular culture itself. The most obvious signs of this were the rise of 'youth subcultures' and other types of minority subculture, and the massive change in the music industry that followed the success of rock'n'roll. Popular culture could no longer be seen simply in terms of the old 'Hollywood' mass-media model. It was a complex, multiple, fissile system that had developed new types of relationship with new types of audience and whole areas that could not be summarily dismissed by monolithic reference to 'dominant codes' or 'classic texts'. In fact, popular culture seemed to cover everything from TV ads to subway graffiti. It was no longer monolithic and it was no longer pyramidal in structure with everything coming downwards from the top, if it ever had been.

(12) In fact, aspects of popular culture paradoxically echo many of the themes of post-structuralist para-literature. For instance: 'Rapping takes disco leaps ahead: a disco d.j. introduces a number, sometimes chats, plays around with the control board and alters bass and treble, even possibly remixes the music. Between tracks, the d.j. chats to the audience, sometimes leaking over the beginning or the end of a record. Put on an instrumental, chat over it and the d.j. has taken over the function of the singer/performer. Multiply by four, all bursting with their own tale to tell, take turns at the mike . . . the intro is also the outro, there is no point to the song because the rap is the point. For the new, black, New York d.j.s who back raps, cutting is co-extensive with play-back.

Break-mixing creates a multi-layered, almost textural sound which locates the word for rap in a space of "found" sounds.' (Mix of Sue Steward, 'The Key of R-A-P', Collusion 1, Summer 81 and Atlanta & Alexander, 'Wheels of Steel', ZG 6, 81). As Atlanta and Alexander point out rap recalls Burroughs's cut-up and play-back. But it also echoes Barthes's plurality of voices—in fact, *S/Z* looks like a rap over the found sound of *Sarrasine*, with Barthes as the d.j. usurping the performer's position, layering and re-mixing as he goes along. If *S/Z* is para-literature for one subculture, rap is para-music for another.

(13) Perhaps the avant-garde art-world and audience is simply one more subculture (subculture of resistance, it should be said, at least potentially) and then, of course, it will be subject to the same pressures of fragmentation and marginalization as any other. The way out of the ghetto and beyond the fragments can only be by crossover, hybridization and interzoning with other subcultures, to connect and articulate a culture of resistance (a counter-culture, if the term hadn't been pre-empted by just one subculture already) within, overlapping with and outside the dominant culture of the mediocracy. Clearly, this entails crossover between audiences as well as formal crossovers and also the development of institutions, through which work can be produced, distributed and shown/bought. Already the outlines of what an independent cultural sector would look like institutionally can be seen in the prolifer-ation of alternative and independent journals, labels, venues, spaces, stores, workshops, imprints, catering for minority groups and interests within the spectrum of popular culture. These both intersect with mass culture and are independent of it.

In conclusion, I want to return again to my earlier invocation of the names of Brecht and Breton, two emblematic figures in the history of the avant-garde. I think it is important to mention names like these, both because a sense of history is always neces-sary but also because it is crucial to stress that revolutionary artists must strive as they did, not only to reach their own minority audi-ence but also to play a hegemonic role in the general culture of

their time, even in the official culture with all its recuperative zeal. Brecht and Breton suggest two very different avenues for art, but I think each insists on things that are necessary—Brecht on understanding and explanation, Breton on freedom and the power of the unconscious. Of course, each also had a vivid interest in popular art and entertainment and incorporated elements from it into their own work.

Here is a quote from Breton (to the Paris Congress of Writers in 1934:

> 'In art we rise up against any regressive conception that tends to oppose content to form, in order to sacrifice the latter to the former.'

And a quote from Brecht:

> 'Even an ivory tower is a better place to sit in nowadays than a Hollywood villa.'

# References

## The Two Avant-Gardes

1.  Stephen Dwoskin, *Film Is...*, London 1975. David Curtis, *Experimental Cinema*, London 1971.
2.  Standish Lawder, *The Cubist Cinema*, New York 1975.
3.  See Sophie Lissitzky-Kuppers, *El Lissitzky*, London 1968.
4.  Theo Van Doesburg, 'Film as Pure Form', *Form*, Summer 1966, translated by Standish Lawder from *Die Form*, 15 May 1929.
5.  See Victor Burgin, 'Photographic Practice and Art Theory', *Studio International*, July /August 1975.
6.  See Roland Barthes, *Elements of Semiology*, London 1967.
7.  Christian Metz, *Language and Cinema*, The Hague 1974.
8.  Barbara Rose, 'The Films of Man Ray and Moholy-Nagy', *Artforum*, September 1971.
9.  See 'Ontology and Materialism in Film', pp. 189-207 below.
10. Sergei Eisenstein, 'The Cinematographic Principle and the Ideogram', *Film Form*, New York 1949.
11. Eisenstein, 'A Dialectic Approach to Film Form', in *Film Form*.
12. Jean-Luc Godard, *Le Gai Savoir*, Paris 1969. The script, 'mot-à-mot d'un film encore trop réviso', was published by the Union des Ecrivains formed during May 1968.
13. Julia Kristeva, *Semeiotike*, Paris 1969.
14. See Ian Christie, 'Time and Motion Studies: Structural Cinema and the Work of Bill Brand', *Studio International*, June 1974.
15. The British landscape film-makers often use a new type of narrativity, in which both film-maker and 'nature' as causal agent play the role of protagonist. A pro-filmic event, which is a conventional signified ('landscape'), intervenes actively in the process of filming, determining operations on the 'specifically cinematic' codes.

## Cinema and Technology: a Historical Overview

1.   It is worth noting that the light source is different at each stage: sunlight or artificial lights during filming, printer light and then projector light.

2.   Dai Vaughan has graphically described the impact of Scotch tape on editing in 'The Space Between Shots', *Screen*, vol. 15, no. 1, Spring 1974.

3.   *The Jazz Singer* was sound-on-disc. Without the optical track sound would probably have been restricted to leading inner-city theatres (as stereophonic sound is today).

4.   The relevant patents were controlled by ATT and RCA who struck a deal at the expense of Fox who tried to use the German Tri-Ergon patents. The whole story is reminiscent of earlier bitter battles over the Edison-inspired Patents Trust. Later Technicolor and Eastman worked out a patent-pooling arrangement until Eastman were ready to launch their own colour system.

5.   Red, which had come out black on orthochromatic stock, now came out nearly white, with a particular effect on hair and lip hues. Contour make-up became a key development later on in the thirties.

6.   Hand-cranking disappeared and editing, previously done by eye and hand, was standardized by the introduction of the moviola.

7.   Carbon arcs came back after the electrolytic capacitator was introduced. The blimped Mitchell BNCs were sold to Goldwyn in 1934 or 1935. In time these innovations fed into *Citizen Kane*, an anomalous film that took the possibilities of sound as far as was possible before magnetic tape. Disney's *Fantasia* was similarly pioneering, but a failure: only six theatres used the stereo version.

8.   Early colour devices included filtered projection light, multiple projectors, 'pointilliste' emulsions. Two-colour Technicolor was used throughout some films in the twenties, though mainly restricted to set pieces and finales.

9.   Natalie Kalmus's favourite picture was *The Red Shoes*.

10.   *The Robe* was important because it introduced Eastman color, Cinemascope and tape-based stereophonic sound together.

11.   The same was true of 3-D which has used Trucolor or Anscocolor.

12.   Actually, labour costs associated with lighting were probably more important than the lighting costs themselves.

13.   Like Technicolor, Cinerama was backed by Whitney (cf. *Gone With The Wind*) and by Reeves Sound Studio which hoped to break into the field of cinema through stereo. Early Cinerama attempts were shown at the New York World's Fair—fairs and exhibitions have often been privileged places for introducing new technology only rarely taken up industrially.

14.   During the 1914-18 war. Autant-Lara made a Scope film in the 1920s, when the system was called Hypergonar. Fox bought the patents to fight the twin threats of TV and 3-D.

15.   Snow's camera is also itself exhibited as a sculpture.

# Photography and Aesthetics

1.  See Jean Clair, *Duchamp et la Photographie*, Paris 1977 and, for suggestive comparisons with pure technical drawing, the illustrations in *Le Macchine Celibi/ The Bachelor Machines*, Venice 1975. P.J. Booker, *A History of Engineering Drawing*, London 1963 provides an excellent account of a neglected area.

2.  For Robinson's views see *Pictorial Effect in Photography*, London 1869; for Emerson's: *Naturalistic Photography for Students of the Art*, London 1889. Shorter, characteristic texts by both men are reprinted in Nathan Lyons, *Photographers on Photography*, New Jersey 1966. They were both very vigorous controversialists quite unafraid of either prejudice or abuse, which they relished and lavished liberally on others.

3.  Originally titled *The Old Farmstead*. Davison used sheet-metal punched with a small hole instead of a lens. Gernsheim, in his classic *Creative Photography*, London 1962, writing from a 'New Objectivity' standpoint, denounces Davison almost as virulently as he does Robinson.

4.  The best account of these bitter quarrels—for and against the gum process that allowed 'intervention', for and against combination printing, for and against diffused focus, for and against innovation in painting and photography, and so on, is John Taylor's introduction to *Pictorial Photography in Britain*, Arts Council of Great Britain, London 1978. Taylor writes with sympathy both for pictorialism and for the conservative 'British' trends within it, a sign of a swing of the pendulum away from the dogmas of naturalism and the straight print as well as modernist influences and ideas.

5.  For Demachy's own spirited polemics, see Bill Jay, *Robert Demachy*, London 1974, which reprints a number of his essays as well as a limited selection of photographs. Demachy developed Whistlerian effects in the direction of Carrière. For Frank Eugene, see C.H. Caffin, *Photography as a Fine Art*, New York 1901.

6.  There are a number of works with material on Stieglitz and his multifarious activities—his journals, his galleries, his propaganda and polemic, his 'circle'. Among the most interesting are Bram Dijkstra, *The Hieroglyphics of a New Speech*, Princeton 1969, and Dickran Tashjian, *Skyscraper Primitives*, Wesleyan 1974, which deal with Stieglitz's role in the introduction first of Cubism and then Dadaism to the United States.

7.  *Broom*, vol. 3, no. 4, 1922, reprinted in Lyons, *Photographers on Photography*. *Broom* was always eager to link the destiny of American art to American technology.

8.  In *Philebus*, Plato praises shapes and solids 'produced by a lathe or a carpenter's rule and square from the straight and the round'. Stieglitz liked and used this quote. Dijkstra comments on Stieglitz and Plato in different terms.

9.  Weston often returns, in his *Daybooks*, New York 1973, written during the twenties and thirties, to the differences between and supremacy of photography over painting (for him, the touchstones were Duchamp, Picasso and Brancusi on the one hand, and himself on the other). Weston's co-worker, Tina Modotti,

attempted to give his style of photography a political message, till she abandoned photography to become a professional revolutionary.

10. Gombrich bestows his praise on Cartier-Bresson in the Scottish Arts Council *Cartier-Bresson Catalogue*, Edinburgh 1978. He concludes his essay with the succinct statement, 'He is a true humanist'.

11. Walter Benjamin wrote frequently about photography. See especially his: 'A Short History of Photography', *Screen*, vol. 3, no. 1, 1972; 'The Work of Art in the Age of Mechanical Reproduction' and 'The Author as Producer', in *Illuminations*, London and New York 1968. For an account of the controversy with Adorno see Susan Buck-Morss, *The Origin of Negative Dialectics*, London and New York 1977, and *Aesthetics and Politics*, London 1977. For a convenient history of New Objectivity, see John Willett, *The New Sobriety—Art and Politics in the Weimar Period 1917-33*, London 1978.

12. Berenice Abbott, *The World of Atget*, New York 1964 (reprint).

13. Susan Sontag, *On Photography*, London and New York, 1977, pivots on a chapter critical of Arbus. On the subject of photography Sontag is even more 'saturnine' and pessimistic than Benjamin. The Arbus quote is from Gordin Fraser, *Diane Arbus*, London 1973.

14. Two Surrealists were active as photographers: J.A. Boiffard and Man Ray. Boiffard took the famous photograph of a big toe for Bataille.

15. Wolfgang Kayser, *The Grotesque*, Indiana 1963. Kayser argues that 'the official theory of Surrealism ultimately rejected the quest for the grotesque'. Perhaps we should agree too with the photographer Manuel Alvarez Bravo who commented, in an interview in *Camerawork*, no. 3, on Breton's assertion that Mexico was a Surrealist country: 'That is what Breton says. In fact, Mexico can be a dramatic country, a country full of contrasts, even bordering on the fantastic, which does not precisely fit in the concept of Surrealism which like any other "ism" is an academic term'.

16. See *August Sander*, London 1977; *Antlitz der Zeit*, introduction by Alfred Döblin, Berlin 1929, republished Munich 1973.

17. Brecht's remark is quoted by Benjamin, 'The Author as Producer'. There is a strong animus against photography in almost all Marxist aesthetics—Adorno and Lukács are united on this point—apparently because it is connected with naturalism, with Zola rather than either Balzac or the avant-garde. It is interesting that Eisenstein is almost alone among Marxists in defending Zola.

18. Barthes's other contribution to the discussion of photography is the concept of 'connotation'. However, he uses different explanatory schemas for this concept in *Mythologies, The Elements of Semiology*, and *Système de la Mode* all of which are digested and regurgitated as yet another, this time very different type of schema in *S/Z*. Barthes's original model, Hjelmslev, uses the concept as a stylistic category. Barthes seems to mean by connotation something like an intension exemplified in a text (connotation in J.S. Mill's sense but re-deployed within a borrowed Hjelmslevian framework, emptied of Hjelmslev's own 'purport'). Even re-interpreted as above, this notion remains impressionistic.

19. John Berger argues in *Selected Essays and Articles*, Harmondsworth 1972 that photography, contrary to expectation, is more concerned with time than

space in that it primarily represents an instant, abstracted from a narrative event the spectator constructs (or which is constructed for one by a caption). Perhaps this is an over-generalization from the news or documentary photograph, but in any case this characteristic of photography need not be seen as essential. As for Wagner, photographs are rarely accompanied by music, so any integration is relatively less than total. Slides are used, of course, in some concerts and performances.

20.   Emerson remarks that photographs of record (faces, buildings, landscapes) 'always require a *name*. It is a photograph of *Mr Jones*, of *Mont Blanc*, or of *The Houses of Parliament*. On the other hand, a work of Art really requires *no name*—it speaks for itself' (in Lyons, *Photographers on Photography*). C.S. Peirce remarked on the indexical nature of photography, seeming to consider the photograph a quasi-predicate and the object of the photograph its quasi-subject. For a more modern treatment of a similar issue, see David Kaplan, 'Quantifying In' in Leonard Linsky, ed., *Reference and Modality*, Oxford 1971, which is particularly interesting on portraits.

21.   See Dawn Ades, *Photomontage*, London 1976, and Robert A. Sobieszek's articles in *Artforum*, September and October 1978. See also *Alexander Rodtschenko, Fotografien 1920-1938*, Köln 1978, and Sophie Lissitzky-Kupper's classic *El Lissitzky*, London 1968. John Berger in *Selected Essays* has an interesting text on photomontage and, for an excellent account contemporary with Benjamin's, see Harry Alan Potamkin's essay in Frank Fraprie and Walter Woodbury, eds., *Photographic Amusements*, Boston 1931. For German work, less well-known than Heartfield's, there is Emilie Bertonati, *Das Experimentelle Photo in Deutschland 1918-1940*, Munchen 1978, as well as Franz Roh's essential *Photo-eye*, Stuttgart 1929.

22.   The category 'modernism' has increasingly been captured by those who see twentieth-century art primarily in terms of reflexivity, ontological exploration, and so on. In this context, the category 'avant-garde' is best reserved for works that prolong and·deepen the historic 'rupture' of Cubism.

23.   For an interesting sample of recent American photography, see *(photo) (photo)$^2$ . . . (photo)$^n$*, the catalogue of an exhibition of 'sequenced photographs' at the University of Maryland Art Gallery, 1975.

24.   For an overview of recent British photography, see *Time, Words, and the Camera*, Jasia Reichardt, ed., Graz 1976.

For Victor Burgin's photographic work see *Work and Commentary*, London 1973; *Victor Burgin*, Eindhoven 1977; *Family*, New York 1977; *English Art Today 1960-76*, Milan 1976, pp. 361-67. *Hayward Annual 77*, London 1977 pp. 82-5, and *Thinking Photography*, London 1982.

For David Dye see *English Art Today*, pp. 368-373; for Alexis Hunter, *Hayward Annual 78*, London 1978, pp. 38-40, and for John Stezaker, *Fragments*, London 1978, and *Works*, Kunstmuseum Luzern, 1979.

The work of Mary Kelly provides a related instance of the rigorous non-use of photography.

25.   These remarks also apply to film, where purism of a modernist type is much more strongly entrenched. As outlined above, photographic purism has

gravitated towards a 'Bazin' rather than 'Sharits' aesthetic. In contrast, Godard-Gorin's *Letter to Jane* or McCall and Tyndall's *Argument*, raise problems about the aesthetics and politics of photographic signifieds.

26.  In talking about knowledge I am assuming the possibility of historical epistemologies, which would include concepts of 'reference', 'data', 'experiment', and so on. The place of an empirical component in the production of knowledge is, of course, historically determinate and not absolute. I assume that knowledge may be of different types and orders, of which 'scientific knowledge' is only one category. Art, though it may make use of various forms of knowledge, scientific included, perhaps produces a reordering and re-categorizing of the thought-materials and epistemological components necessary to the production of new knowledge elsewhere.

## 'Ontology' and 'Materialism' in Film

1.  Vols. 1-4, Paris 1938-62; part translated as *What is Cinema?*, Berkeley 1967.

2.  *Qu'est-ce que le cinéma?*, Vol. 1, p. 15.

3.  Ibid., p. 19.

4.  Ibid., p. 139.

5.  See Patrick Ogle: 'Technological and Aesthetic Influences upon the Development of Deep Focus Cinematography in the United States,' *Screen*, Vol. 13, no. 1, Spring 1972, pp. 45-72.

6.  Bazin, Vol. 2, p. 38.

7.  Ibid., Vol. 1, p. 122.

8.  The Complete Psychological Works of Sigmund Freud (Standard Edition), London 1966, Vol. 21.

9.  *Qu'est-ce que le cinéma?*, Vol. 1, p. 124.

10.  *Cinim*, no. 3, 1969, p. 3.

11.  'My films are (to me) attempts to suggest the mind in a certain state or certain states of consciousness. They are drug relatives in that respect.' Michael Snow, *Letter from Michael Snow to P. Adams Sitney and Jonas Mekas, Film Culture*, no. 46, 1967, pp. 4-5.

12.  *Michael Snow/A Survey*, Art Gallery of Ontario, 1970, p. 83.

13.  *Studio International*, Vol. 184, no. 948, 1972, pp. 110-14; see also *Kansas Quarterly*, Vol. 4, no. 2, 1972, pp. 60-70.

14.  Greenberg, 'Modernist Painting', *Arts Yearbook*, no. 4, 1961, p. 103.

15.  *Projected Images*, Walker Art Center, 1974, pp. 22-5.

16.  *Artforum*, September 1971.

17.  See 'Definition and Theory of the Current Avant-Garde: Materialist/Structuralist Film', *Studio International*, Vol. 187, no. 963, 1974, and 'Theory and Definition of Structural/Materialist Film', *Studio International*, Vol. 190, no. 978, 1975.

18.  *Projected Images*, p. 25.

19.  Discussion between Jean-Marie Straub, Glauber Rocha, Miklos Jancso

and Pierre Clementi, arranged by Simon Hartog and filmed in Rome, February 1970. Tape published under the title 'The Industry and European New Cinema', *Cinemantics*, no. 3, July 1970.

20. For Godard's ideas during the crucial period of the late 1960's, see *Kinopraxis*, no. 0 (sic), published by Jack Flash, 'who may be reached at 2533 Telegraph Avenue, Berkeley,' 'under a rubric dating to May 68,' but, in fact, 1970. This broadside contains a collection of interviews given by Godard.

21. See especially *Language and the Cinema*, The Hague 1973.

22. 'Words per Page', *Afterimage* 4, Autumn 1972, pp. 26-42.

23. 'Introduction', *Three American Painters*, Fogg Art Museum 1965, pp. 3-53.

24. Sharits, 'Words per Page'.

25. Michael Snow, *Cinim* no. 3, 1969, no. 5.

26. Paris 1974.

27. See Brion Gysin, *Brion Gysin Let the Mice in*, Something Else Press, West Glover Vt. 1973, and William Burroughs and Brion Gysin, *The Exterminator*, Auerhahn Press 1960.

28. Sharits, 'Words per Page', p. 32.

29. Paul L. Garvin, ed., *A Prague School Reader on Esthetics, Literary Structure and Style*, Georgetown 1964.

30. Cornwell, 'Some Formalist Tendencies in the Current American Avant-Garde Film', p. 111.

31. Brakhage, 'A Moving Picture Giving and Taking Book', *Film Culture* 41, Summer 1966, pp. 47-8.

32. For instance, Brecht talks about epic theatre as 'picture of the world' in the notes to *Mahagonny*, and of plays as 'representations' in the *Short Organum*.

33. The concept of 'text' is developed especially in the writings of the *Tel Quel* group. See, for instance, Philippe Sollers, 'Niveaux sémantiques d'un texte moderne', in *Théorie d'ensemble*, Paris 1968, pp. 317-25.

34. See Victor Shklovsky, 'Art as technique' in Lemon and Reis, eds., *Russian Formalist Criticism*, Lincoln 1965, pp. 5-57, and Roman Jakobson, 'Concluding Statement: Linguistics and Poetics' in Seboek, ed., *Style in Language*, Cambridge Massachusetts 1960, pp. 350-77.

35. P. Adams Sitney, 'The Idea of Morphology', *Film Culture*, 53/4/5, Spring 1972, p. 5.

36. Cornwell, 'Some Formalist Tendencies', p. 111.

37. Roland Barthes, *Le Degré zéro de l'écriture*, Paris 1953, translated as *Writing Degree Zero*, London 1967. Barthes distinguishes between '*style*' and '*écriture*' or 'writing', seeing style as a blind force in comparison with a writing marked by intentionality.

38. Sitney, 'Structural Film', *Film Culture Reader*, New York, 1970, p. 327.

39. See 'Counter Cinema: Vent d'Est', pp. 79-91 above.

40. Among many signs of a possible convergence, I would like to mention the writing of Annette Michelson—the interest, for instance, in Vertov and Eisenstein that she shares with Godard and European theorists—and the stand taken by the magazine *Afterimage*. The relationship of the film avant-garde to politics

is discussed by Chuck Kleinhans in 'reading and thinking about the avant-garde', *Jump Cut*, no. 6, March-April 1975, pp. 21-5. For more detailed treatment, see 'The Two Avant-Gardes', pp. 92-104 above.

# Name Index